PUBLIC INTIMACY

ARCHITECTURE AND THE VISUAL ARTS

Writing **Architecture** series

A project of the Anyone Corporation

Earth Moves: The Furnishing of Territories
Bernard Cache, 1995

Architecture as Metaphor: Language, Number, Money
Kojin Karatani, 1995

Differences: Topographies of Contemporary Architecture
Ignasi de Solà-Morales, 1996

Constructions
John Rajchman, 1997

Such Places as Memory: Poems 1953–1996
John Hejduk, 1998

Welcome to the Hotel Architecture
Roger Connah, 1998

Fire and Memory: On Architecture and Energy
Luis Fernández-Galiano, 2000

A Landscape of Events
Paul Virilio, 2000

Architecture from the Outside: Essays on Virtual and Real Space
Elizabeth Grosz, 2001

Public Intimacy: Architecture and the Visual Arts
Giuliana Bruno, 2007

PUBLIC INTIMACY

ARCHITECTURE AND THE VISUAL ARTS

GIULIANA BRUNO

THE MIT PRESS

CAMBRIDGE, MASSACHUSETTS

LONDON, ENGLAND

MIT Press books may be purchased at special quantity discounts for business or sales promotional use. For information, please email special_sales@mitpress.mit.edu or write to Special Sales Department, The MIT Press, 55 Hayward Street, Cambridge, MA 02142.

This book was printed and bound in Spain.

Library of Congress Cataloging-in-Publication Data

Bruno, Giuliana.
 Public intimacy : architecture and the visual arts / Giuliana Bruno.
 p. cm. — (Writing architecture)
 Includes bibliographical references and index.
 ISBN-13 978-0-262-52465-0 (pbk. : alk. paper)
 1. Art and architecture. 2. Art and motion pictures. I. Title.
N72.A75B78 2007
720.1—dc22

 2006046723

10 9 8 7 6 5 4 3 2 1

for Annette Michelson

CONTENTS

FOREWORD Anthony Vidler ix

ACKNOWLEDGMENTS xiii

RECOLLECTED SPACES

1. Collection and Recollection: 3
 On Film Itineraries and Museum Walks

2. Modernist Ruins, Filmic Archaeologies: 43
 Jane and Louise Wilson's *A Free and Anonymous Monument*

SCIENTIFIC SCENOGRAPHIES

3. The Architecture of Science in Art: An Anatomy Lesson 87

4. Mind Works: Rebecca Horn's Interior Art 119

FABRICS OF TIME

5. Fashions of Living: Intimacy in Art and Film 163

6. Architects of Time: Reel Duration from Warhol 189
 to Tsai Ming-liang

NOTES 215

INDEX 237

FOREWORD

Three-dimensional space, inhabited and set in virtual motion
by the body, has formed the material of modern architecture; its
representation in two dimensions, with the added dimension of
time, has been the work of film. Both arts have been inextricably
linked since the end of the nineteenth century: architects have
taken their cue from film, filmmakers from architects. Sigfried
Giedion coined the triplet "space, time, and architecture"; Le
Corbusier and Sergei Eisenstein served as the emblematic duo
in this cross-medium relationship; Walter Benjamin sealed the
marriage as a product of modern technological reproduction; and
psychology reinforced it with the concept of mental projection.
Architecture now operated as a psychic mechanism, constructing
its subjects in time and space. Film not only depicted movement
in space and space in movement, it also unpacked the modern
subject's spatial unconscious and its layers of (repressed) mem-
ories. These are the arenas in which film theorist Giuliana Bruno
focuses her critical analysis of bodies, space, and the projection
of two-dimensional pictures, both moving and still.

 While modernism in architecture and the then-new medium
of film have served as the leitmotif of the avant-gardes since
the 1900s, the intersection of mental-spatial experience and its
illusory depiction has a long prehistory in the phantasmagoria
of nineteenth-century panoramas, the anatomy theaters of early
medical presentation, and the memory theaters of the Renais-
sance that Bruno considers. The psychoanalyst Jacques Lacan
even traced it back to the very origins of architecture and painting
where, as he noted, architecture primitively "organized around a

void" gave place to perspectival painting as an image of the void, only to be subjected itself to the painterly laws of perspective. In this primal scene of architecture as its own image of an illusory emptiness that it originally sought to control, Lacan intimates the psychic structure that would bind all spatial relations within a single screen, one that would serve at once as an alienated mirror image of the self and as a projected window onto its conflictual social relations.[1]

It is these relations that contemporary installation art has explored; now with the aid of bodies, their prostheses and stand-ins; now with screened images that themselves, like Lacan's Renaissance wall paintings, stand in for walls. Drawing on all of the yet-untapped resources and devices inherited from the modernist avant-gardes, while using more and more sophisticated digital technology, yesterday's simulated virtual environments are transformed into today's real virtual environments, or rather, into environments constructed in the world of four-dimensional sensory perception out of virtual materials that project multivalent and other environments *en abîme*. Finally, all the "disciplinary" divisions between the arts set up by rationalist aestheticians and media specificists since Gottfried Lessing seem to have been overcome, and the synesthesia propounded by modernists achieved—all by the means of technology.

And yet, as Bruno's essays here demonstrate, the historical lineage of these new experiments, as well as that of their avant-garde predecessors, complicates any such simple vision of progressive interartistic fusion. For while it is clear that since the 1960s and 1970s painting and sculpture have expanded their fields, and that since the 1980s film and video have expanded their own territories, and that even architecture has embraced and incorporated the formal results of digital animation, it is equally clear that such fields of specificity, with their own micro-histories, still offer strong resistance to complete absorption.

The body, in its anatomical corporeality, together with all its prosthetic accoutrements, still obstructs total virtuality; architectural space, in its role as a stimulator of mental introjection (memory) and physical and psychical projection (event), still retains its primal power to capture the body; filmic media, as simulated movement in movement, and simulated space in two dimensions, still operates as an analytical instrument akin to that of the surgeon's scalpel or psychoanalyst's couch, to discover and display all the lapses of memory and consciousness.

Indeed, the best work in architecture, film, and installation explores and exploits these resistances, as Bruno notes in Rebecca Horn's investigation of medical archaeology and body machines in reality and in film and in Jane and Louise Wilson's *A Free and Anonymous Monument,* in such a way that they endow memory and history with a new and critical life. The Wilsons' *Monument* demonstrates how without nostalgia, but with immense respect, a modernist work of art conceived with all the brutal power of late 1950s architecture—a vaunted example of Reyner Banham's "architecture autre," now abandoned and attacked as ugly—can be recuperated and reformulated in an installation at once physical and virtual, and revealing the multidimensionality of what, in situ, is taken as a reduced, if not meaningless, object. Here, what Lacan refers to as painting attempting to recuperate the original void of architecture in perspective is newly animated by the new wall painting of digital screens that recombine perspectives in shifting viewpoints, moving over architectural surfaces that in true three dimensions reenact the physical presence of the monument. In this sense, such an installation might be conceived as the late modernist equivalent to the late Renaissance/baroque anamorphosis, where the anamorphosis, itself the product of an exquisite and polished machine for illusion, operated, so to speak, to reverse the objective role of perspective (that of representing the illusion of space) in order to

reveal the original aim of the painterly/architectural art as a support for the void, that hidden reality attempting to encircle emptiness. In the case of *Monument*, the screens that are not walls, playing on walls that are screens simulating walls, go one step further than the classical movie, which reveals the void in its montage effects, in order to recuperate architecture in its primitive state—a neat return to origins of *architecture brut*, but also a structured analysis of such a return.

If, however, such work does not complete itself as total synesthesia, but rather constitutes an overlapping of (quasi-expanded) fields, how might we characterize its relationship to the modernist or late modernist aspirations toward the "total work of art"? Perhaps, again following Lacan, who sees the linguistic equivalent to the anamorphosis effect in the late medieval discourse of courtly love, we might treat these field relations as discursive, as conversations among previous and present specificities, as structured in fact on their several resistances, rather than ignoring and collapsing them. And, in the same way that the filmmaker Guy Debord recognized the origins of the *dérive* in the *promenade architecturale*, and the origins of this again in the seventeenth-century maps drawn by the "Précieux" in their conversational circles—the celebrated *Carte du pays de Tendre* of Madeleine de Scudéry's imagination—so might we begin to interpret our present intradisciplinary experiments not as failed total utopias, nor as lost disciplinary practices, but rather as elaborate conversations between private subjects in a newly constituted public realm: an interior constructed as an exterior in order to capture and analyze, as Bruno does here, a collective private void in public.

Anthony Vidler
New York
December 31, 2005

ACKNOWLEDGMENTS

I am very grateful to Cynthia Davidson who has made this publication come to life; working with her has been not only productive but a real pleasure. Special thanks to Tony Vidler for writing such an insightful foreword. My gratitude goes also to Roger Conover, executive editor at MIT, and to Marc Lowenthal. In thanking all those who contributed to the publication of the original essays, and helped with this present version, I offer special thanks to Jane and Louise Wilson, Clare Coombes and the Lisson Gallery, Steven Bode, Nancy Spector, Deborah Drier, Rebecca Horn, Richard Allen, Malcolm Turvey, Gwendolyn Foster, Wheeler Winston Dixon, Shujen Wang, and Tsai Ming-liang. I also wish to acknowledge Allan Shearer, Diana Ramirez, Mattias Frey, and Ally Field for sharing ideas and work. Thanks to Jonah Lowenfeld and Tei Carpenter for their help during my image research. Sally Donaldson encouraged me to pursue this. And, as always, I owe the most to Andrew Fierberg, whose love and support have sustained the making of another book: this time, mercifully, it is relatively short.

RECOLLECTED SPACES

1 COLLECTION AND RECOLLECTION
ON FILM ITINERARIES AND MUSEUM WALKS

Recollection is a discarded garment.
—Søren Kierkegaard

A garment, discarded. A texture holding a text. As part of an aesthetic collection that speaks of its wearer's taste, the discarded garment enacts recollection, recalling for us the person who inhabited its surface—the lively body that animated it. A familiar scenario for the artist Christian Boltanski, the material of the discarded garment embodies a projection: the textile surface acts as a screen. The filmic screen is also fiber, a material weave that absorbs and reflects. Such is the screen—the fabric—upon which the stories of history are inscribed.

It is from this narrative of the discarded garment that I would like to launch a reflection on the mobile activity of recollection. If this essay joins recollection and garment on a screen, it is to call attention to the "fashioning" of archival space, considering, in particular, the place of cinema and the museum in this process. Ultimately, its aim is to foreground the interaction between film's imaginative route and the museum walk and, recognizing a reversible process at work, to link their emotive impact along the experiential path including acts of memory, the

itinerary of the imagination, the place of collection, and the journey of recollection.

Cinema and memory have been linked since the inception of film history and theory. They are bonded in the very archaeology of the moving image and the spaces of its exhibition. In his 1916 pioneering study of cinema, Hugo Münsterberg introduced a model of theory that accounted for the intimate binding of film to affects and memory.[1] Münsterberg underscored the psychic force of filmic representation, and claimed that the medium itself is a "projection" of the way our minds work. Cinema is a materialization of our psychic life. It makes visibly tangible all psychic phenomena, including the work of memory and of the imagination, the capacity for attention, the design of depth and movement, and the mapping of affects. In suggesting that with film "we have really an objectivation of our memory function," Münsterberg claimed cinema's fundamental mnemonic function.[2] Film is a medium that can not only reflect but produce the layout of our mnemonic landscape. It is an agent of intersubjective and cultural memory.

Mnemonics is an integral part of film's own geopsychic apparatus. If the design of memory is a generative function of cinema, this mnemotechnical feature of the medium is apparent even at the textual level. The work of memory is particularly prominent in science fiction and in film noir, two modes of storytelling whose narrative borders fluctuate and often overlap. As part of its plot-making, film noir plays mind games with the viewer and is particularly fond of manipulating memory, shifting both personal and social history as it does so. Its more contemporary offspring, from *Blade Runner* to *Memento*, remind us of the very change of memory's status in our culture. These films expose modern memory as an image and pictures as the very *architecture* of memory. Mnemonic traces slide toward and collide with marks on celluloid. Film repeatedly shows that pictures—moving pictures—are the current documents of our histories. Indeed,

filmic memories—fragile yet enduring—are fragments of an *archival* process porously embedded in our path, part of our own shifting geography.

The geography of museum culture has changed as well and now incorporates moving images into its various forms of exhibitionary practice. The museum's own agency as a space of cultural memory has been mobilized by the presence of moving images. To reflect on this new geography of (re)collection we thus need to pursue the critical interaction between art and film and to engage the discourse of exhibition. Considerations of exhibition are the focus of a current reconfiguration of art history and curatorship.[3] In its many compelling forms, exhibition has become a locus of serious artistic practice as well as a site for the study of the design politics of artistic space.[4] The resonance between art and architecture is a particularly fruitful issue for the reconfiguration of exhibition and one that both concerns and affects the work of film. Film theory, however, despite its interest in exhibition, has yet to engage fully with this art-historical discourse. This remains the case even though film has encountered art on the terrain of exhibition in many ways. The intent here, in considering the space of cinema and the museum and their possible conjunctions, is to sustain interdisciplinary research and foster a cross-pollination of film and art theory.[5] This means opening the doors of the movie house and showing that the motor-force of cinema extends beyond the borders of film's own venues of circulation. The affective life of cinema has a vast range of effects and, in general, its representational and cultural itineraries are productive outside the film theater. They are implanted, among other places, in the performative space of the art gallery, and they affect the nature and reception of this space. In the spirit of theoretical crossovers, let us then pursue this interaction and look at the encounters between film and art at the interface of the museum wall and the film screen.

Film and Museum *Architexture*

The work of Lewis Mumford provides insights that can enlighten us on this interface between film and art and guide us in theorizing the subject of an archive of (e)motion pictures. It was Mumford who, early on, articulated an interaction between cinema and the museum in architectural terms by assigning a museographic function to film. In his view, film becomes a modern way of documenting culture's memorials by offering for our viewing different modes of life and past existences. In this way, it allows us to cope with other historical periods; or rather, as he put it, to have "intercourse" with them. According to Mumford:

> Starting itself as a chance accumulation of relics, with no more rhyme or reason than the city itself, the museum at last presents itself to use as a means of selectively preserving the memorials of culture. . . . What cannot be kept in existence in material form we may now measure, photograph in still and moving pictures. [6]

For Mumford, the cinema intervenes in museographic culture by providing a measure of what cannot be kept in existence. Relating to preservation, Mumford offers a version of the embalming process represented by the reproduction of life on film—the mummification process activated, at some level, in the genealogy and archaeology of film.

This discourse has circulated in film theory as well, following André Bazin's contemplation of a "mummy complex" in the arts. For Bazin, cinema is an heir of the plastic arts and represents the most important event in their history, for it both fulfills and liberates art's most fundamental function—the desire to embalm. According to Bazin, this archaeological drive embodied in the arts can be uncovered if we dig psychoanalytically into their genealogical texture:

If the plastic arts were put under psychoanalysis, the practice of embalming the dead might turn out to be a fundamental factor in their creation. The process might reveal that at the origin of painting and sculpture there lies a mummy complex. . . .

Cinema [is] the furthermost evolution to date of plastic realism.[7]

Bazin recognized that cinema has a place in the history of art and within the space Mumford defined as the "memorials of culture." But Mumford goes further than Bazin. As his text invokes an image of the city and its motion, it offers us a less static picture. Going beyond the notion of cinema as a death mask, Mumford's words enable us to recognize cinema as a moving imprint and an active mnemonic measure: that is, as a *mapping* of an archive of images. Taking this route of mapping a step further (and further away from preservation), we can recognize the random accumulation—the rhyme and rhythm that accrue to the collection of relics—mobilized in exhibitionary discourse when it is intersubjectively shared in intimate exchange. This is precisely the geographic narrative of cinema, the effects of which are equally felt in urban rhythm as random, cumulative assemblage mobilized in *emotion*al traversal. On Mumford's moving map the celluloid archive thus joins the city and the museum. On this field screen, let us consider further the possibility of mapping intersections between wall and screen.

A Tour through the Gallery's Film Archive

Mumford's words lead us to ask how the urban rhyme and rhythm of museographic display, which molded the plastic language of cinema, affects us today in the current space of the museum and the gallery.[8] The convergence of the museum and the cinema is

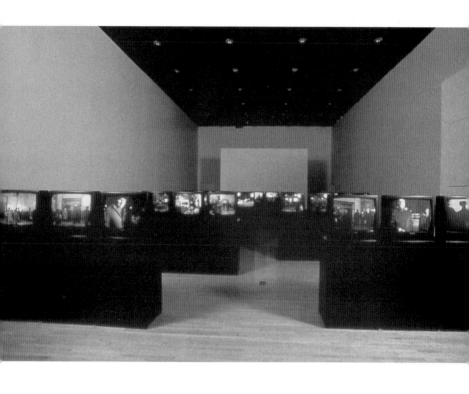

1.1

Chantal Akerman, *D'est,* 1995.
View of the installation at the Walker
Art Center, June18–August 27, 1995.
Courtesy of the artist.

established as a main constituent of film genealogy in Mumford's way of reading collection and recollection. This convergence has become a newly articulated strain in contemporary visual culture. It is especially visible and vital in the realm of art installation. In recent years, we have witnessed an interesting phenomenon—a cultural migration between art and film. Motion pictures have now actually moved. To a certain extent, they have changed address. They have exited the movie house to take up residence in the museum, becoming, in different forms, a steady feature of gallery shows and museum exhibitions. This phenomenon signals motion on the grounds of cultural memory and its location. In many ways, an exchange has taken place on the field screen of visual archives.

In a concrete sense, the new interface has led filmmakers to produce installations reformulating the architecture of the moving image. They include Chantal Akerman, Atom Egoyan, Peter Greenaway, Hal Hartley, Isaac Julien, Abbas Kiarostami, Chris Marker, Yvonne Rainer, Raúl Ruiz, Trinh T. Minh-ha, and Agnès Varda. A prominent example of this reconfiguration is Akerman's decomposition of her film *D'est* (From the East, 1993) into the form of an art installation.[9] The film is literally dislocated: made to reside in triptychs of twenty-four video monitors spread across the gallery space. The gallery viewer is therefore offered the spectatorial pleasure of entering into a film as she physically retraverses the language of montage. This kind of viewership signals a passage between art, architecture, and film, predicated on exhibition. As Peter Greenaway muses: "Isn't cinema an exhibition . . . ? Perhaps we can imagine a cinema where both audience and exhibits move."[10] At times, this movement is directly engaged in the exhibitionary ability to collect and recollect. Such is the case for Isaac Julien's installation *Vagabondia* (2000), which traverses the space of an art collection as it offers a wandering reflection on recollection.[11] Here, a split screen is used to take viewers into the

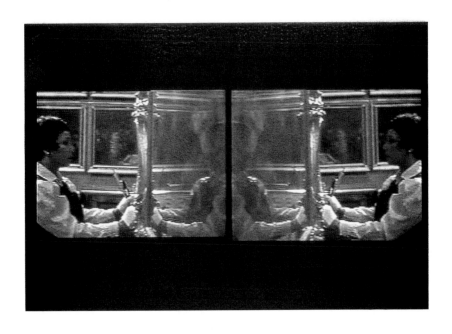

1.2

Isaac Julien, *Vagabondia*, 2000.
View of the installation at Tate Britain,
2001–2002. Copyright @ Isaac Julien.

seams of mnemonic space as a loop reiterates the movement of regression into museographic exploration.

Just as filmmakers have turned to installation, many notable contemporary artists, conversely, have turned to filmmaking. This is hardly a new phenomenon, for the language of twentieth-century art has variously intersected with film, especially in its modernist configurations. But the recent incarnation of the exchange engages more directly in the work of narrative and has, at times, a greater predilection for popular culture. Sophie Calle, for instance, who works narratively in photography and is concerned with detecting and investigating intimate space, created *Double Blind* (1992) with Gregory Shephard, a road movie that records, from their different viewpoints, the disintegrating course of their relationship during a car trip across the United States.[12] Larry Clark, Robert Longo, David Salle, Julian Schnabel, and Cindy Sherman have all worked in feature film formats, making fictional films that do not fit the rubric of the so-called art film.[13] Rebecca Horn also has creatively navigated the language of fiction, working extensively in film performance and feature film formats for a number of years.[14] Matthew Barney has created his own "mutant" *Cremaster* (1994–2002) film form, working in the interstices of sculpture, photography, video, and cinema to compose anatomical hybrids that challenge distinctions of species and gender and drive them into new, intricate designs.[15]

Moving images have made their way into the art gallery and the museum on a larger scale as well, returning spectatorship to exhibition. This trajectory is reciprocal and is articulated spatially. Looking at the ways in which the art installation has established itself as a crucial nexus in the museum, one cannot help thinking of the cinema. In many ways, the form of this aesthetic—in which art melts into architecture—is reminiscent of the space occupied by cinema itself, that other architectural art form. In even more graphic terms, one might say that the rooms of an installation

often become a literal projection room, transforming themselves into actual filmic space.

In this hybrid screening process, numerous occurrences of cinematic deconstruction and decomposition have taken place in the museum and gallery space. At times, these experiments resonate with the researches into film language made by an earlier film avant-garde, especially in the cinematic genealogies of Ken Jacobs or Bruce Conner.[16] Thus a number of contemporary artists have come to engage with the language of film by analyzing specific film texts, retraversing film history, or breaking down film movement and duration. They have deployed in their artistic practice the use of slow motion and techniques such as the freeze frame, looping, and the reworking of found footage. Particularly notable in this respect are the installations of the Canadian artist Stan Douglas, whose media work refashions space and duration in the face of history and in the guise of historical memory, thereby propelling a remapping of cultural landscapes by means of historical inventories of representation, including cinema's own.[17] As Kerry Brougher claims (and has demonstrated in the space of an exhibition), in many ways "the cinematic is alive and well within . . . the network of images and sounds" mobilized in art.[18] A 1996 London exhibition in which the relationship between art and films was staged further proved that such crossovers can, indeed, hold one "Spellbound."[19] Without pretending to assess the state of the art, and aware of the limits of an essay, these partial observations are meant to point out that the genealogical life of film is being extended—perhaps even distended—in the space of the contemporary gallery.

On one level, what has occurred in the exhibition space is something resembling a drive to access the work of the film apparatus itself in relation to modes of picturing. Having gained this access, the installation space then contributes to a remapping of the cultural space of the cinema, as well as the cultural space of

art. In this exchange between art and film, the seduction of the screen is displayed in all its fragmentation and dissolution at the nerve center of viewing positions, creating possibilities for exploring points of montage, narrative junctures, and the art of framing. Sometimes the discourses of art and film intertwine directly in the archive of film genealogy. This is the case for works such as Chris Marker's *Silent Movie* (1994–1995), an actual archival project. Marker remakes film history in a multiple-video installation that engages film's modernity, its urban physiognomy and motion.[20] A different example of exploring film history is offered in a specifically genealogical work by the Scottish artist Douglas Gordon, whose manipulation of cinematic material has included extending Alfred Hitchcock's *Psycho* (1960) into a *24 Hour Psycho* (1993) installation event.[21] His *Hysterical* (1995) is a video installation that rereads the familiar relationship between hysteria and representation. It projects footage from a silent film onto two screens, making two loops—one moving at normal speed, the other in slow motion—whose rhythms occasionally and casually meet up. The archival source, a filmed medical experiment, remains unnamed in the installation loop, but it is identifiable on the reel of film history as *La neuropatologia* (Neuropathology).[22] When the Italian doctor Camillo Negro filmed this with Roberto Omegna in 1908, he exhibited the supposed "female malady" as the theatrics of representation itself. When the film was first shown, a reviewer aptly remarked that "the white film screen was transformed into an anatomical table."[23] The comment points to the sort of genealogy Gordon exposes as, reworking the film in an art gallery, he exhibits the very representational grounds upon which the filmic bodyscape itself was built and mobilized.

Gordon's use of the loop exposes another aspect of cinema as well by engaging with its material history. Accentuating the "wheeling" motion that is the material base of filmic motion and the motor-force of its emotion, Gordon's loop reminds us that

1.3

Chris Marker, *Silent Movie*, 1994–
1995. Installation view. Courtesy of
the artist.

the wheel of memory constitutes the very materiality of film. As an intervention on the matter of real duration, it plays on cinema's "reel" time. This kind of motion is key to creating filmic emotion and to making a genealogic installation into an actual mnemonic project. In fact, Gordon's work shows that film is our collective memory not simply because of its subject matter but because of the form that re-presents it: a technique that goes far back in time and has its roots in the *ars memoriae.* Let us recall that the art of memory long relied on a wheeling motion. Back in the thirteenth century, Ramon Lull introduced movement into memory by experimenting with circular motion and creating an art of memory based on setting figures on revolving wheels.[24] The reeling motion of the wheel is therefore itself a mnemonic technique. The many contemporary art installations like Gordon's that play with loops represent a technological remaking of the mnemotechnical apparatus. In other words, by way of image technology, we are still playing with the moving images placed on revolving wheels by Lull, who, understanding the role of movement in memory, represented psychic motion. In fact, this type of circular mechanics, together with the automated motion that includes repetition, constitutes the essential "wheel" that drives our imaginative processes and forges representational history—a spinning continuum of subjectivity, mnemonics, and imagination that marked the prefilmic history of the mechanics of imaging implanted, eventually, in the movie house.

This type of wheel, inscribed on the cinematic reel, returns as a motif in contemporary art installations dealing with technology and psychic space. By way of Buddhist itineraries and prayer wheels, for example, it shapes the form of Bill Viola's *Slowly Turning Narrative* (1992), in which the landscape of a video self is meditatively observed in projection on a constantly moving wheel with repetitive sound. Motion, activated in the palimpsestic writing of emotions onto images, informs the subjective representational

histories that extend from the waxed mnemonic images of earlier centuries all the way to our digital screen and impresses itself into the transparent layers of Viola's *The Veiling* (1995).[25]

We are still coupling motion with emotion in filmic reels and in mnemotechnical art installations that rework the matter of cinematics. A most interesting expression of this cultural movement is found in the loops of Shirin Neshat, who uses this technique as part of an image-making process wholly grounded in cinema's history and language.[26] Her trilogy including *Turbulent* (1998), *Rapture* (1999), and *Fervor* (2000) deeply engages the specificity of film language and aspects of its history, including the particular cinematic rhythms characterizing Iranian film. Neshat's project is genealogical. Her black-and-white photography and use of discrete, staged scenes clearly resonate on the reel of early film history, while her use of the split screen reinvents for the gallery-goer a fundamental component of cinematic spectatorship. The split screen becomes the place in which the gaze takes place and the site in which it becomes gendered. As we watch, we become the link. It is we who join these two separate gendered worlds as we experience the attraction and longing occurring between the two. As we exchange gazes that could not otherwise be exchanged we also experience the very filmic work of suture. The erotics of desire are inscribed in the play of the split, in the space of an in-between. Despite the apparent disavowal of editing, Neshat's work is all about montage and its attractions. In the end, it comments on an important aspect of film language. It makes us aware of the fact that, in film, montage is located in the viewing process: that is, it is created in our own psychic space, in the imaginative process of spectatorship. Ultimately, in Neshat's loops and split screens, it is the loops of our imagination and the memory of film history that become embodied.

In many ways, cinema exists for today's artists outside of cinema as a historic space—that is, as a mnemonic history funda-

mentally linked to a technology. Walking in the gallery and the museum, we encounter fragments of this history. Filmic techniques are reimagined as if collected together and recollected on a screen that is now a wall. In the gallery or the museum, one has the recurring sense of taking a walk through—or even into—a film and of being asked to reexperience the movement of cinema in different ways as one refigures its cultural ground of "site-seeing."[27] Entering and exiting an installation increasingly recalls the process of inhabiting a movie house, where forms of emotional displacement, cultural habitation, and liminality are experienced. Given the history of the installations that gave rise to film, it is only appropriate that the cinema and the museum should renew their convergence in ways that foster greater hybridization. Let us remind ourselves of this history.

Film Genealogy and Museographic Space

Cinema emerged from an interactive geovisual culture. Indeed, tracing the relation of film to the history of exhibition tactics reveals how early museographic spectacles and practices of curiosity gave rise to the very architecture of interior design that became the cinema.[28] This composite museographic genealogy, characterized by diverse georhythms of site-seeing, comprised a prefilmic theatrics of image collection active in forms of spectacular array that enacted recollection. These spaces for viewing included cabinets of curiosities, wax museums, *tableaux vivants*, fluid and automated spectacular motions, cosmorama rooms, panoramic and dioramic stages, georamic exhibition, vitrine and window display, urban viewing boxes such as *mondo nuovo*, and view painting.

Film exhibition developed in and around these intimate sites of public viewing, within the history of a mobilized architectonics of scenic space in an aesthetics of fractured, sequential, and shifting views. Fragments were crystallized, serialized, and automated

in the cabinet of curiosities, the precursor of the museum; objects that were cultural souvenirs offered themselves to spectatorial musing; views developed as an art of viewing, becoming a gallery of *vedute*. This absorption in viewing space then became the "-oramic" architecture of the interior that represented a form of "installation" *avant la lettre*. Cinema descends from this travel of the room—a waxed, fluid geography of exhibition that came of age in the nineteenth century and molded the following one.

What turned into cinema was an imaginative trajectory requiring physical habitation and liminal traversal of the sites of display. The establishment of a public in this historical itinerary made art exhibition cross over into film exhibition. The age that saw the birth of the public was marked in the realm of art by the establishment of such institutions as the Paris Salon, where art was exhibited for public consumption.[29] Cinema, an intimate geography born with the emergence of such a public, is architecturally attached to this notion. The movie house signals the mobilization of public space with its architectonics of display and architectural promenade, experientially implanted in the binding of imaging to spectatorial life.

Site-Seeing: Filmic and Architectural Promenades

To further explain the journey of the imagination and the mnemonic traversal linking cinematic to museographic space, it is helpful to revisit "Montage and Architecture," an essay written by Sergei Eisenstein in the late 1930s.[30] Eisenstein envisioned a genealogic relation between the architectural ensemble and film, and he designed a moving spectator for both. His method for accomplishing this was to take the reader, quite literally, for a walk. Built as a path, his essay guides us on an imaginative tour:

> *The word* path *is not used by chance. Nowadays it is the imaginary path followed by the eye and the varying per-*

ceptions of an object that depend on how it appears to the eye. Nowadays it may also be the path followed by the mind across a multiplicity of phenomena, far apart in time and space, gathered in a certain sequence into a single meaningful concept; and these diverse impressions pass in front of an immobile spectator.

In the past, however, the opposite was the case: the spectator moved between [a series of] carefully disposed phenomena that he observed sequentially with his visual sense.[31]

The (im)mobile film spectator moves across an imaginary path, traversing multiple sites and times. Her fictional navigation connects distant moments and far-apart places. Film inherits the possibility of such a spectatorial voyage from architecture. As Eisenstein claimed further, in another reflection on visual space:

An architectural ensemble . . . is a montage from the point of view of a moving spectator. . . . Cinematographic montage is, too, a means to "link" in one point—the screen—various elements (fragments) of a phenomenon filmed in diverse dimensions, from diverse points of view and sides.[32]

The filmic path is the modern version of the architectural itinerary, with its own montage of cultural space. Film follows a historical course—that is, a museographic way to collect together various fragments of cultural phenomena from diverse geohistorical moments open for spectatorial recollection in space. In this sense, film descends not only historically but also formally from a specific architectural promenade: the geovisual exploration of the curiosity cabinet and the "-oramic" traversal of an architecture of

display. It also ventures to draw on the multiple viewpoints of the art of viewing and of the picturesque route, reinventing these practices in modern ways. The consumer of this architectural viewing space is the prototype of the film spectator.

The Architectural Paths of the Art of Memory

Eisenstein's imaginistic vision of the filmic-architectural promenade follows a mnemonic path. It bears the mark of the art of memory and, in particular, its way of linking collection and recollection in a spatial fashion. Let us recall that the art of memory was itself a matter of mapping space and was traditionally an architectural affair. In the first century A.D., more than a hundred years after Cicero's version, Quintilian formulated his architectural understanding of the way memory works, which became a cultural landmark.[33] To remember the different parts of a discourse, one would imagine a building and implant the discourse in site as well as in sequence: that is, one would walk around the building and populate each part of the space with an image. Then one would mentally retraverse the building, moving around and through the space, revisiting in turn all the rooms that had been decorated with imaging. Conceived in this way, memories are motion pictures. As Quintilian has it, memory stems from a narrative, mobile, architectural experience of site:

> Some place is chosen of the largest possible extent and characterized by the utmost variety, such as a spacious house divided into a number of rooms. Everything of note therein is carefully imprinted on the mind. . . . The first thought is placed, as it were, in the forecourt; the second, let us say, in the living-room; the remainder are placed in due order all round the impluvium, and entrusted not merely to bedrooms and parlours, but even to the care of statues and the like. This done, when the memory of the

facts requires to be revived, all these places are visited in turn. . . . What I have spoken of as being done in a house can equally well be done in connexion with public build-ings, a long journey, or going through a city or even with pictures. Or we may even imagine such places to our-selves. We require therefore places, real or imaginary, and images or simulacra which we must, of course, invent for ourselves. . . . As Cicero says, "we use places as wax."[34]

As Frances Yates demonstrates in her study of the subject, the art of memory is a form of inner writing.[35] Such a reading, in fact, can be extended all the way from Plato's "wax block" of memory to the wax slab of mnemonic traces, impressed on celluloid, in Freud's "Mystic Writing Pad."[36] In Cicero and in Quintilian, whose arts of memory are particularly relevant here, the type of inner writing that is inscribed in wax is architectural. *Places* are used as wax. They bear the layers of a writing that can be effaced and yet writ-ten over again, in a constant redrafting. Places are the site of a mnemonic palimpsest. With respect to this rendering of loca-tion, the architecture of memory reveals ties to the filmic experi-ence of place and to the imaginative itinerary set up in a museum. Before motion pictures spatialized and mobilized discourse—substituting for memory, in the end—the art of memory under-stood recollection spatially. It made room for image collection and, by means of an architectural promenade, enabled this pro-cess of image collection to generate recollection. In this way, memory interacts with the haptic experience of place; it is pre-cisely this experience of revisiting sites that the architectural journey of film sets in place and in motion. Places live in memory and revive in the moving image. It is perhaps because, as the filmmaker Raúl Ruiz puts it, "Cinema is a mechanical mirror that has a memory"; or, better yet, because it is in this mirror-screen that the architecture of memory lives.[37] Mechanically made in

the image of wax simulacra, the projected strip of celluloid is the modern wax tablet. Not only the form but the very space of this *écriture* is reinvented in film's own spatial writing, decor, and palimpsestic architectonics, as well as in the spectatorial promenade. The loci of the art of memory bear the peculiar wax texture of a filmic "set"—a site of constant redrawing, a place where many stories both take place and take the place of memory.

The architectural memory system, grafted onto the site of a house or a building or, indeed, redrawn in (motion) pictures, is also drafted in the form of a visit to a museum: all are sites of the production of mental imaging. The memory inscribed here is material and spatial and its imaginative visual process is an emotional affair providing access to knowledge. In fact, as Mary Carruthers shows in her study of mnemonics, "a memory-image . . . is 'affective' in nature—that is, it is sensorially derived and emotionally charged. . . . Recollection [is] a re-enactment of experience, which involves . . . imagination and emotion."[38] Physiological processes are involved in the emotions, for memory affects physical organs and engages our somatic being as it responds by way of movement and mental walks. The objects that are architectonically set in place and revisited in the architectural mnemonic include ideas and feelings, which are thus understood as fundaments of collective decor.

The art of memory that grew out of Quintilian's architectonics found a site of development in theater before implanting itself in the theatrics of museum display and in the movie theater. A theatrical version of this art was most prominently offered by Giulio Camillo (1480–1544), who devised his Memory Theater as a collection.[39] According to his theory, inner images, when collected together in meditation, could be expressed by certain corporeal signs and thus materialize and be made visible to beholders in a theater. As Erasmus put it, "it is because of this corporeal looking that he calls it a theatre."[40] It is also because of

this corporeal mnemonic looking that we may now call this archi-tectonics a movie theater—a house of haptic imaging. As an in-carnation of the Memory Theater, the movie theater, too, is an architecture of image collection for collective exploration. It is, in this sense, museographic.

The work of Giordano Bruno (1548–1600) plays an important role in connecting external space to interior geography, through which the art of memory evolved from mnemonic theater into museum exhibition and the movie theater.[41] His architectural memory system consists of a sequence of memory rooms in which images are placed according to a complex curatorial logic, based on everything from magical geometry to physiognomy to celestial mechanics. In designing a form of local memory, Bruno con-structed a type of mobile knowledge. In order to map a great num-ber of memory places, he envisioned a flow of movement between them, creating a composite geography. In Bruno's mobile archi-tectonics, one can travel through different worlds, assembling disparate places as if connecting the memory sites on a journey (as the filmic spectator or museum visitor does). His art of mem-ory turns the imagination into an alchemy of the inner senses and imparts associative power to images. As shadows of ideas, mem-ories, for Bruno, must be *affectively charged* in order to move us and pass through the doors of the memory archive.

Bruno's mobile architectonics thus results in the mapping of emotionally striking images that are able to "move" the affects as they chart the movement of the living world. The pictures of his memory systems look like maps: they dream up the art of mapping imaginary places that became image collecting and cinematic writing. In fact, as an "art of memory," film itself draws memory maps. In its memory theater, the spectator-passenger, sent on an architectural journey, endlessly retraces the itineraries of a geo-graphically localized discourse that sets memory in place and reads memories as places. As this architectural art of memory,

filmic site-seeing, like the museum's own version, embodies a particularly mobile art of mapping: an *emotional* mapping.

In the course of mapping this inner space that led to filmic and museographic recollection, the art and theater of memory interacted closely with actual theater design. It is well known, for example, that London's celebrated Globe Theatre is related to Robert Fludd's Memory Theater. And it was by way of a theatrical incarnation that the art of memory was revived in the movie theater: it was transformed, in architectural terms, in that mnemonic architectonics that became the mark of the movie palace. The atmosphere of the "atmospheric" movie theater created a sensory remake of mnemonic space. Here, one could walk, once again, in the imaginary garden of memory.

Moving through Inner Landscapes

The notion that memory and the imagination are linked to movement was advanced in yet more geographic ways during the eighteenth century, when motion became more clearly bound to emotion. Motion was craved as a form of stimulation, and sensations were at the basis of this geographical impulse to expand one's inner universe. Although garden theory was not the only site of this articulation, the garden was a privileged locus in this pursuit of emotive space. Diversely shaped by associative philosophies, eighteenth-century landscape design embodied the very idea that motion rules mental activity and generates a fancying. The images gathered by the senses were thought to produce "trains" of thought.[42] This philosophy of space embodied a form of fluid, emotive geography. Sensuously associative in connecting the local and topographic to the personal, it enhanced the passionate voyage of the imagination. Fancying—that is, the configuration of a series of relationships created on imaginative tracks—was the effect of a spectatorial movement that evolved further in cinema and the museum. It was the emergence of such

sensuous, serial imaging (an affective transport) that made it possible for the serial image in film and the sequencing of vitrines to come together in receptive motion, and for trains of ideas to inhabit the tracking shots of emotion pictures.

The legacy of the picturesque, in particular, was "to enable the imagination to form the habit of feeling through the eye."[43] Sensational movements through the space of the garden animated pictures, foregrounding the type of haptic sensing enacted by film's own animated emotion pictures. Not unlike cinematic space and the display of collections, picturesque space was furthermore an aesthetics of fragments and discontinuities. A mobilized montage of multiple, asymmetrical views emphasized the diversity and heterogeneity of this representational terrain. The obsession with irregularity led to roughness and disheveledness. Fragments turned into a passion for ruins and debris. Relics punctuated the picturesque map, preparing the ground for more modern experiences of recollection.

A memory theater of sensual pleasures, the garden was an exterior that put the spectator in touch with inner space. As one moved through the space of the garden, a constant double movement connected external to internal topographies. The garden was thus an outside turned into an inside, but it was also the projection of an inner world onto the outer geography. In a sensuous mobilization, the exterior of the landscape was transformed into an interior map—the landscape within us—as this inner map was itself culturally mobilized. In this "moving" way, we came to approach the kind of transport that drives the architectonics of film spectatorship and of museumgoing.

Architectural Journeys and the Gardens of Memory

As we consider the extension of the picturesque promenade into modern itineraries of re-collection, we can uncover another resonant aspect of the art of memory in Eisenstein's own imaginistic

theory. In fact, Eisenstein used the picturesque views of Auguste Choisy (the architectural historian interested in peripatetic vision) to illustrate his conception of a filmic-architectural promenade, following Le Corbusier's own appropriation of this vision.[44] Eisenstein and Le Corbusier admired each other's work and shared common ground in many ways, as the architect once acknowledged in an interview. Claiming that "architecture and film are the only two arts of our time," he went on to state that "in my own work I seem to think as Eisenstein does in his films."[45]

Indeed, their promenades follow the same mnemonic path, which engages the labor of imagination. Before the eyes of a mobile viewer, diverse asymmetrical vistas and "picturesque shots" are imaged.[46] As the architectural promenade unfolds a variety of viewpoints, it makes the visitor of the space quite literally into a consumer of views. From this moving perspective, one also performs an act of imaginative traversal. An architectural ensemble is read as it is traversed. This is also the case for the cinematic spectacle, for film—the screen of light—is read as it is traversed and is readable inasmuch as it is traversable. As we go through it, it goes through us and our own inner geography.

A filmic passenger is the subject of a practice also known to the museum visitor. At one level, this is a passage through light spaces. The passage through light spaces—revived today in contemporary art installation on the gallery wall—is the very spectacle of the cinematic screen and the architectural wall. As Le Corbusier put it, building his notion of the architectural promenade: "The architectural spectacle offers itself consecutively to view; you follow an itinerary and the views develop with great variety; you play with the flood of light."[47] Le Corbusier's views of a light space were, indeed, themselves cinematic.[48] Further developing the idea of the *promenade architecturale*, Le Corbusier stated that architecture "is appreciated *while on the move*, with one's feet . . . while walking, moving from one place to another. . . . A true

architectural promenade [offers] constantly changing views, unexpected, at times surprising."[49] Here, again, architecture joins film in a practice engaging psychic change in relation to movement. As site-seeing, the architectural promenade of the moving image is inscribed into and interacts with "streetwalking" and the museum's own narrative peripatetics. In this way, the route of a modern picturesque is constructed, and modern views of memory and imagination take shape on this path, in between the wall and the screen.

Light Space, from Cinema to Art Installation

Thinking of modern views like the ones Le Corbusier helped to shape in relation to promenades, one travels the contact zone between the architectural journey enacted in film and the one mapped out in the art gallery. With architectural sites that are scenically assembled and imaginatively mobilized, an inner site-seeing is atmospherically produced. Such geopsychic traveling is generated in museum walks as well as in film itineraries; both create space for viewing, perusing, and wandering about, and in such a way engage the architecture of memory. Acting like a visitor of a museum, the itinerant spectator of the filmic ensemble reads moving views as imaginative practices of imaging.

Thus generated out of modernity's itineraries, film movement genealogically includes in its cultural space the intimate trajectory of public exhibition. As we have seen, in many ways the exhibitionary itinerary became a filmic architectonics of traveling-dwelling. Now this zone in which the visual arts have interacted with (pre)cinema can be signaled as the very matter of cinematics that attracts art to the moving image in a contemporary hybrid exchange. Today, back in the museum and the gallery space, this moving topography once again can be physically and imaginatively traversed in more hybrid forms, where the genealogy of cinema is displayed on the walls to be walked through, grasped, and reworked.

She who wanders through an art installation acts precisely like a film spectator absorbing and connecting visual spaces. The installation makes manifest the imaginative paths comprising the language of filmic montage and the course of the spectatorial journey. If, in the movie theater, the filmic-architectural promenade is a kinesthetic process, in the art gallery one literally walks into the space of the art of memory and into its architecturally produced narrative. One's body traverses sites that are places of the imagination, collected as fragments of a light space and recollected by a spectatorial motion led by emotion. Ultimately then, the form of the art installation reproduces the haptic path that makes up the very museographic genealogy of cinema.

An editing splice and a loop thus connect the turn of the twentieth century to the dawn of the twenty-first. We can now fully understand why so many contemporary art installations directly engage the genealogy of film. In a historic loop, the moving geography that fabricates the cultural mapping of cinema comes to be exposed, analyzed, even remade—at crucial nerve points—on the field screen of the gallery. This artistic process demands a refiguring of the cinematic work of cultural imaging and of the space of image circulation as it forces art to reconfigure itself. Along the way, something important is set in motion: the installation space becomes a renewed theater of image (re)collection, which both takes the place of and interfaces with that performative space the movie theater has represented for the last century and continues to embody. An archive of moving images comes to be displaced in hybrid, residual interfacing.

Interfacade: Cinema and the Museum

The renewed convergence of moving images and the museum also engages the domain of design. This conflated geography informs the geography of intimate space itself, as well as its forms of liminal navigation. Thus the passage between interior and exte-

rior is not only enacted on the walls of the museum, and in curatorial practices that have absorbed a cinematic itinerary, but is staged, structurally, on the surface of the architectural premise itself. This is an age where new architecture is mobilized with, and as, museal exhibition, from Bilbao to Berlin, Los Angeles to Seattle, Santiago de Compostela to New York, Helsinki to Boston. At the level of a filmic interface, a challenge may then involve the task of refiguring spatial cinematics as geopsychic navigation on the screen of the architectural site itself.[50] With his Jewish Museum in Berlin, Daniel Libeskind achieves this by engaging with a lived map. Libeskind inscribes (inter)subjective cartography in his design by slashing windows into the building's surface that correspond to places on the map of what Walter Benjamin called "Lived Berlin."[51] In the architect's words, the building itself, an architectonics of lacunae, emerges out of "the openness of what remains of those glimpses across the terrain—glimpses, views and glances . . . belonging to a projection of addresses traversing the addressee."[52]

We appear to be moving toward a cinematic-museographic interfacade. In the Institut du Monde Arabe in Paris, Jean Nouvel challenged the permeability of the facade with windows that contract and expand with the mechanics of light-sensitive photographic shutters.[53] Frank Gehry's unrealized design for a new Guggenheim Museum in New York City, stretched out on the waterfront and floating with the city's harbor life, looked like a film strip unraveled in endless folds. This architecture of the fold recalls those folds of celluloid once deposited on an editing floor.[54] Gehry says he "dream[s] of brick melting into metal, a kind of alchemy . . . [that tries] to get more liquid, to put feeling, passion and emotion into . . . building through motion."[55] This alchemy, as we have claimed, is the very matter of celluloid imaging—that fluid place where motion becomes emotion. The motion picture, with its fabric and folds of moving images, circulates

an affective architexture: *emotion* comes into place in fluctuating cultural geography.

In the face of new image-network meltdowns, then, one might envisage further hybridized geographies, such as those found in the work of architect Hani Rashid. His studio project *220 Minute Museum* (1998) is a timed sequence of eleven virtual museums projected onto several movable fabric scrims suspended from pivots on and around the facade of the Storefront for Art and Architecture in New York.[56] Thinking of this pivoting movement as we watch the wheel of museographic debris potentially melting into cinema in the art gallery, we begin to confront an interfaced reconfiguration of the residual pieces of a nomadic visual archive.

*Cine*res and *Cine*mas

Another dimension of the collision of museographic architexture with filmic texture can be exposed by turning to the work of the visual artist Judith Barry, who explores inhabited, imaginary spaces in postperspectival ways, investing space with whirling history. Here, the museum, the cinema, and the department store share a common architectural form, insofar as all are showcases of cultural design.[57] In her installation *Dépense: A Museum of Irrevocable Loss* (1990), for example, set in an abandoned nineteenth-century marketplace in Glasgow, vitrines of the sort used in history museums become a screen on which to project early silent films of city life. In revisiting this interaction in contemporary installation, we return to an aspect of the genealogy mapped earlier in this essay, for these three exhibitionary sites were, historically, visited the same way: in fluid intersection, passing from space to space, in joined trends of public consumption.[58] Our interest in this relationship extends to the shape of the interior design itself of these spaces and to commonalities in lighting and spatial layout as well as spectatorial architectonics.

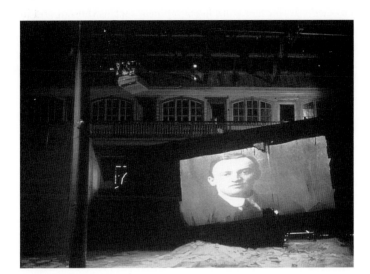

1.4

Judith Barry, *Dépense: A Museum of
Irrevocable Loss,* 1990. Installation
view, Glasgow. Courtesy of the artist.

Such convergences have not appealed to critics concerned with the demise of spectacle. Moreover, some have maintained that the museum is the cemetery of the artwork. By the same token, the cinema has been declared dead (or deadly) more than once. An appreciation of this design of visual space, however, need not become a celebration of the museum (as) store. We might alternatively think of the fashioning of cultural space as an actual matter of fashion—as haptic texture. The museum, the cinema, and the department store all represent textural places: fabrications of visual fabric, emoving archives of imaging. To reclaim the museum and the cinema from the land of the dead is to refashion them together in this archival interface, connecting their exhibition and spectatorship on the level of *habitus*. After all, habitus, as a mode of being, is rooted in *habitare*, dwelling. That is to say, we inhabit space tactilely by way of habit, and tangibly so. If habitus and habitation are haptically bound, *abito*, Italian for dress, is an element of their connection. It comes from the same Latin root. A haptic bond links sheltering to clothing the body. In fact, *abito* is both a dress and an address. In German, too, *Wand*, which connotes both wall and screen, is connected to *Gewand*, meaning garment or clothing.[59] In other words, to occupy a space is to wear it. A building, like a dress, is worn, and wears out. As we recognize this fashion of dwelling, we return to the "discarded garment"—that sartorial notion with which we began our musing on recollection.

Such a theoretical fabrication will also take into account the fact that a habitus, in the definition of Pierre Bourdieu, is not only a cultural design but cultural baggage.[60] This understanding of design does not reject the past but, indeed, enables us to conceive of it as a suitcase with which we may return to the cemetery—for it may contain something we need today or something we desire for the future. We might wish to concede to the cemetery a certain heterotopic liveliness insofar as it displays a conflated geography

and historicity. The city of the dead is not frozen in time. It does not simply hold or arrest but extends life, for it is a geography of accumulating duration offered to a public. This permeable site is capable of inhabiting multiple points in time and of collapsing multiple (body) spaces into a single place. This cumulative view of the cemetery may enable us to look differently at the conjoined histories of topoi like the cinema and the museum, which fashion, like the cemetery itself, a mnemonic archive of images. Moving in this way from *cine*res to *cine*mas, from the ashes of the necropolis to the residual cine city, something of this heterotopic force may be opened up to more hybrid forms of reinvention.

Traversing the interface of *cine*mas and *cine*res is an archaeological project—one that exposes the conflation of images in the present as a way of looking at their future. There might be in store for us an altogether new configuration of the architectonics of moving images that should proceed along with the funereal project, for both are woven into the fabric of the spectatorial habitus. After all, museographic sites are, as we have seen, consumer versions of the architectonics of memory theaters. In other words, as Benjamin put it, "memory is not an instrument for exploring the past but its theatre."[61] In such a way, museums, like memory theaters, have genealogically offered to cinema the heterotopic dimension of compressed, connected sites. A movie house provides a version of the spatial work of memory, requiring the labor of search and the accumulation of imaging; it furnishes a fictional itinerary traversing historical materialities and bridging the path from producer to consumer.

In some way, then, the cumulating fictions of the cinema and the architecture of film theaters have come to reinvent—however transformed in heterologies—some of the imaginative process that, in 1947, André Malraux called the *musée imaginaire:* a boundless notion of imaginative production that, in English translation, becomes "a museum without walls."[62] As art historian

Denis Hollier notes, Malraux's imaginary museum was itself "a museum conceived in terms of cinema."[63] This interaction has invested the architectural premise with an interface of passage. It is important to note that museum derives from muse: at the root of the museum is the activity of "musing." Not unlike fancying, this is a space of moving absorption. In the kind of musing that makes up the museum experience, to wonder is to wander. Historically, the museum has been experienced through this practice of perambulation in a trajectory that, in the age of modernism, is laid out as a spiral—most notably literalized, as Rosalind Krauss notes, in Frank Lloyd Wright's design for the Guggenheim Museum in New York City.[64] In the cinema, another product of modernity, the perambulating activity takes place as an imaginary process, also interfacing exterior and interior. One practice has not substituted for the other, although, at times, one has taken the other's place and in so doing changed the very nature of that place. The stories written on the mobilized figures of the transparent wall that is the screen, and on the space that surrounds it, are there to be retraversed by the film/museumgoer, for the fluid collection of imaging in both invites a shifting form of recollection. The interface between the exhibition wall and the film screen, as mapped here, is thus both reversible and reciprocal, even in the process of transhistorical imagination. A work of mutual historical "resonance," to use Stephen Greenblatt's notion, is set in motion as the cultural force of the interface.[65] Here, memory places are searched and inhabited throughout time in interconnected visual geographies, thus rendering, through cumulation and scanning, our fragile place in history. This architexture is an absorbing screen, breathing in the passage and the conflated layers of materially lived space in motion.

Ways of experiencing cinema also inform the imaginative space of the museum, inasmuch as both are public-private affairs that are constantly mutating. If, in evolving form, the museum

serves as "counter-hegemonic memory," in the apt words of Andreas Huyssen, such capacity for cumulation of temporality and reflection on subjectivity runs counter to mummification.[66] A transient memorial function can also shift and travel in other mediatic spaces. In fact, when our feelings about temporality and subjectivity change, they also change cultural locations. The notion that the movie theater has come to inhabit this shifting museal *architecture* is literally exhibited, for it even shapes the architectural appearance of the movie house. This affective change is played out on the very surface of the space. The architecture of the movie palace, with its recurrent memorial decor, temple motifs, and funerary design, and of the atmospheric theater, with its penchant for architectural mnemonics, suggests that cinema is the kind of museum that may even act as a secular place of mourning. In the range of its offerings, it houses a variety of liminal experiences, including an inner search that is publicly shared and exhibited. The museum, according to Carol Duncan, also publicly houses the performance of such private voyage, inscribed in the ritual history and dramas that constitute museographic spectatorship.[67] In the narrative habitation of the installation space, as in the liminal movie house, personal experiences and geopsychic transformations are transiently lived in the presence of a community of strangers.

Over time, the itinerary of public intimacy has built its own museographic architectures, changing and exchanging, renewing and reinventing the rhyme and rhythm of social mnemonics in an architextural trajectory that transforms *cine*res into *cine*-mas. If, as the French historian Pierre Nora puts it, there are now only *lieux de mémoire* which are "fundamentally remains," then "modern memory is, above all, archival."[68] But sites of memory are generated in the interplay of history. In this sense, cinema, as constructed here, is the unstable site that affirms a transmigrating documentation of memory against monumentalization: itself

a trace, it is an essential part of a museographic archive of *cine*res. The modern experience of memory is, quite simply, a moving representational archive. Such a museum of emotion pictures has been built along the retrospective route that has taken us to and from cabinets and *studioli*, museums and exhibition halls, houses and movie houses.

Our atlas of memory consists of this kind of textural exposure, which travels in different public rooms (of one's own) in reversible routes, in passage on a field screen that interfaces with cultural itineraries. After all, Mnemosyne—the mythological figure of memory who, according to legend, was the mother of knowledge—became an "atlas" in the hands of the art historian Aby Warburg, taking on the shape of an atlas-album at the very threshold of the cinematic age. As Warburg himself put it, the enduring "images of the Mnemosyne atlas are . . . the representation of life in motion."[69] Paying particular attention to "the engrams of affective experience" and "including the entire range of vital kinetic manifestations," Warburg pictured on panels "the dynamics of exchange of expressive values in relation to the techniques of their means of transport."[70] This included the design of a room, the physical movement of a person, and the flow of a dress. Concluding that "the figurative language of gestures . . . compels one to relive the experience of human emotion," he mapped "the movement of life" with his "pathos formulas" in atlas form.[71] Thus mapped in visual space, the Mnemosyne atlas did not simply take up a new place in this realm but became space itself: a multi-screened theater of (re)collection. A peculiar atlas. A movie theater. The perambulating affair, proper to museum-going and its architectures of transit, transferred in reciprocal ways to imaginative film spectatorship and, thus mobilized and interfaced, became the circulation of an album of views—the atlas that is our own museum.

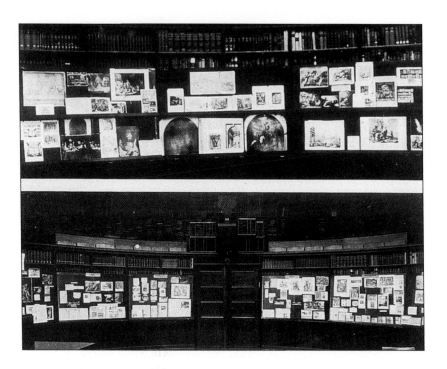

1.5

Memory mapped in atlas form in
Aby Warburg's *Mnemosyne Atlas*, 1929.

An Album of Views, an Archive of Imaging

Inscribed on transparent celluloid and scripted in its mechanical history, the cultural journey of images projected onto the white screen surface has become a museum of *emotion* pictures. But this museographic function of the moving image was acknowledged as a mnemonic affair from the time of precinema. Speaking of the daguerreotype and its future in 1838, a critic interestingly observed the relation of the photographic image to a potential atlas-album:

> *How satisfying the possession of this machine must be to a traveler, or to a lady who, wishing to make an album of the finest views that have ever struck her eyes, can compel Nature to reproduce them as perfectly as She herself has created them.*[72]

The imaginative passion—the drive to design an imagined geography, to circulate a *collection* of one's "views"—ventured forth into filmic traveling as film intersected with the movement of museographic culture in the act of documenting space, which issued from the desire to make a private album of moving views for public consumption.

In an archival way, the culture of travel, formed in relation to imaging, has engaged the moving image as a site of intimate exploration—a screen of personal and social, private and public narratives. This ultimate residual incarnation of modernity's trajectory created an imaginary mobilization of the traveling room. In such a way, cinema—a nomadic archive of images—became a map of intersubjective views. A haptic architexture. A topophilic affair. A place for the love of place. A site of close picturing for undistanced e*motion.* A museum of emotion pictures.

The Emotion of Topophilia: Voyages of the Room

A form of topophilia molds the museographic discourse that exposes the labor of intimate geography—a love of place that works together with the residual texture of *cineres*.[73] As we come to the close of our exploration of this mental geography, we might pause to consider that, as Simon Schama shows, any landscape is a work of the mind.[74] In this vein, a cultural landscape, broadly conceived, can be regarded in many ways as a trace of the memories, the attention, and the imagination of those inhabitant-passengers who have traversed it at different times. It is an intertextural terrain of passage carrying its own representation in the threads of its fabric, weaving it on intersecting screens. A palpable imprint is left in this moving landscape; in its folds, gaps, and layers, the geography of cinema and the museum holds remnants of what has been projected onto it at every *transito*, including the *emotion*s. Imaged in this way, such a landscape is an archaeology of the present.

From the art of memory to the emotional maps of film and museum viewing, we experience, on topophilic grounds, an architecture of inner voyage, a geography of intimate space. Filmic site-seeing is immersed in the geopsychic act of interfacing affect and place that has driven the architectonics of memory from Quintilian all the way to the art of Janet Cardiff, whose own "Walks" reinvent this mnemotechnics in a contemporary aesthetic practice.[75] Cinematically, the affect is rewritten on the cultural terrain as on a palimpsest, and the moving landscape returns a sign of affect. Residing in this way as an in-between, in a pause of movement, permanence turns into permeability as intimacy becomes publicly shared in the museum-movie house.

Space—including cinematic space—emoves because, charged with layers of topophilic *emotion*s, it is invested with the ability to nourish the self. This psychic process involves making claims and demands on the site. Cultures and individuals fixate on specific landscapes for different reasons and reactively pursue them. A

traveler seeking a particular landscape may go there, even filmi-
cally, to be replenished, restored, held, and fed.[76] In the hub of
traveling and dwelling, we are absorbed in the stream of *emotion*s
and experience an embracing affective transport. The museum—
itself a psychogeographic landscape—is likewise one of these
topophilic places that can hold us in its design and navigate our
story. In this "film" of cultural landscapes our own unconscious
comes to be housed.

People are drawn to places—museums included—for psychic
reasons, just as they may find themselves emotionally attracted to
a place of moving pictures. This includes revisiting affective sites
of trauma, as the wounded architectural work of the artist Doris
Salcedo reminds us.[77] Her passage into countermemorial is a
kind of mourning, a process that works by way of incorporation.
Such passage can make textural exposure something that binds.
We are held there, in the material site of loss, in the traces of
the fabric remnants constituting the "discarded garment" of rec-
ollection. But it is precisely this intimate holding in affective
vicinity, in the architexture of loss, that can become a form of sus-
tenance and a way of moving on with life. It is in this way that
*cine*res turn into *cine*ma.

As they are materially traversed in representation—in itiner-
aries of affective reality including museums and motion pic-
tures—places change shape. Sometimes a site speaks only of
passage and revisitation, for when we absorb places as they ab-
sorb what is laid out on them, an iterative mapping emerges. On
this terrain, cartography encounters psychoanalysis, for, as we
learned long ago from Gaston Bachelard, not only is "the uncon-
scious . . . housed" but, in the poetics of space, "a voyage unreels
a film of houses."[78] Now, having passed through the mnemotech-
nic architectonics of museographic culture, we can uncover the
(psycho)analytic residue. This itinerary excavates one's archae-
ology: the fragments and relics of one's *terrae incognitae*, some-

times traveled so much by way of habit and habitation that they have become unknown. Such is the ruined map re-collected in the cinema and the museum. Wandering in this imaginary atlas-album, the fabric of this fabrication—an architexture—shows.

In the course of the journey of film, we are held, as in the museum walk, in an intimate binding that can even transport us backward. This is the place of projections, where the voyage of the unconscious works itself into stories and dreams that end up populating the walls of the room. In this sense, the museum is a house of pictures, like film's own movie house. Evanescent and fugitive, emotion pictures fix themselves on the screen surface—the skin of film—reflective and translucent. Layered on the white texture of an erasable palimpsest, moving images can be the wallpaper of a room, the peeling layers of painted and inhabited stories, the fanciful decor of a *studiolo*, the traces of analytic debris. Housed in the public intimacy of spectatorship, such cinematics of *emotion*—the very *tactics* mobilized today in art installation—reinvents what Xavier de Maistre called a *Voyage around My Room*.[79] This intimate exploration of the room is held in the room of the camera obscura/lucida, revisited in the room of the installation, and attached to the room of one's own. In this residual sense, the architectural journey is indeed an emotional voyage. It is an actual matter of interior design. In filmic-museographic architecture, a wall that is a textured screen projects the inner film that is our own museum.

2 MODERNIST RUINS, FILMIC ARCHAEOLOGIES
JANE AND LOUISE WILSON'S *A FREE AND ANONYMOUS MONUMENT*

*Artist and architect speak the same language. . . . Urban
environment is an artificial landscape so the process of con-
structing it is not unlike making a pictorial composition
through which you move imaginatively; along the road,
down the path, through the trees, round the corner, over the
hill. . . . Space is a function of feeling.*
—Victor Pasmore

You walk into the space. An architectural remnant stands there. It
frames the space, both literally and metaphorically, giving it per-
spective. The mental geometry of the work is all there. All you
have to do is yield to it. And so you enter this large frame, sensing
a tectonic concrete surface. The frame soon presents itself as an
entranceway and becomes a liminal passageway. There is a long
suspended wall above your head that leads you inside a space. You
walk beneath this structure, allowing it to guide you, as if prepar-
ing you for a walk-through experience.

At your own pace you advance toward other kinds of architec-
tural remnants. The walls you now face are moving. In fact, they
are made of moving images. They are walls of light and screens of
motion. The thirteen separate, projecting planes, which create

two chambers of vision, are oriented in divergent directions. Disjoined, they come at you from different angles, are reflected on the floor, and even hover over you from above. On the sheer surfaces of the variously positioned screens you see a veritable pandemic of images. They are projected simultaneously, on all those screen-walls, from all the different angles of vision. Images shot in industrial and postindustrial sites are presented in looped sequences, and as you watch these light planes exploding with images, you are mesmerized. You walk, stand, stare, and walk again, and become totally immersed in this multifaceted visual geography. The space takes hold of you, viscerally, by the force of its audiovisual construction. Upon exiting, you encounter another suspended concrete structure that, itself functioning as a passageway, becomes a bookend for the installation.

At some level in its burgeoning complexity, beneath the pristine surface you sense a material weariness, the force of a languid vision. Ultimately, the place exudes a lingering sense of melancholia. This kaleidoscopic space seems haunted by a memory. It is as if the space itself were a recollection, speaking of some place you, too, knew intimately.

A Monumental "Set" of Images

Jane and Louise Wilson's multi-screen moving-image installation *A Free and Anonymous Monument* (2003) feels like an elaborate stage set. And as a set, it is a lived space, frequented by the stories that took place there over the course of time, and bears traces of those spatial narratives. The first set of these memories is inscribed on the surface of the walls, in the very architecture framing the space of the installation, providing both access and egress. The evocative concrete architectures we described standing at the entrance and exit are, in fact, stand-ins for a construction of the past. They are, indeed, remnants—vestiges of the Apollo Pavilion, built by the artist Victor Pasmore in Peterlee New

Town, near Newcastle upon Tyne, in 1958. The suspended walls are, literally, suspended memories.

As you access the two chambers between, created by the free-standing screens, they, too, feel suspended in space. Without a frame, they do not read as pictorial but rather as architectural space. Built in such an environmental way, these screens recall a suspended construction Pasmore himself made with Richard Hamilton for an exhibition of "Environmental Painting" at the Hatton Gallery in Newcastle in 1956. Appropriately called *An Exhibit*, this was an environmental painting through which the viewer, turned spectator, could walk.

Following the path set by Pasmore, Jane and Louise Wilson have designed their own environmental walk-through. Their architectural journey, a reconstructed memory of Pasmore's spatial vision, is an actual construction—a mnemonic fabrication haunting the space of *A Free and Anonymous Monument* throughout. But it is when you are immersed in the chambers of the installation, looking at the different kinds of walls—the surfaces that are screens—that you are literally inside the Pasmore memory space. Among other images, the screens project scenes of the Apollo Pavilion. This utopian bastion of urban renewal and regeneration, now neglected, is shown in its current use as a playground for local youngsters. Its ludic use takes us back to the idea of what a pavilion was in its original architectural function. In fact, several traces of memory are inscribed in the form of the pavilion, and it is up to us, the viewers, to unravel their story.

The Fabric of Memory: The Ghost of Victor Pasmore

If memory here is actually fabricated, it is also inhabited, and Pasmore is the primary dweller of this mnemonic architecture. He is the ghost of the place, for the pavilion is not merely the object of portrayal here but a formal element of the representation, the key to unlock its vision.

The recollection of Pasmore's visual planes haunts *A Free and Anonymous Monument* in several layers—or planes—of the past. On one level, it reflects how Pasmore himself bore a trace of the past in the way he shaped his own artistic vision. After moving away from an early interest in landscape painting toward abstract art and urban design, the artist himself looked backward to an earlier time. In constructing his view of postwar modernism, he turned back to the canons of prewar modernism in Europe, reviving and reinterpreting the rational visions, abstract forms, architectural promenades, and utopian dreams of this earlier era in an effort, as he put it, to establish "an alphabet of visual sensations in abstract form."[1]

In 1955, Pasmore was asked by the general manager of the Peterlee Development Corporation to collaborate with the architects in shaping the urban design of sections of this new town near Newcastle, then under construction. He was involved in this process for more than twenty years, until 1977. In Pasmore's hands, the abstract relief form that characterized his art at the time turned into the grid of an architecture. As he put it, he reached the point where he was "able to construct an abstract relief on the scale of a town. The relief becomes an architectural environment of great complexity which, like the interior of a building, is experienced internally; as such it takes on a subjective quality which is multi-dimensional in implication."[2]

Abstract texture and movement were joined in Pasmore's vision, for like a relief laid out environmentally, the layout of the sections of town was conceived in a dynamic fashion. The spatial conception present in Pasmore's art migrated easily into this urban planning, for both art and urban design were jointly thought of as practices of space. As such, they were both attuned to experiential modes of reception and careful to include in their very conception those who would make use of the space. In fact, to see Pasmore's artwork, the viewer needed to displace herself in order

to grasp the subtle shifts occurring in light and color on the projecting forms. One could even say that such a viewer, turned spectator, would *activate* the artwork. A maker of artworks that ask the viewer to move around in order to experience them would readily embrace town planning—which, too, is a matter of motion through space. Indeed, as Le Corbusier notably exemplified in his notion of an "architectural promenade," architecture "is appreciated *while on the move,* with one's feet . . . while walking, moving from one place to another. . . . A true architectural promenade [offers] constantly changing views, unexpected, at times surprising."[3]

Following the trajectory of modernist architecture, then, Pasmore reinvented architecture in postwar times as a practice that engages seeing peripatetically. And thus the spatial movement that had characterized his paintings and reliefs turned into urban motions. The design of a new town became the veritable extension of Pasmore's innovative, mobile artistic vision of space.

On and beyond Pasmore's Path

As a landscape painter one develops a sense of form and space as a mobile experience—an essential condition of urban design, and indeed of all architecture.
—Victor Pasmore

Victor Pasmore's itinerary has been influential. Through his art and design work as well as his extensive involvement in education, he carved out a path in British art that has been followed by many and is now repaved by Jane and Louise Wilson in *A Free and Anonymous Monument.*[4] Their monument to Pasmore is, indeed, faithful to the work it references: here, seeing *is* an activity; looking *is* walking. As spectators walk through the space of the installation and engage in its visual display, they activate the work.

Their presence and the physical articulation of their motion design the artistic space.

Walking around the Wilsons' installation, one hears subtle echoes of the mobile design Pasmore intended for his own "Exhibit." You can almost overhear him say: "I imagine that I am walking or driving on the roads drawn out on my cartoon. It's a kinetic process. As you walk there, turn here, through a little passage there, out into an open space here, meet a tall building there, a gable-end here, a group of houses there."[5]

In the Wilsons' installation, space is encountered precisely this way, for the very placement of the projecting screens is conceived kinetically. Here it is not just the images that move: the image of architecture does. The diverging directions of the screens speak of an artistic plan itself conceived in motion, and the installation's design offers more than paths to be followed: it creates a mobile architecture of vision. In such a moving way, Jane and Louise Wilson have not simply referenced Pasmore's artistic itinerary and design method; they have, in fact, reengineered it.

In this process of reengineering a mobile visual space, the Wilsons go further than Pasmore in establishing the mobility of the design process. This is especially the case in regard to the conception of the beholder of the artwork. If Pasmore's viewer, impelled to move, was made into a spectator, here the viewer is quite literally a spectator—a film spectator. The Wilsons' reengineered architectural promenade is not simply kinetic but truly cinematic. No static contemplation is possible in this installation since the viewer is engaged in a fully mobilized audiovisual design—a filmic-architectural mobile montage.

As the viewer of the installation moves through the space, the spectacle of the images is reflected in the shadow of their reception. Silhouettes of people walking and watching animate the space. And as the gallery-goer activates the work, a narrative develops cinematically, whose plot ensues from the very act of being

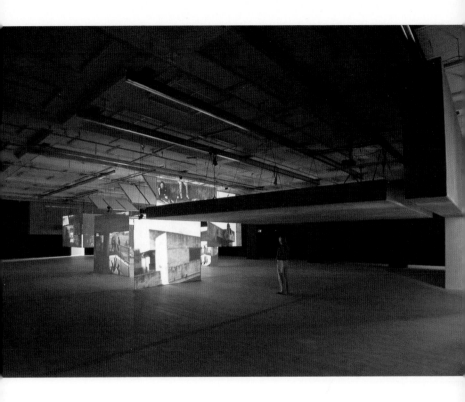

2.1

Jane and Louise Wilson, *A Free and Anonymous Monument,* 2003. View of the installation at the BALTIC Centre for Contemporary Art, 13 September–30 November 2003. Photo: Jerry Hardman Jones and Colin Davison. Courtesy of the artists and Lisson Gallery, London.

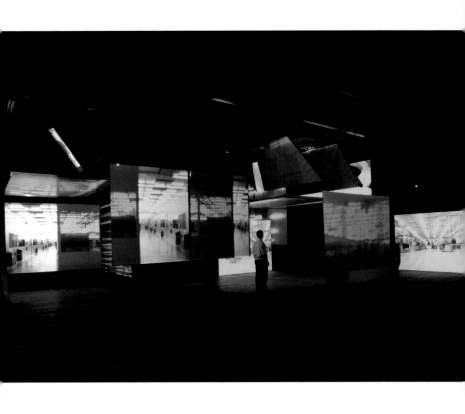

2.2

Jane and Louise Wilson, *A Free and Anonymous Monument,* 2003. View of the installation at the BALTIC Centre for Contemporary Art, 13 September–30 November 2003. Photo: Jerry Hardman Jones and Colin Davison. Courtesy of the artists and Lisson Gallery, London.

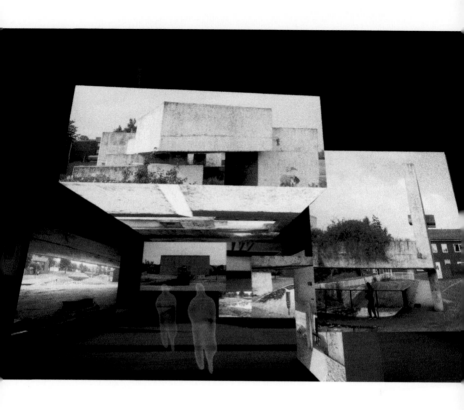

2.3

Jane and Louise Wilson, *A Free and
Anonymous Monument,* 2003.
Three-dimensional design for walk-
through of the installation, showing
Victor Pasmore's Apollo Pavilion, at
the BALTIC Centre for Contemporary
Art, 13 September–30 November
2003. Courtesy of the artists and
Lisson Gallery, London.

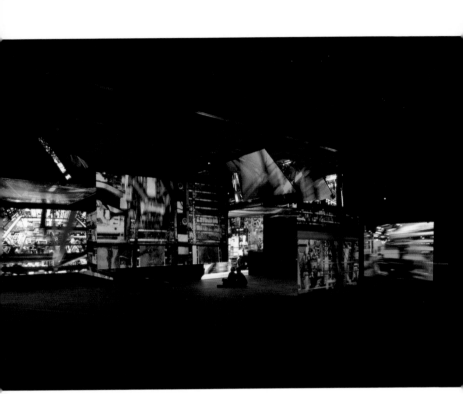

2.4

Jane and Louise Wilson, *A Free and
Anonymous Monument,* 2003.
View of the installation at the BALTIC
Centre for Contemporary Art, 13
September–30 November 2003.
Photo: Jerry Hardman Jones and
Colin Davison. Courtesy of the artists
and Lisson Gallery, London.

in the space. A story, that is, emerges out of the location itself, emanating from the surface of the place—from its skin. Configured as a moving construction and reflected in the form of the work's reception, the narrative is here a veritable architectural exploration. It takes its form—often a suspended shape—from the internal architecture of the spaces being examined, and as it develops the story is progressively molded, suiting itself to this internal architecture. It is, in other words, fully designed.

The Installation as Pavilion

As the space itself progressively tells its story in *A Free and Anonymous Monument*, a bridge is constructed. The trajectory of the installation bridges together, in form and content, the very structure of Pasmore's Apollo Pavilion, making it not just the major player in this architectural-spectatorial design but the actual matrix of the installation.

The driving force of the Wilsons' moving-image installation even takes the literal form of a bridge. In many ways, Pasmore's pavilion itself functioned in this capacity. It was conceived as a bridge over a stream and conceptualized as a moving platform from which one could view the surroundings and gather informally. The entry to the installation re-presents this idea of the passageway that opens itself to view. It even closely reconstructs the walkway of the pavilion, actually reproducing the promenade underneath the structure that one could take on the ground floor of the original.

Pasmore's pavilion was also erected as a bridge between different artistic configurations as it attempted a spatial synthesis of all the art forms. As an architecture, it was sculpturally shaped, painterly defined, and furthermore designed with a wink at the history of landscape design. The layout of *A Free and Anonymous Monument* takes after Pasmore's design since here, too, one

art form turns into another, creating a fluid relation between art and architecture.

The Apollo Pavilion was constructed of several layers of abstract forms and flat planes, which intersected to create a sculptural third dimension for the space. In *A Free and Anonymous Monument*, the thirteen two-dimensional screens are placed around the space at angles of vision that bespeak the same pavilion architecture. The screens, that is, are designed as if they were planes of vision and positioned in such a way as to enhance the intricate layers of visual intersection present in the pavilion. They create the kind of volumetric, plastic architecture of vision that Pasmore himself strove to achieve in his design. Furthermore, the three screens placed on the ground of the installation correspond exactly to the three planes that are the concrete supports of the real-life pavilion.

Pasmore's architecture conveyed the haptic quality of the relief, a form of art that, as art historian Alois Riegl (1858–1905) noted, is appreciated by way of touch—for touch alone can reveal its formal structure and nuances.[6] *A Free and Anonymous Monument* recalls this aspect of Pasmore's abstract relief in tangible ways. With every screen placed as if it were the plane of a relief, one senses the layers and the depth of the space. One is physically engaged in its plastic density and can experience it kinesthetically. The viewer is here led into the play of light and shadows characterizing the very architecture of the relief. Ultimately, then, the projecting planes of the Wilsons' installation can be said to project, phenomenologically, the architectural planes of the artist-designed building they reference.

The Pavilion, a Modern Architecture

Victor Pasmore's utopian construction was also a metaphorical bridge in the way it echoed past structures—the pavilion, a typical building of the early modern era—while projecting itself onto the

future. In creating a monument to Pasmore's own monumental pavilion—an act reflected in the installation's very title—the Wilson twins have produced a double monument, as "free and anonymous," to use the words Pasmore invoked for his own structure, as a pavilion itself. In order to appreciate the depth of architectural reference—a veritable theater of memory—built into this installation-pavilion, some consideration of the architectural history of the pavilion may prove helpful at this point.

The pavilion was an important element in the design of modernity, employed most significantly in world exhibitions and fairs.[7] A large, open construction conceived to display and to house activities and movement, it presented a public use of architecture. A parent of such nineteenth-century venues as arcades and department stores, which were often shaped in its form, the pavilion of exhibition halls was itself a place of public "passage" (the term for an arcade in French). A site of circulation made to display the goods produced by the industrial era, the pavilion of world expositions exemplified the very architecture of the modern era.

As an architecture, the pavilion bears another set of connotations relevant to an understanding of the Wilsons' appropriation of this form in their installation: the heritage of landscape design in the cultural design of the modern pavilion. The pavilion was an ornamental building common in parks and public gardens. Garden pavilions were grand, light, open, and semipermanent architectural structures expanding outward toward the landscape, providing temporary shelter while embracing the outdoors. Set in a landscape, they could be used as a place of rest or retreat but also of congregation. Pavilions would dot the design of a park, punctuating the path of gardens and the movement of people through the landscape. Pavilions were also conceived as pleasure houses, hosting such diverse social activity as spectacles, *fêtes*, and musical life. The name would also be given to any building

appropriated for the purpose of amusement; or to a place attached to leisure activities or sporting grounds, built for the convenience of spectators.

In the modern era, the pavilion bridged the gap between the city and the garden when it became an element of urban public gardens. In its double usage, the pavilion was then, fully, a place of modern spectacle. As both display for the commerce of world expositions and quintessential architecture of garden spectacle, the pavilion was architecture made theater. A site of public display, a place of circulation for people and goods, the pavilion was a spectacular architecture that embraced the very spectacle of modern life.

The pavilion, itself a site of exhibition, in turn exhibited the culture of modernity, for it represented the very architecture of perceptual change the era brought about. Displaying in its structure the modern vision, the pavilion was ultimately a machine to see, and to see differently. This light architecture was first an architecture of light. A trace of an outdoor space, the pavilion was open to sunlight and embodied lightness. It made for less tectonic and more agile form. As both an outdoor-indoors and an indoor open to the outdoors, such architecture broke the boundaries between exterior and interior and created a space in between. The openness of the pavilion further embodied a social inclusiveness that defied elitist, privatized spatial exclusion. Conceived as social space that was public, the pavilion reinforced the very sense of public and the kinetic sensation of space made for and used by a public.

The pavilion, in fact, would gather public activity of transit from different places and draw together goods themselves travelling from afar, not only to it but also through it. In its historical trajectory, it would be joined by bridges and moving walkways, railways and steamships, elevated skyscrapers and the mobility of the means of communication. The pavilion was the architec-

tural prototype of all those means of transport and leisure, which is to say of the machines of mobility, that characterized modernity and housed the many different motions of social transit. This kinetic exhibitionary place displayed the perceptual, cultural, and social transformation of space that occurred in the modern era.

Visions of Transit, Fractured Spaces

The architecture of the pavilion exemplified the fact that in the modern era space could no longer be conceived as static and continuous. As an outcome of modernity, space has been radically mobilized and new horizons of seeing have opened up. As space was dynamically traversed by new means of transportation and communication, different perspectives were revealed and new and multiple planes of vision emerged. The perceptual field became discontinuous, shattered, and fractured. As a result of this radical cultural mobilization, our visual terrain changed in ways that are still visible, becoming what it is for us today: disjointed, split, fragmented, multiplied, mobile, transient, and unstable.

The new visual landscape ensued also from the entrance of cinema into the picture. Born of modernity's mobile vision, motion pictures incarnated the very geography of modernity. Cinema displays disjointed space in motion. It introduces a language made entirely of cuts and movement, of multiple and fragmented planes of vision. Cinema is moreover a quintessential public space: an inclusive place of social gathering and public transit as well as a site of spectacle. Seen in this light, motion pictures thus join the pavilion as agents of the mobilization of visual space—that which created us as spectators and modern subjects.

A Pavilion of Architectural Imaging

Against this background, we can fully appreciate the function of *A Free and Anonymous Monument* as complex monument—an aggregate mnemonic structure—a construction made, in many ways,

of multiple levels and planes of recollection. Excavating the terrain of this monument one finds various strata of architectural memory, built around the idea of the pavilion, inscribed within the stunning visual composition of the installation. Ultimately the template of the work derives from the act of dissecting the visual architecture of the pavilion in its very history.

Pasmore's monumental revival was supposed to revitalize a postindustrial urban area, giving back to it the sense of public space. Jane and Louise Wilson's attraction in remaking a remnant of this form might be explained in part, then, by recalling this vital function of the pavilion, itself conceived as a public construction, as a grand public space. The work is presented as an architecture that is to be used publicly, and one that anyone can appropriate.

Reappropriation is the name of the game here. The memory of the pavilion's public use as the architecture of amusement and leisure is recalled as we are shown how the local youth have repossessed the dilapidated pavilion for their own use. Victor Pasmore's playful structure, itself a play on the old garden pavilion, is reactivated as young people come back there to make it a place of amusement. A free zone, a noninstitutionalized meeting point, the pavilion is, once again, the site of public diversion. This involves playing with the structure itself of the building, extracting from its architecture every possible opportunity for fun, making the pavilion into an urban form of rock-climbing. Poignantly, images in the installation show us how the new users have reconceived structural elements on the side of the building as climbing platforms. This space of recreation is thus fully "played out."

Jane and Louise Wilson continue to play with the structure of the pavilion as they recall its function as a resting point in a garden tour and a pivot of multiple moving perspectives. The setting of the installation is composed as if precisely drawn on this map of modern visuality. The visual matrix generated from the architecture of the pavilion is reinvented here, however, in moving images.

In transparent ways, the Wilsons' installation formally recasts the pavilion's itinerant status as passageway while visually constructing its function as viewing platform. The installation—a multiple space of image traversal—is a permeable viewing field of circulation. Because the screens have no frame and appear suspended in space, there is clear vision across the field. The texture of the screens reinforces this openness. Indeed, the double-sided screens have the same image resolution and provide equal clarity of vision from both sides. As a result, no matter where you stand in the installation, you can see clearly. Designed this way, this is a space of light. The luminous visual zone is even pictured as a light space and embodies a further lightness of being. Again because of the open framing and the screen texture, there is no sense of being either inside or outside the picture. As with the pavilion's agile garden architecture, here there is an interior-exterior visual play. It is in this sense that *A Free and Anonymous Monument* really mirrors the visual design of the pavilion—a light architecture of light.

A plane on which to walk, and walk through, the space of the installation redesigns the garden path in that it offers picturesque planes of vision. Looking at the multifaceted design of the installation, one is reminded of how one would see differently as one walked through a pavilion-dotted garden. The picture would change, seamlessly, as one progressed in the space, offering the spectator different views and panoramas. These were truly different perspectives. Here, the same effect is achieved as our motion in the multiform space recreates the multivalent perspectives of a complex visual landscape. As they are drawn on the map of the installation, intensely different visual planes are here literally pictured in motion.

A Free and Anonymous Monument also recalls the visual status of the pavilion as a folly. It is a monument to the visual playfulness of this viewing platform, set in a fluid landscape of vision. A place to

view out from, the pavilion is in turn projected outward from its own visual diversity. In the installation, as if to enhance the pavilion effect, this special effect is reproduced as moving images present themselves from different angles in composite visual planarity. The visual diversity issuing from the texture of the projecting planes is also a function of the form and the shape of the screens. Each screen has a specific proportion, and all of the screens are designed in different sizes. The resulting fragmented visual space feels explosive, and mirrors enhance the kaleidoscopic effect. Three angled mirrors, set above the installation, reflect and magnify the space. A true spectacle of images thus envelops the spectator in this hall of mirrors.

As *A Free and Anonymous Monument* dissects the pavilion's spectacular function as a mechanism for seeing, and seeing differently, it reminds us again how the pavilion represented not only the birth of modern spectacle but of the modern subject—what Charles Baudelaire poetically called the "passionate spectator . . . a kaleidoscope gifted with consciousness."[8]

In keeping with this design of modernity, the installation celebrates the multiple, fractured, disjointed, fluid, and unstable nature of modern space. The design of the screens and the imagery on their surfaces together form a veritable exhibition of urban culture and industrialization. As various sites of modernity are displayed (a factory, an oil rig), we are reminded of the pavilions of exhibition halls and international expositions, with their capacity to display—assemble—not only the products but the very essence of modern life.

The assemblage of the screens as shattered, moving, visual planes echoes the montage of sequences shown on their surfaces. In this respect, Jane and Louise Wilson play the role of women with a movie camera, whose kino-eye is especially tuned to the cinematic history of montage. These artists almost always shoot in film rather than video, preferring the articulation of film

2.5

Jane and Louise Wilson, *A Free and
Anonymous Monument,* 2003.
Axonometric drawing of the installation
at the BALTIC Centre for Contemporary
Art, 13 September–30 November
2003. Courtesy of the artists and
Lisson Gallery, London.

language and editing and the textured grain of the film image.[9] Their montage of the effects of industrialization is not only historical in nature but shot in the tradition of modernist cinema. Their cuts imaginatively take us from 1920s practices of montage to the bare-boned, relentless motion of structuralist cinema. Ultimately, as if recalling Sergei Eisenstein's own penchant for connecting "montage and architecture," *A Free and Anonymous Monument* revisits, on multiple screens, this modernist, rhythmic, architectural assemblage.[10]

An Industrial Archaeology

In the Wilsons' own "Metropolis," urban space is activated as industrial space is animated, all pulsing with the life of the machine. As if emerging out of the central pavilion—itself a *machine* of the visible—other spaces of modernity and industrialization arise into view. Creating an assemblage of industrial zones, the artists take us on a specific regional journey, exploring sites in the area of Newcastle upon Tyne. These other sites in the region of Pasmore's urban intervention issue from the visual range of the derelict pavilion, opening themselves up to observation from this moving viewing platform.

The Wilsons' urban archaeology owes a debt to Kuleshov's notion that montage enables a "creative geography." The sisters' inventive industrial topography is an assembled geographic history, a chronicle covering the whole spectrum of the industrial age, from mechanical reproduction to digital representation. In this installation, we travel from a vision of engine-making and the mechanics of oil drilling to digital engineering as we move from the Cummins engine works in Darlington to a high-tech lab, Atmel, in North Tyneside. We journey, that is, from the inner working of actual engines to a factory that designs modern-day engines: the computer microchips driving the machines of our technologically defined digital life.

2.6

Jane and Louise Wilson, *A Free and Anonymous Monument*, 2003. Image of Atmel from the installation at the BALTIC Centre for Contemporary Art, 13 September–30 November 2003. Courtesy of the artists and Lisson Gallery, London.

2.7

Jane and Louise Wilson, *Corridor, Safe Light,* 2003. C-type print on aluminum in Perspex, from *A Free and Anonymous Monument,* 2003. Courtesy of the artists and Lisson Gallery, London.

On the same creative regional map we find the abandoned Gateshead car park, a multi-story structure featured in this moving-image installation in reference to its use as a set in *Get Carter* (the 1971 film directed by Mike Hodges). Completing the postindustrial landscape, and after a return to the image of the Apollo Pavilion, we are shown an offshore oil rig, an iconic structure associated with the North Sea.

The sequence of the images on the loop (of memory) begins with shots of the empty Apollo Pavilion. As the space is animated by the young people energetically climbing its walls, the Wilsons' artwork is activated. Because of the placement and the scale of the screens, the youths appear, in a doubling effect, to be actually climbing up the evanescent screen-walls of which the installation is composed.

In the sequence showing the Apollo Pavilion, the images displayed on the thirteen screens are each unique. This plurality of viewpoints is enhanced by the asynchronicity of the editing, with its staccato tempo, as the cuts come at different times on the different screens. Materialized here is the very visual multiplicity and fragmentation that we have seen in the architecture of the pavilion, characteristic of the montage of modern spatio-visuality. Its vision is reflected in the multiform structure of the editing: a fractured composition with a disjointed pulse. As the images of the Apollo Pavilion unfold, the rhythm itself of the installation appears composite and unstable, with visuals dancing on screens at different beats.

The form of the representation changes in the other sequences, in which the spaces are less populated. Here the cuts happen simultaneously on all screens, creating less of a visual fragmentation and more of an expanded sense of landscape. An environmental rhythm pervades the space of the installation now, made continuous by the synchronous editing. As the images move and change rhythmically together, a mood develops. A history of

industrial landscape glides across the expanded screen space. Such history is, in many ways, a psychogeography.

The Psychology of Architecture

Town planning is a kinetic process of which the fulcrum point is interior. . . . Urban design . . . [engages] the whole gamut of the human psyche.
—Victor Pasmore

In *A Free and Anonymous Monument*, spaces are acted upon, cut by the kino-eye with the incisiveness that characterized the gesture of cutting into an abandoned, disused space enacted by Gordon Matta-Clark, but here reinvented cinematically.[11] Jane and Louise Wilson do not just glance at space; they delve into it, kinetically accessing its interior. In their work, the inner workings of architecture are exposed.

With the inscription of their *caméra-stylo*, these artists strive to create a particular design favored by Victor Pasmore: they aim to chart the psychic makeup of an architectural space. *A Free and Anonymous Monument* extends Pasmore's understanding of architecture as psychic space and shows that artists and architects do, indeed, speak the same language when they conceive of urban and artistic environments as places through which one moves not only physically but also imaginatively. In general, as one moves through space, a constant double movement connects interior and exterior topographies.[12] The exterior landscape is transformed into an interior map—the landscape within us—as, conversely, we project outward, onto the space we traverse, the motion of our own emotions. Space is, totally, a matter of feeling. It is a practice that engages psychic change in relation to movement.

Architectural design, then, engages mental design. In reconstructing this aspect of Pasmore's plan, Jane and Louise Wilson ac-

tivate the geopsychic design of architecture, following Pasmore's path closely and making use of his suggestion that urban design is a matter of interiors—a kinetic process corresponding to an internal movement. Indeed, this internal process extends to memory, and memories are themselves projected upon a space. They are traces inscribed in places. As *A Free and Anonymous Monument* attests, memories are "architected"—designed—in motion.

In this installation we actually see the work of memory. Traces of the industrialized world are here conceived as mnemonic dreams—mental architectures. The space of the installation is oneirically populated by machines. The ambiance is sparse but not pristine. Desuetude, obsolescence, and entropy emerge from this mental landscape. If architecture creates mood, so does the design of this installation. Although several states of mind come to the surface of the screen, the prevalent mood, shadowed by melancholia, is never nostalgia.

We do not sense a celebration of the machine. Nor do we experience abjection in this highly mechanized landscape. The Wilsons' installation rather exudes a dark sense of solemnity. The feeling seems appropriate to its monumental effort to record a history of regional industrialization and its demise. Here the magnitude, grace, and elegance of the industrial landscape strike us. As we walk through the installation, a grand sense of loneliness takes hold of us. The inner beauty of machines is revealed as the sole inhabitant of the space.

Sometimes, alien-looking mechanized arms and the mechanics of the robotic are displayed in clamorous montage. Then, almost suddenly, the mood changes. In a space of absence, it is people who become robots. We enter the world of the Atmel lab, our own contemporary digital world, and glimpse our future. Interestingly, while the noisy mechanism of making engines and drilling for oil is fully exposed to view, the images of Atmel exhibit the deceptive invisibility that distinguishes the design of our digital age.

A beautiful, bright space opens to view. This is a vast and rather barren architectural site that feels uncannily like an operating room. It is absolutely surgical. And no wonder this mood predominates here, for, as we discover, the dust-free and highly protected environment is what enables workers to "operate" on computer chips.

The light in the space is not only striking but makes room. It creates ambiance, atmosphere, and mood. We feel that we are inside the very space of light. And we can see even why: the physical process of etching on a wafer requires the use of a particular photographic type of illumination. The photo-litho process used for this digital engraving is, indeed, photogenic. This yellow-lit glaring space is pure, absolute lightness.

Such luminous atmosphere has suited Jane and Louise Wilson's sensibility, which has captured a photographic lightscape and reactivated it with moving images. The installation shows this light space as an energy field. Exposed here is an electric reservoir of energy: light as a force of life. The Atmel laboratory pulses with energy as the camera unveils the undercurrent of this architecture of light. As we travel through the installation we enter the lab's intestines. They are quite extensive, for four floors of Atmel are used exclusively to power the one floor of the operation. With such invisible mechanics built into its body, the building feels corporeal. This light space is an organism in its own right.

As we glide through the yellow-lit landscape, the sequence turns hypnotic. Space is suspended. But this suspense is not thrilling. We rather feel a humming tension: the suspended state of lingering, hovering inside our head. We are pending, waiting, floating in mental space. A mental architecture is indeed represented here: a pensive state of mind. This is a true, enlightened interior space.

In exposing this kind of inner working, the Wilsons show how completely they have appropriated Victor Pasmore's architectural

2.8

Jane and Louise Wilson, *Ballroom,
Safe Light,* 2003. C-type print on
aluminum in Perspex, from *A Free
and Anonymous Monument,* 2003.
Courtesy of the artists and Lisson
Gallery, London.

lesson. For as he put it, "urban space is interior like the interior of a house."[13] Urban landscape is, indeed, a work of the mind. It is a trace of the memories, the attention, the imagination, and the affects of those inhabitant-passengers who have traversed it at different times. And that includes us, spectators of a moving-image installation. Ultimately, Jane and Louise Wilson show that moving images are the projection of our inner workings—the architecture of our minds.

Soundscape

As the composite audiovisual architecture of *A Free and Anonymous Monument* activates the spectatorial imagination, its participatory structure supersedes the usual image of control and surveillance associated with the machine and digital age to engage the viewer's own anonymous freedom to roam inside the work. The visual geometry of the installation defies the model of the panopticon that, in some form, generated a portion of the previous artworks the Wilsons have made.[14] In exploding all structures of control, the installation also moves beyond the symmetry of the stereoscopic vision characteristic of their earlier work. The visual metaphor for the twins' double vision is here shuttered in favor of a layered, complex architectural montage that is not only visual but aural.

In fact, the psychic architecture exposed here is not entirely a visual matter. The psychology of architecture is also, even primarily, a function of sound, which is an internal structure in the articulation of mental space. Here it is engineered in the very mechanism of the installation. Each screen has a single speaker emitting its own sound, so you can move through the space of the installation following the sound cues. The sound guides you through the work, and it can direct you or misdirect you. It can make you take tours or detours. The sound ultimately locates you. And it locates the mood.

The aural environment of *A Free and Anonymous Monument* is articulated with care as a landscape of sounds is created. The installation is pervaded by specific sounds, each coming from a different location. Thus the spatial realism that arises in the installation issues not merely from the visual but from the aural structure of the work. Sound enables you not simply to locate a place but to feel the space. A variance in ambiance arises from this aural communication. We sense the different atmospheres, the various moods of a place, by the way they resound. We can actually *hear* the moods, and hear them change. Ultimately, it is sound that gives you a sense of place. Sound is the *genius loci*—the very spirit of place.

In *A Free and Anonymous Monument*, sound montage has its own spirit. Here you traverse the whole spectrum of industrial sonority: you hear the loud sounds of mechanization, experience the music of engineering and the quiet melody of automatism. You access the clamor and the clatter, the clang and the bang, the jangle and the rattle, the clash and the crush. Blaring, roaring, blasting noises resound tumultuously throughout the space. Then, there is a pause. You know you have reached a different zone. In contrast to the sounds of the Cummins engine works, in the Atmel lab there is an eerie stillness, a strange automatic tranquillity. You hear only zipping noises, which appear actually to flash through the quiet space. The silence is punctuated, with a cadence, by zips and beeps, by peeps and cheeps, by squeaks and clicks.

An aural choreography is set in motion in the Wilsons' installation as the sounds make a rhythm, a tempo: it rises, fades, and quiets down. This rhythmic choreography is most spectacularly conceived in the sequence of the oil rig. This is an actual symphony. All is silent for thirty seconds before the sound comes in and fades up. The loudness of the drilling noises is contrasted with the contemplative silence of a seascape. The lonely drilling platform appears to float on the surface of the water. At sunset, it simply

stands in this silenced landscape, looming over the horizon line. In the space of an aural edit, you have traveled from the energetic mechanics of Vertov to the sublimity of a Turner landscape.

In the installation, absences are sounds, too, that make rhythm. The pauses let us *listen* to the machines, not simply hear them. They are not just making noises but are animated by sound. Like humans, machines emanate internal sounds. Their noises have a distinctive character—a personality. It is as if these were thinking machines. Each tone gets us closer to their inner workings and to the way they activate a building. As we listen carefully, we can actually access not only the mind of the building but its soul.

At some level, exposed in this sound installation is a mental mechanics: the very noises in our brain. The Wilsons' symphony ranges in tone from the quietness of mind to the chatter clouding our heads. The mood of the installation is not just varied but modulated. You can feel energized or overwhelmed by the utter clamor of mechanical engines at work. You can lose yourself in the meditative, automatic serenity of Atmel's muffled sounds. Or you can fear the absence of aural turmoil. Ultimately, it may force you to enter the silence of your mind.

Lost Sites of Power

Jane and Louise Wilson's excavation into the psychology of architecture, deep into the way it sounds, reacquaints us with a particular use of archaeology. As an archaeology of the modern, *A Free and Anonymous Monument* represents the culmination of the artists' sound meditation on architectural ruins and technological obsolescence. It is a mature articulation of many of the themes that have emerged in the past work of the pair, and its suspended, mnemonic design reinforces the affinity for mental architectures present in their earlier work.

Take *Stasi City* (1997) and *Gamma* (1999), for example, each of which consists of two pairs of screen projections on walls meeting

at two 90-degree angles, diagonally opposite from each other. The architectural layout of these installations—two points of view shown simultaneously and bound together—mirrors a psychic architecture. This architecture of vision reveals the kind of double vision characteristic of the bond connecting these artists, who are identical twin sisters. Conceived in a double frame, a Wilson installation is almost never a single work but most often paired up, as happens with both *Gamma* and *Stasi City*, linked double works.

Gamma was shot in the former U.S. Air Force base at Greenham Common, a Cold War operation that housed nuclear weapons and which is now a decommissioned site. The installation inspects spaces of inspection and surveils control rooms and security zones, taking us off-limits into untouchable spaces of power. Exhibiting the same vision, *Stasi City* was also shot in abandoned buildings. Since these buildings are the former East German secret police headquarters in Berlin and a former Stasi prison, one might describe the work itself as interrogating places of interrogation.

In powerful and subtle ways *Stasi City* feels, as do others of the twins' works, like a set. The installation in fact restages situations that were themselves staged in order to instill anxiety or fright. Figures hang in the space, evoking perhaps a deadly fear of death by hanging. Or maybe they are just suspended, pending judgment—suspended, that is, in that zero gravity of lengthy bureaucratic time. The space is carefully choreographed. Devoid of human presence, with the closed doors that once imprisoned the investigated subject now pushed wide open, the construction of the very space of fear is revealed. We can now see the cheapness, even the fakeness, of the psychic mechanism staged here—the mechanism that runs a theater of terror.

The technique of revealing the internal mechanism of a disused architecture recurs in the work of the Wilson twins. For

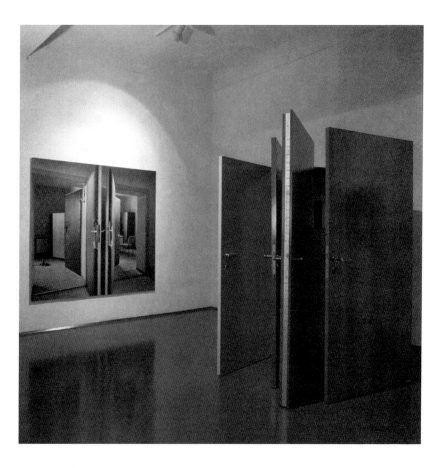

2.9

Jane and Louise Wilson, *Reconstruction
of Doors, Erich Mielke's Office, Former
Stasi Headquarters,* 1997. View of
installation of *Stasi City,* 1997, at
Grazer Kunstverein, Hannover, 1998.
Photo: Steirischer Herbst. Courtesy of
the artists and Lisson Gallery, London.

example, in different yet related ways, the open doors of the British House of Parliament in *Parliament* (1999) also question power this way, enabling us to get a glance at the mechanism regulating social domination as we peer into the system of authority and legality. However, we can only be there when the place is not active, precisely because it is not functioning. Jane and Louise Wilson are endlessly attracted to places of power and control, but only when those in command have left the site. They are interested in accessing emptied, evacuated places to explore what is no longer in control there. They fancy a place out of control. Or, rather, they are interested in what happens when a place has lost control, or else when a place is simply lost.

In this respect, the work of the Wilsons recalls that of another talented architectural artist, Robert Polidori. In his photographic portraits, especially in his vision of Chernobyl and Pripyat, Polidori puts himself in the same position.[15] He, too, investigates the leftovers, picturing the ruins of power and the effects of industrialization, and does so also with an explorative architectural eye. His camera also travels through spaces bearing traces of destruction. Redolent with the patina of time, abandoned places are shown, or rather laid bare, in Polidori's photographs—their intestines wide open to view. In many ways, his renderings of Chernobyl and Pripyat parallel the Wilsons' *Home/Office* (1998), an installation that re-presents rescued footage from London's fire brigade. Their memory loops let us into the ravages of destruction, enabling us to inhabit what are now uninhabitable spaces.

Archaeological Journeys

A Free and Anonymous Monument shares with many other works the pair has made the form of a meditation on matters of desuetude, postindustrial ruination, and technological waste. In fact, these artists have long shown a predilection for visionary, machinic installations—mental architectures that are barren landscapes

and deserts of the mind. Take, for example, the desolate spatial layout of *Proton, Unity, Energy, Blizzard* (2000). Four screens simultaneously track the space of a Russian cosmodrome, introducing us to the engineering mechanism of a proton rocket factory. We hang in a barren hangar, visit empty offices and medical facilities. We follow a narrative sequence of telephones that no longer ring. We try to decipher signatures—traces of life—left on doors, now left hanging, doors no longer opening or closing for anyone. Camels inhabit the literally deserted space. As they walk away from what were launch site towers, they lead us out of this human desert.

In a similar vein, *Dreamtime* (2001) examines the rituals of rocket launching and space travel with monumental military solemnity. It parallels *Star City* (2000), also devoted to the once futuristic, now bygone, art of travel out-of-space. In this lost city, we architecturally explore the kinetic form of rockets and spaceships as the artists let us travel inside and out of off-limits space. Here, again, we are impressed by the presence of absence. Empty astronaut suits, empty dressing rooms, empty capsules and offices. Suits and rooms both voided of presence. In this way, the Wilsons' acute, observant camera connects architecture to clothing, equating them as spaces of the body, both inhabited by flesh. It shows what happens when bodies leave and places are evacuated of life. With the inhabitants that suited these spaces now departed, only empty shells are left, melancholically drifting lifeless on screen.

Gardens of the Postindustrial Era

Jane and Louise Wilson constantly return to what is left of a place—left out or even left over—and this return extends to the industrial landscape that makes up *A Free and Anonymous Monument.* Turning to a regional geography marked by the problems of postindustrialization, the installation looks at a place in ruin.

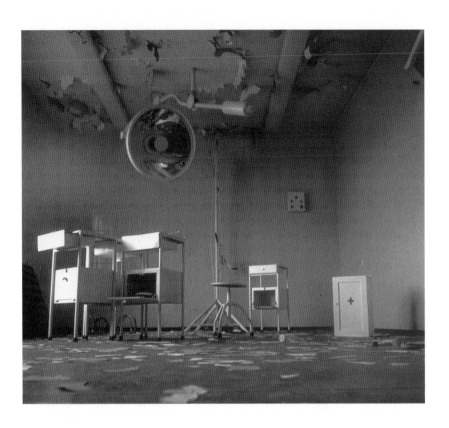

2.10

Jane and Louise Wilson, *Hospital Room,
Hohenschönhausen Prison*, 1997.
C-type print mounted on aluminum,
from *Stasi City*, 1997. Courtesy of the
artists and Lisson Gallery, London.

Ruinous is, indeed, the state of Victor Pasmore's pavilion. Once a pristine structure, a utopian monument to the idea of enacting social transformation by way of urban design, the Apollo Pavilion is now a shadow of its former self. What we see over and over again in the installation is a building that is badly maintained, dilapidated, partly dismantled, and even locked up.

In July 2000, the *Sunday Telegraph* happily announced the potential success of a campaign to demolish the Apollo Pavilion, despite its status within English heritage as "an internationally important masterpiece." The *Telegraph* labeled the Apollo Pavilion a "concrete bungle." Less than charmed by its modernist material, the paper reported that "people around here think of it as just a heap of dirty, slimy concrete which youths climb up to have sex and urinate on passers-by."[16] Indeed, the space has been consummated by the younger population's way of using the lonely concrete structure.

This never seemed to bother Victor Pasmore, who died in 1998. When the artist returned to the Newcastle region to visit Peterlee, he witnessed the defacement of the murals with which he had decorated the pavilion. Graffiti covered the crumbling facade of his concrete building. He was not disturbed by what others saw as a state of desolation. On the contrary, he found the graffiti to be an improvement. He mentioned that this intervention ameliorated the architecture of his building more than he himself could have done and believed this act of appropriation to have humanized the building.

A cinematic inscription of pavilion architecture, Jane and Louise Wilson's *A Free and Anonymous Monument* is a metaphoric graffito. It is itself an act of appropriation, not only of the Apollo Pavilion as an artistic matrix but of the entirety of its postindustrial region. It is furthermore an intimate appropriation, since it is an act of love for the place of the artists' youth. It is not irrelevant that Jane and Louise Wilson were born in Newcastle, in

this nineteenth-century center for coal export, shipbuilding, and heavy engineering, and that Jane studied at Newcastle Polytechnic. In some way, the mnemonic structure of their monument is a moving monument to their own past and to the crumbling nature of the region's postindustrial landscape.

Victor Pasmore's postindustrial pavilion made an artificial garden out of the urban industrial zone in the northeast of England where Jane and Louise Wilson grew up. Its modernist design was a utopic attempt to create recreation where there was industrialization. His restorative gesture addressed what continues to be a problem today. Urban regeneration is now a social and political issue at a global level. As artists brought up in a place that faced this issue early, the Wilson sisters are particularly sensitive to this landscape.

In their art, Jane and Louise Wilson make continual attempts to investigate, and intervene in, sites that bear the texture of their region and of Pasmore's own site of urban intervention. Completing the collection of their previous projects of recollected landscapes, their latest venture is a work shot on location in New York, on Governors Island.[17] An island off the shore of Manhattan, this was home not only to the governor but also to marine, penitential, and military structures. A place of residence for nearly 5,000 people who worked in those infrastructures, it is now totally evacuated of life. It is no wonder that this—the largest and most attractive site of potential urban regeneration in the New York region—has attracted the Wilsons for another filmic intervention. It is sited precisely along their path of creative lost urban geography.

Our Modernist Ruins

The installation of *A Free and Anonymous Monument* ultimately places on exhibit Jane and Louise Wilson's relentless, recurring fascination with the ruins of modernity. Although their approach

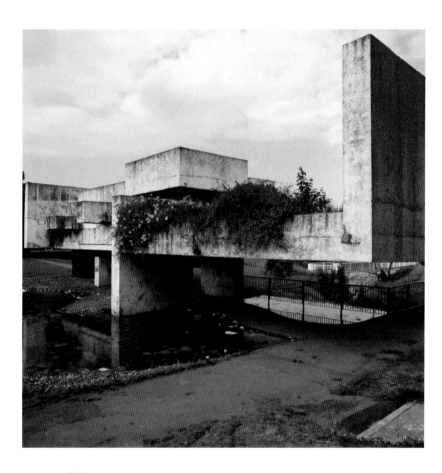

2.11

Jane and Louise Wilson, *A Free and Anonymous Monument,* 2003. Production still for the installation at the BALTIC Centre for Contemporary Art, 13 September–30 November 2003, of Victor Pasmore's Apollo Pavilion, Peterlee, 1958. Courtesy of the artists and Lisson Gallery, London.

to this mental architecture is so personal and intimate here that it exudes traces of a psychogeographic return, one can see throughout their work a personal interest in the environmental history of the aftermath of industrialization and the Cold War, which formed them as modern artistic subjects.

With respect to a specific engagement with the vicissitudes of modern architecture, their act of reengineering Victor Pasmore's design tackles a particular issue in the demise of modernity— the ruins of modernism. In this regard, their intervention joins that of other contemporary artists for whom the legacy of modernism is a present history to contend with. In a similar way, for example, Gabriel Orozco has taken it upon himself to reconstruct Carlo Scarpa's once pristine and now crumbling 1952 modernist architecture, in a work presented at the 2003 Venice Biennale.

But what do we mean by intimately revisiting this legacy? Can we really speak of a modernist ruin? Unlike the porous, permeable stone of ancient building, the material of modernism does not "ruin." Concrete does not decay. It does not slowly erode and corrode, fade out or fade away. It cannot monumentally disintegrate. In some way, modernist architecture does not absorb the passing of time. Adverse to deterioration, it does not age easily, gracefully, or elegantly.

Modernism, after all, had an issue with history. It was an art of the present. Modern architecture looks good in its own present. It wears itself in the now, and does not wear out. It shines when recently constructed or freshly painted. It looks at its best dressed in white. It wears only pure coats of paint and pristine fashions. It looks outstanding when freshly made up. Its facade is a face that cannot bear age marks, does not like to "wear" them. With concrete, there no longer can be lines emerging gently on the face of a building, line drawings on the map of time past. With concrete comes only cracks, the breaking up of the facade.

If the facade is a face, then the problem of modernism is skin. Modernist architecture was, after all, an architecture of the surface. This modern epidermics has the same issue with time that we do. We modern subjects, too, have an increasing issue with the deterioration of our skin. Refusing to age gracefully, we seek the radical fix. Plastic surgery is perhaps itself a measure, if not quite an invention, of modernist time and its passing. It is the sign of our times.

As we live in an age in so many ways repelled by ruination, what kind of archaeology can we now create? In answering this question, we can take one last look at Jane and Louise Wilson's archaeology, and ponder in yet one more way their fascination with postindustrial ruins. We should recognize that our history is made up of different ruins. In modern times, different architectures bear the mark of time. Time passing is not simply etched on the surface of stone, but is marked on the skin of celluloid. It is impressed on other kinds of architecture—the translucent screens of moving-image installations. Pictures in motion write our modern history. They can be the living, moving testimony of the effects of duration. Moving images *are* modernity's ruins. They are our kinds of monuments. A Free and Anonymous Monument.

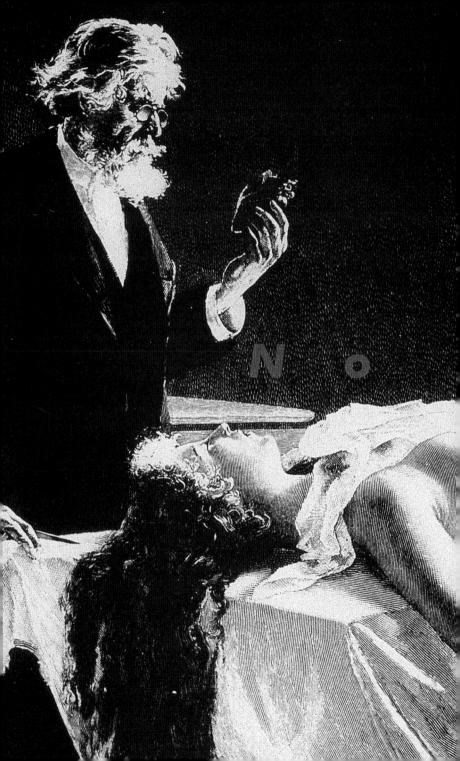

SCIENTIFIC SCENOGRAPHIES

a d i o

3 THE ARCHITECTURE OF SCIENCE IN ART
AN ANATOMY LESSON

The world panorama . . . towers in the arcade like the anatomy.
—Siegfried Kracauer

In a passage on Berlin's Linden Arcade, Siegfried Kracauer—a theorist sensitive to spectatorial architectures and interested in the space of cinema[1]—articulated a relation between *transito*[2] and the "anatomy lesson":

> *Transient objects attain in the arcades a sort of resident status. . . . They satisfy physical needs, the desire for images, just as they appear in one's daydreams . . . ; body and image become united. The Anatomical Museum occupies the place of honor in the Linden Arcade, with its exhibitions dedicated to corporeality, to the body itself. It is the queen of the arcade. . . . A picture in the display window betrays the kind of revelation the visitor will experience inside; a frock-coated doctor presides over an operation on the stomach of a naked female. . . . The body's internal growth and monstrosities are shown in painful detail. . . . Even the street shops . . . have moved into the arcades to pay homage to the Anatomical Museum. . . .*

TABULÆ
ANATOMICÆ,
IO.AD.KUL MI, Med.Doct.
et P.P.O.atq.A.N.C.S.

3.1

Title page by Jan Caspar Philips of
Johann Adam Kulmus's *Tabulae
anatomicae* (Amsterdam, 1732).

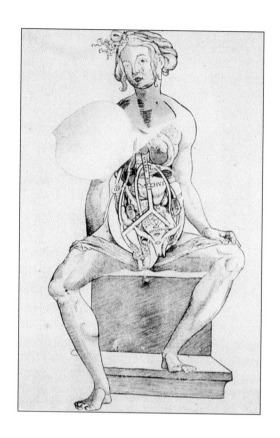

3.2

Table from a work by Jacob Frölich
(Strassburg, 1544).

> It was a clever coincidence that the entrance to the
> Linden Arcade was flanked by two travel offices. . . . Pic-
> tures invoke a return to the foreign lands once seen; the
> world panorama . . . towers in the arcade like the
> anatomy. . . . Behind the peepholes, which are as close as
> one's own window frames, cities and mountains glide by.
> They look more like faces than travel highlights.[3]

In Naples, cinema was implanted on the very threshold of the
panoramic and the anatomical, as mapped by Kracauer. The fol-
lowing microhistorical case, pertaining to the city's first movie
theater located in the area of the railway station, suggests that the
genesis of film reception is inscribed in a visual curiosity about
the body's landscape. In a proleptic movement of spectacles, the
female body is revealed as the fantasmatic site of cinema.

Film pleasure, as it derives from the motion of *curiositas*—the
desire to explore mapped on "the lust of the eyes"[4]—is embedded
in spectacle. The lust to find out leads to a fascination with seeing,
a perceptual attraction for sites, and consequently the formation
of spectacle. This type of lust may lead the traveler-spectator
astray, for, as Tom Gunning shows, an aesthetic of attraction, with
its perceptual shocks, implies distraction.[5] And this very *curiosi-
tas* may also draw the viewer toward unbeautiful sights, for this
noncontemplative mode entails an attraction for the dark sides
of the visible. The lust of the eyes may turn into a panoramic-
anatomic lust, leading our traveler-spectator into a curiosity for
such things as mangled corpses.

The Anatomy Lesson

The first Neapolitan movie theater was opened by Menotti Catta-
neo. He began screening films in 1899 in a wood shack, which was
soon rebuilt as a concrete structure. The Sala Iride was the first
permanent Italian movie house, constructed of cement, which was

specifically built for showing films. Inaugurated on September 25, 1901, it was still reported to be the only one of its kind in the city in 1906.[6] Like Mario Recanati, who had opened the first movie theater in the arcade, Cattaneo was a nomadic social type, a man who had wandered all over Italy and several other European countries. Once settled in Naples, he began to present a show wherein, for a few pennies, neighborhood *flâneurs* could watch him take apart and reconstruct a wax model of a human body, including its internal organs. It was not long before he decided that this kind of performance—the exhibition of a *corps morcélé*—would be well complemented by film screenings. In Naples the spectacle of the anatomy lesson is, in fact, the predecessor of cinema:

> *Menotti Cattaneo was simply the proprietor of a wood shack in the Foria neighborhood, where idlers, spending a few pennies, could be struck with wonder and horror in front of pieces of a human body anatomically reconstructed in wax. In fact, Menotti Cattaneo had made out of wax a heart, a pair of lungs, a spleen, a stomach, a gullet, etc., and the spectacle was conceived thus: dressed as a surgeon, with his white overall and plastic gloves, Menotti Cattaneo, a knife in his hands as surgical instrument, would dissect a wax human model and extract from its interior various organs, which he would then exhibit to the public. This spectacle was called the "anatomy lesson."*[7]

From the exhibition of the anatomy lesson, Cattaneo could smoothly shift to film exhibition, as both forms of popular spectacle shared a fantasmatic ground. Their common terrain is a discourse of investigation and the fragmentation of the body. The spectacle of the anatomy lesson exhibits an analytic drive, an obsession with the body, upon which acts of dismemberment are

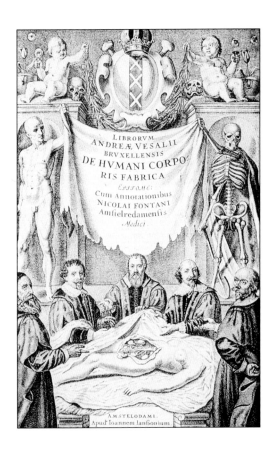

3.3

Title page of Andreas Vesalius, *De humani corporis fabrica. Epitome* (Amsterdam, 1642).

performed. Such analytic desire is present in the very language of film. It is inscribed in the semiotic construction of film, its *découpage* (as the very word connotes, a "dissection" of narration in shots and sequences), its techniques of framing, and its process of editing, literally called "cutting," a process of (de)construction of bodies in space.

Just like the anatomical gaze, the cinematic gaze dissects by moving across and in depth, plunging into space and traversing it. This corporeal form of visuality shapes the effects of pleasure supplied by the cinematic apparatus. The epistemology of visible invisibility epitomized by the anatomy lesson[8] lies at the very basis of the filmic *dispositif*. Both the space of reception—that is, the architecture of obscurity that enables filmic visibility—and the (in)visibility of spectatorial dynamics inscribed textually as a point of address indicate that the cinematic apparatus is built upon the geography of the visible invisible. Constructing spaces of light and shadow, obscurity and visibility, the filmic text transforms the human body and the body of things into a geometry of shapes, surfaces, volumes, and lines. Changing the relation to perception, cinema has changed the relation to the body—it has both embodied and disembodied the gaze. Film is another form of vision that affects the mapping of the body and its appearances.

On the basis of anatomy and its perceptual model of the body, we may establish an epistemological relation between the cinematic eye and the anatomist's eye. The anatomical-analytical gaze provides a model of perception, proleptically pointing toward film's visuality. Film articulates anatomies of the visible. The writings of Walter Benjamin enlighten this link when they refer to the anatomy lesson in a discussion of the masses' desire to bring things closer spatially.[9] "The Act of Seeing with One's Own Eyes"—as Benjamin, and also Brakhage's film, suggest—is grafted on the body, for such an act is in itself a mapping of bodyscape: in the chart of linked fragments, close-ups adjoin

cut-ups. A comparison of anatomy and the language of film exposes the camera's dissecting quality:

> How does the cameraman compare with the painter? To answer this we take recourse to an analogy with a surgical operation. The surgeon represents the polar opposite of the magician. The magician heals a sick person by the laying on of the hands; the surgeon cuts into the patient's body. The magician maintains the natural distance between the patient and himself; though he reduces it very slightly by the laying on of the hands, he greatly increases it by virtue of his authority. The surgeon does exactly the reverse; he greatly diminishes the distance between himself and the patient by penetrating into the patient's body, and increases it but little by the caution with which his hand moves among the organs. . . .
>
> Magician and surgeon compare to painter and cameraman. The painter maintains in his work a natural distance from reality, the cameraman penetrates deeply into its web. There is a tremendous difference between the pictures they obtain. . . . That of the cameraman consists of multiple fragments which are assembled under a new law.[10]

Benjamin concludes that "the boldness of the cameraman is comparable to that of the surgeon."[11]

The missing link in this comparison is the dialectics of gender inscribed in such a gaze. On the ashes of anatomy a female body is engraved. Cinema's analytic genealogically descends, in a way, from a distinct anatomic fascination with the woman's body.[12] Such corporeal desire is strongly instantiated in early cinematic forms, which were obsessed with performing acts upon the body.

These acts were of a magical nature for Georges Méliès, who both dismembered and levitated bodies. They were of a scientific nature for Eadweard Muybridge, who dissected and analyzed bodily motion.

The Bearded Woman

Desire and sexual difference inscribed in the body's anatomy were the very foundation of Menotti Cattaneo's spectacle. His anatomy lesson was followed by another presentation which involved a fetishization of the female body—the exhibition of a bearded woman.

With this exhibition, popular culture re-presented an image of high culture, which was in turn drawn from popular culture, the circus and freak shows. Cattaneo's bearded lady recalls a well-known image of the Neapolitan Baroque, the extraordinary painting of a bearded woman by the Spanish artist Jusepe de Ribera (1591–1652). Court painter in the kingdom of Naples and an influential figure in the Neapolitan art world, Ribera had "the same key position in the development of Neapolitan drawing that Caravaggio holds in painting."[13] Painted in Naples in 1631, *Madgalena Ventura with Her Husband and Son*, more popularly known as the portrait of "the bearded woman," had a considerable impact, and its subject matter assured its fame through the ages.

The painting had a lengthy written inscription in Latin, from which we glean its scientific objective: the representation of an anomalous female anatomy. The inscription tells us that the painting portrays a "great wonder of nature," a woman from the town of Accumoli in the kingdom of Naples, the mother of three sons, who at the age of thirty-seven had grown a beard as long as that of a man. The portrait is uncanny: Magdalena Ventura, with a long beard, is shown in the act of offering her breast to her son. The contrast between her naked female breast and her bearded male face is rather disconcerting, bordering as it does on the

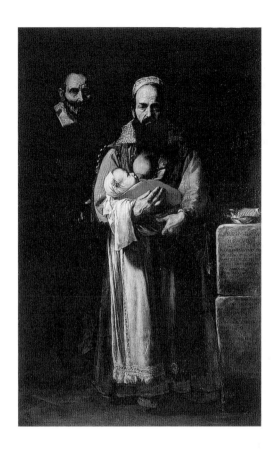

3.4

Jusepe de Ribera, *Magdalena Ventura
with her Husband and Son,* 1631.
Oil on canvas.

psychoanalytic terrain of fear of castration and fetishization. A predecessor of Ribera's rendering is the portrait of Brígida del Río by Juan Sánchez Cotán, *The Bearded Woman of Peñaranda* (1590s). Although a much more timid representation, this portrait also testifies to a cultural interest in anatomical anomalies and in the female body as the site of scientific discourse—a representation of "I know, but all the same." The fetishistic perversion, which as a topos informed the scientific and aesthetic discourse on the female body, crossed over into the popular domain. In Naples the bearded woman became a popular form of theater, the spectacle replaced by cinema.

Early Cinema and Bodyscapes

Studies on the genesis of cinema have revealed an impulse to reenact transformations, mutilations, and reconstructions upon the female body that are not dissimilar to the anatomy lesson and the bearded woman. Feminist theorists have pointed out that such impulses dwell upon sexual politics, and have particularly stressed a fetishization of the female body. The tricks of anatomical dismemberment, typical of Méliès's filmic techniques, have been revealed as a sign of male fears evoked by the female body and read as a manifestation of male envy of female procreative abilities.[14] The fetishization of the female body is a terrain Méliès shares with Muybridge. The invention of the cinematic apparatus and its early manifestations participate in the discourse on sexuality and sexual difference. Cinema functions, in the words of Linda Williams, as a "film body," offering to the gaze a fetishized female body trapped between the contradictory affirmation and denial of castration fear.[15] Film is therefore another instantiation of corporeality and gender difference, a form in which the "implantation of perversions" extends power over the body—especially the female body.

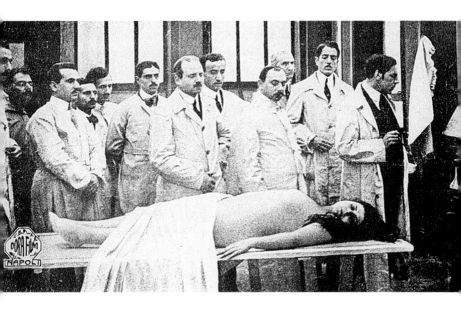

3.5

The anatomy lesson in *'E scugnizze*
(Urchins, 1917), a film by Elvira Notari.

The cinema of Elvira Notari (1875–1946), Italy's first and most prolific woman filmmaker who was active in Naples between 1906 and 1930, participated in this performative embodiment, including both figurations of Cattaneo's precinematic spectacle. With a pronounced materiality of writing, Notari represented grotesque figures, and in her 'E scugnizze (Urchins, 1917) offered a narrativization of an anatomy lesson. This text depicts a medical ritual in which a young female body is exhibited for anatomical dissection. Maria, a destitute madwoman, dies in a fire at the insane asylum. The corpse of the madwoman—pauper, unwanted—is donated to the academy, to be the subject of an anatomy lesson. The film ends in the anatomical dissection theater, where the female body lies on the table, surrounded by male doctors, displayed for the medical and spectatorial gaze, awaiting dissection—until a coup de théâtre interrupts the course of events. The professor assigned to perform the anatomy lesson turns out to be Maria's ex-lover. The knife falls from his hands. She, object of scrutiny, becomes the subject instead: it is the professor who has something to learn. He abandoned her because of her lower social position, eliminated her from sight, and made her mad. In the anatomy room the return of the repressed takes place, and, both doctor and lover, the aristocratic professor of cadaveric anatomy is taught a lesson in socio-sexual anatomy by the *popolana* Maria, a madwoman of the people. Subverting the fetishism of early cinema, the (mad)woman, object of a medical-cinematic gaze that unveils and analyzes, figuratively rises from the dead to denounce her own condition and reclaim her place and desire. And she is rescued from the anatomy lesson. As the surgical instrument that cuts into the female body is stopped, so is that other instrument that also cuts—and cuts off—woman's (own) image.

Genealogical Travelogue: Corporeal Visuality

The recurrence in early cinema of acts of somatic transformation and dismemberment, epitomized by the anatomy lesson, signals a discursive movement toward the inscription of desire and power in the cinema. The anatomy lesson points to an epistemology of the body, a broad transdisciplinary construct where codes of the visible are mapped upon the (female) body.

Various versions of the anatomy lesson and the bearded woman exist at the genesis of cinematic desire. These anatomies circulate not only in the filmic texts of Muybridge, Méliès, and Notari but also in fantasmatic forms, in utopian and anticipatory instances of cinema, such as the Neapolitan precinematic spectacles and literary predecessors like Villiers de l'Isle-Adam's *The Eve of the Future* (1881–1886). Writing about this novel, Annette Michelson describes it as a prefiguration of cinema.[16] This utopian text about Thomas Edison, in which an anatomical wax model informs the imaging of a female android, epitomizes the dynamics of representation leading to the invention of the cinema. Retracing the epistemophilic trajectory of cinema's forerunners, and pointing in the direction of the philosopher Condillac's analytic approach, Michelson exposes the representational drive that film comes to embody—a desire rooted in the fantasmatic projection of the female body.[17] This genealogical project uncovers a cultural paradigm, which points beyond fetishism. We recognize "the obsessive reenactment of that proleptic movement between analysis and synthesis which will accelerate and crystallize around the female body in an ultimate, fantasmatic mode of representation as cinema. The female body then comes into focus as the very site of cinema's invention, and we may, in an effect of stereoscopic fusion . . . see the philosophical toy we know as cinema marked in the very moment of its invention by the inscription of desire."[18]

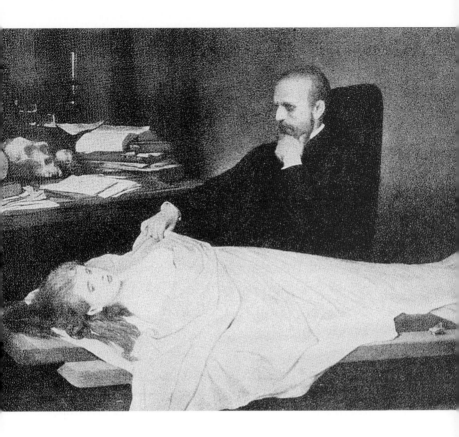

3.6

Der Anatom (The Anatomist),
1869, by Gabriel von Max,
in an anonymous print.

It is within this effect of stereoscopic fusion that the Neapolitan spectacles of the bearded woman and the anatomy lesson are deployed. Such anticipatory examples of the spectacle of cinema reveal a proleptic movement, ranging from high to popular culture, toward the discursive implantation of bodily desire. Linking the anatomy lesson and the bearded woman to cinema in Naples should be understood in this general cultural context as a metonymical shift enacted on a common ground, mapping out the intersection of science and representation upon the geography of the female body. The injection of cinematic language in Naples in a site inhabited by the interaction of medical, scientific, and popular discourses is the sign of an epistemological movement toward the object-body, participating in the drive to establish the body as a privileged object of knowledge, pleasure, and power.

As Michel Foucault has pointed out, the body acquires an increasing interest in the cultural productions of the last three centuries, and there is an explosive growth of sexuality at a discursive level.[19] This observation may be extended to include cinematic discourse, as the genealogy of cinema participates in this epistemology and its representational inscription.

Understood as a discourse on the fabric of the body, cinema shares epistemological foundations with the scientific investigation of *corporis fabrica*.[20] It is both a philosophical and a scientific toy. From genealogy to representational codes, this threshold molds filmic language. Various forms of the anatomy lesson and physiological motions penetrate the filmic landscape "on the eve of the future." The phenomenon has historical as well as epistemological roots. Coincident with the invention of cinema, medical discourse on the body furthered its use of the gaze as an analytic instrument, and advanced the development of visual instruments and techniques. The interaction of scientific and filmic language, as Lisa Cartwright shows, extends well beyond the influence of noted figures such as Eadweard Muybridge and

3.7

Franz Xaver Nissl (1731–1804),
Relief with Muscle Man, Munich,
second half of the eighteenth
century. Wood. Photo: Jens Bruchhaus,
Munich. Courtesy of Kunstkammer
Georg Laue, Munich.

Étienne-Jules Marey.[21] The relation of cinema to physiology concerns their very formation as languages, insofar as both articulate and analyze the body in movement. Like cinema, physiology—the analytical study of physical transformation—is a dynamic language affirming the temporality of the body, its process and motion.

On the eve of the advent of cinema, anatomies of the visible, and visible anatomies, haunt nineteenth-century analytic epistemology. Knowledge, molded on a physical paradigm, advanced with the body, and, in particular, with the exploration of vision. Ultimately the body emerged as a *fabric*ated visual apparatus. Several aspects of this nineteenth-century phenomenon—an embodiment of what Jonathan Crary terms the "techniques of the observer"—are genealogically ingrained in the cinematic apparatus.[22] Alongside the development of precinematic machines of the visible, in which the observing body was implanted, a widespread hermeneutic paradigm exhibited a passion for observing and analyzing faces and somatic traces—for mapping out the very surface of the body. As the proliferation of treatises on physiognomics, phrenology, and physiology testifies, over the course of the century a bodily visual archive was being constructed. The formation of a physiognomic code for the visual reading of dermal surfaces intersected with the establishment of techniques of mechanized visual representation.[23] With an impetus from medical and anatomical illustrations, photography played an important role in establishing the typology of deviance and social pathology. The nineteenth century produced a taxonomic ordering of images of the body. The deviant and the female body emerged as essential components of this visual archive and representational apparatus, epitomizing the exposure of one's material existence. This was a cross-cultural, cross-disciplinary phenomenon. It was also the site of an overlapping of scientific and artistic discourses.

In Italy, for example, Giovanni Morelli (1816–1891), a doctor and art historian, populated his art-historical studies with figures of body parts: ears, feet, fingers, nails. Morelli wrote art history by detecting in painting the representational codes of the body, and dissecting them. Through these visual bodily signs, he explored, analyzed, and authenticated pictorial representations.[24] Morelli's work interested Freud, who read him before he became involved with psychoanalysis; Freud later ackowledged that Morelli's investigative methodology was related to the method of psychoanalysis.[25]

In light of this epistemological emphasis on the texture of the body as the ground of vision, we suggest a close interaction of scientific and filmic languages on such a genealogical terrain. Rather than solely an enactment of fetishism, early cinema's impulse toward a bodily implantation—its insistence on performing acts upon the body and reinventing the anatomy lesson—appears to stem from a larger epistemological analytic paradigm concerning a geography of the interior and the embodiment of the techniques of observation. This epistemology ranges across a vast perceptual field, from the visual recording of bodily morphologies and transformations all the way to the mapping of symptoms.

In this transdisciplinary paradigm, the human body is conceived as intimately visible—both as seeing apparatus and seen sign. *Soma* equals sign in a gendered way, for the nineteenth-century analytic thinking was a function of, and a participant in, the changing axis of private/public. Moving from surface visibility to visible traits inside the body, a form of inferential thinking induced the formation of sexual visions: "A common currency, a shared language . . . produced and sustained the linkage between gendered body images and sex roles. . . . Movements . . . took place between the biomedical sciences, social and cultural processes and representational practices."[26] These movements created a new sense of public privacy in visual culture.

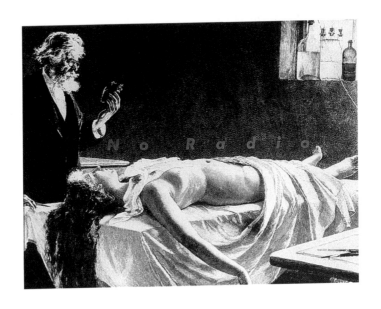

3.8

Barbara Kruger, *Untitled* (*No Radio*),
1988. Photograph. Courtesy of
the artist.

Panorama of an Analytic Spectacle

A number of films made in Italy by Dr. Camillo Negro exemplify this epistemological configuration and point, in particular, to the analytic spectacle of the female body as the shared territory of film and psychoanalysis. In 1908 Negro made *La neuropatologia*, a series of films, now lost save for a few, that displayed various "neuropathological" cases.[27] *La neuropatologia* constitutes a filmic version of the photographic spectacle of hysteria initiated by Charcot at the Salpêtrière in Paris in the late 1870s.[28] Speaking of "the cabinet of Dr. Negro," Italian film theorist Alberto Farassino notes Negro's insistence on the gaze.[29] In most extant fragments the cameraman-doctor directs offscreen various motions of the gaze, and in one segment the camera becomes visible in the form of a reflection on the eyeball of a female patient-character. Particularly interesting is the extant four-minute film featuring a female hysteric acting out on a bed. While the female patient performs her hysterical act for the camera, the doctor, Negro himself, performs his cure, pressing directly on her pelvis. The hysterical woman is masked, as are the female protagonists of early pornographic films. The iconography of the mask charts sexuality as (ob)scene, and, thus formulated, this configuration enters the threshold between hysteria and cinematic representation. This section of *La neuropatologia* cinematically reconstructed the very site of psychoanalysis and psychoanalytic seduction and marked desire and power on the female bodyscape.

Negro's film featured some of the patients previously studied by Cesare Lombroso (1835–1909), who was himself present among the spectators at the opening in Turin.[30] Lombroso, an Italian doctor who formulated the science of criminal anthropology, contended that there is a bodily structure, which is knowable, measurable, and predictable, and that this structure defines the criminal. The father of criminal physiognomy, Lombroso classified and analyzed the physical characteristics of deviation. The

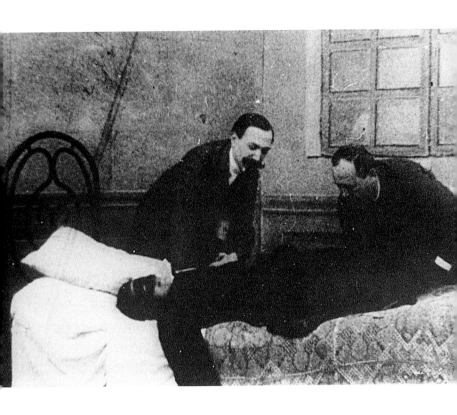

3.9

A frame enlargement from
Dr. Camillo Negro's film
La neuropatologia
(Neuropathology, 1908).

female body, in terms of both normal and pathological anatomy, was the subject of his book *The Female Offender*.[31] Lombroso claimed that the female body possesses a lower visual, aural, and tactile sensibility than the male, and that only maternity may neutralize her physical and moral inferiority. As a result of her resistance to variation, the female adheres to normality more than the male. Woman makes even a lesser criminal. Ultimately, only the prostitute reaches the level of deviance of the male. Prostitution alone reaches the peak, as it were, for the female; it is the only activity that may satisfy the desire for idleness, license, and indecency. Streetwalking incorporates the ultimate criminal pleasure—that of *flânerie*. Such is the very *trans*gressive desire embodied in cinema, and the constitution of the body of female spectatorship extends the enjoyment of nomadic erotic pleasures to the female. Through filmic *transito*, the female spectator may thus reclaim desire—its indecency, license, and wandering paths— outside the logic of the criminalization of pleasure.

Despite the determinism of his approach and its deplorable ideological implications, Lombroso's theories should be reconsidered as part of the proleptic movement that, by way of writing on the body and analyzing its surface, leads to its inscription as site of public privacy through mechanized visual language and, ultimately, in the cinematic apparatus. The influence of Lombroso's work on Negro's *La neuropatologia* and his attendance at the opening night were not fortuitous. They point to an intertwining of physiognomy and cinema as analytic visual discourses on the body. If, on the one hand, the cinematic formation and analysis of dermal spaces and morphologies is related to physiognomy, physiognomy, on the other hand, relies on the mechanical reproducibility of faces. Lombroso made use of photography and exploited its potential to circulate images among a vast public. With his work, physiognomy entered the domain of the mass media and popular culture. We should finally recall film theorist Béla

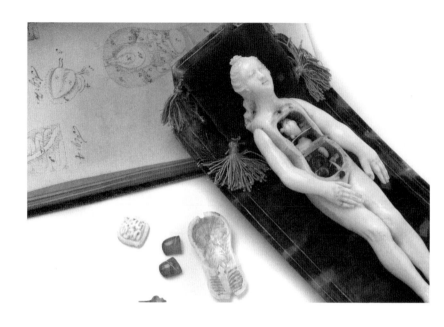

3.10

Stephan Zick (1639–1715),
*Anatomical Teaching Model of
a Pregnant Woman,* Nuremberg, ca.
1680. Ivory, velvet, tortoise shell,
parchment. Photo: Jens Bruchhaus,
Munich. Courtesy of Kunstkammer
Georg Laue, Munich.

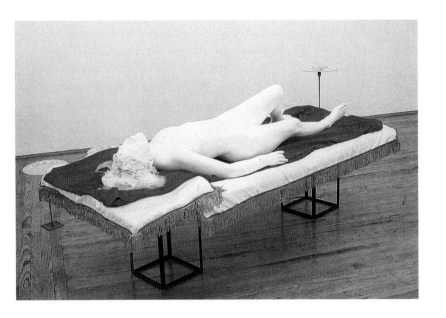

3.11

Orshi Drozdik, *Medical Venus,* 1993.
Installation view, Tom Cugliani Gallery,
New York. Courtesy of the artist.

Balázs's point that the language of the silent cinema is intimately related to physiognomy in that they share a representational terrain. The cinematic close-up offers the possibility to penetrate, reveal, and record the very essence of physiognomy: "Facing an isolated face takes us out of space, our consciousness of space is cut out and we find ourselves in another dimension: that of physiognomy."[32] The establishment of a genre of facial expression in early cinema also testifies to an overlapping of scientific and artistic discourses, bridging the gap between medical and filmic representations of body space.

La neuropatologia was first shown at Turin's Ambrosio-Biograph movie theater on February 17, 1908. It was screened in Naples in 1911, thanks to Gaetano Rummo, a Neapolitan doctor who had been promoting screenings of medical films since the inception of the genre.[33] A film reviewer pinpointed the threshold film/anatomy/(psycho)analysis, stating that "the white film screen was transformed into a vertical anatomic table":

> *Both the public and the spectacle were unusual last night at the Ambrosio Biograph! The theater usually attracts a crowd that peels oranges, a petty-bourgeois crowd, a public of workers and kids who come to see the "funny scenes" of the jealous wife or the really dramatic and moving scenes of the "little heroine." Last night the cinema was crowded with a glasses-wearing, bold, highbrow public, which gave the theater—the site of fresh, childish laughter and sounds of continual surprise and marvel—the severe aspect of the academy.*
>
> *The associates of the Royal Medical Academy and the students of the Esculapio had come to the Ambrosio Biograph, eager to see a living sample of the best neuropathic "subjects." These were to be featured on the white film*

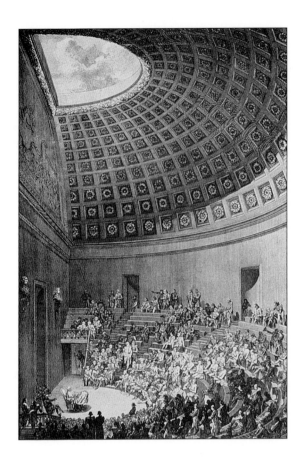

3.12

The Great Amphitheater of the
Medical School in Paris,
engraving by Claude-René-
Gabriel Poulleau, 1780.

*screen, which was transformed into a vertical anatomic
table, thanks to their illustrious colleague, Prof. Camillo
Negro. Prof. Negro's genial idea is to use cinema in the
teaching of neuropathic illnesses. He would like to offer to
the students of small universities who do not have access
to "live" material an archive of "types" and "cases" in
film. The very successful attempt of Prof. Negro will un-
doubtedly raise interest in the medical field, as it is able to
reproduce and foreground the language of "motion," that
which could not be rendered with photography. . . . The
spectacle was not for the family but rather was a scene à
la the Barnum museum. Prof. Negro . . . commented on
the parade of all kinds of neuropathic types, affected by
organic hemiplegia, contracting paralysis, epileptic at-
tacks, hysteria, different types of Saint Vitus' dance,
pathological postures, paralysis of the eyesight, etc. The
filmic image was so sharp that we thought we were in a
clinic. The impression was definitively one of anguish in
looking at that poor hysterical woman who loses her
speech every three months and who cannot speak again
unless Prof. Negro hypnotizes her and orders her to speak.*[34]

The workings of *La neuropatologia* clarify aspects of the fantas-
matic ground of cinema's genealogy and its "technologies of gen-
der."[35] As the reviewer himself notices, this film of clinical cases
reinvents the anatomy lesson in filmic terms. Negro intended to
create a cinematic archive of analytic cases and bodily types to re-
place the expensive anatomy lessons perfomed live. It is the very
nature of the film apparatus, with its inscription of spectatorship,
that makes possible the reenactment of the anatomy lesson. The
audience that customarily attends the performance of the anat-
omy lesson or watches the theater of hysteria becomes institu-
tionalized as spectatorship. The amphitheater where the medical

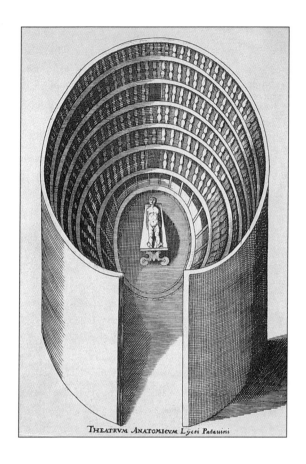

THEATRVM ANATOMICVM Lÿcei Patauini

3.13

The Anatomical Theater in Padua,
1654. Engraving.

spectacle takes place is replaced by another such site—the movie theater. The space of cinema replaces the representational geography, the interaction of subject/object, the spatio-visual topography appropriate to the medical spectacle. The vertical anatomic table becomes a white film screen, and it is the anatomy of female hysteria that is performed and exhibited. *La neuropatologia* transforms the anatomic table into both filmic screen and psychoanalytic couch and points to the female body as the ground upon which this transformation is enacted.

Thus we may understand the shift, undertaken by Menotti Cattaneo, from the ashes of anatomy's spatio-visual apparatus to film exhibition and architecture. Anatomical theaters, like today's film theaters, "should be built in large and well-aired places"— suggested the anatomist Alessandro Benedetti in 1502—"They must be big enough to accommodate many spectators. . . . There should be two ushers to expel intruders and two honest doormen to collect entrance fees."[36] Every epoch dreams of the following one and leaves utopian traces behind. We must pay close attention to the utopian potential of popular culture, for it embodies transitional dimensions.[37] The exhibition in the popular theater of the bearded woman and the anatomy lesson, at the genesis of film exhibition in Naples, voiced in just such a way the discursive movement that, traversing high and low cultures, designed a public intimacy.

4 MIND WORKS
REBECCA HORN'S INTERIOR ART

Named the *caméra-stylo* by Alexandre Astruc,[1] cinema is a *plume*, a means of writing. A language of desire, film extends its feathers to touch the world, and to be touched by it. A vision of touch, a touching vision, it is a machine that extends our sensory apparatus, our ability to map the world. Film is a tool to come to grips with our environment, affecting our possession of intimate space. No wonder the artist Rebecca Horn is interested in film.

Horn is passionate about the cinema and the making of films, a passion that does not begin or end with her film production. The very conception of her machines is cinematic, and the machines structurally evoke the filmwork. Erotically driven systems of representation, they share the psycho-spatial vision of the motion pictures, and its cultural genealogy. Like the cinema, that machine of modernity, they work inbetween anatomy and topography.

As tools for writing bodies in space, the machine and the film are also linked in a more literal way. The apparatuses in Horn's early performance films, which document the interaction of the body and machinery, are themselves characters in those films. In

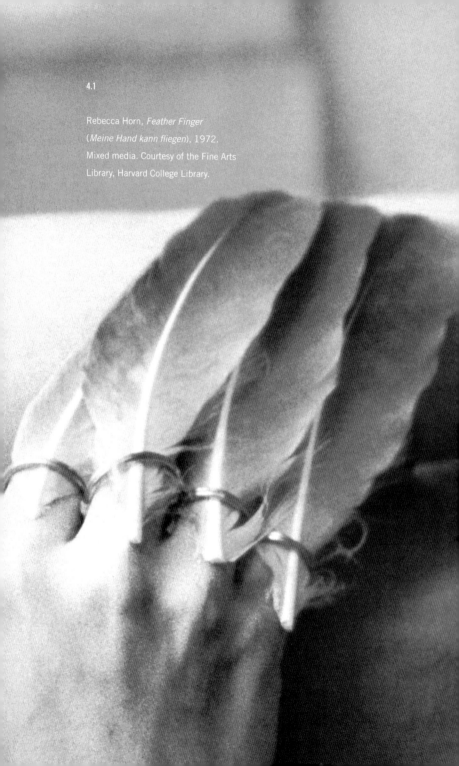

4.1

Rebecca Horn, *Feather Finger*
(*Meine Hand kann fliegen*), 1972.
Mixed media. Courtesy of the Fine Arts
Library, Harvard College Library.

Performances I (1972) and *Performances II* (1973), the body itself becomes an instrument—a tool—and the film apparatus represents a body apparatus. In *Berlin Exercises: Dreaming Underwater* (1974–1975), bodily prostheses affect the body's ability to sense space.

Mechanized objects populate Horn's fiction films, whose characters are often "plumed" machines. *The Feathered Prison Fan* (1978), which is featured in *Der Eintänzer* (1978), has mechanically rotating feathers that turn a dancer into a bird. *La Ferdinanda: Sonata for a Medici Villa* (*La Ferdinanda: Sonate für eine Medici Villa*, 1981) features *Mechanical Peacock Fan* (1979–1980), a love machine of feathers spread open like a peacock's tail.

For the last ten years, the performing objects in the films—plumed or otherwise—have been exhibited in installations in museums and galleries. Horn creates a circulation of signifiers between installation and film, and between them and their exhibition spaces. Not only machines but also objects, people, topics, and topoi travel from one art form to another, and in between the two. The exhibition space becomes a movie theater, and vice versa, for Horn practices a complex, total *techné*. For all these reasons, it would be reductive to speak of Horn's cinematics only as film texts. Better to explore the kinetic interaction between her filmic work and her art work—a haptic mechanics.

The Bride Machine: Touching as Writing

One important site of this interaction is the bachelor machine, an artistic phenomenon that, as Bruce Ferguson has remarked, deeply inflects Horn's practice.[2] Specifically referring to the lower part of Marcel Duchamp's *The Bride Stripped Bare by Her Bachelors, Even* (1915–1923), or the *Large Glass*, the bachelor machine designates an aesthetics of machines inscribing the body in its relation to sexuality, the social text, psychological topographies, forms of authority, and the workings of history.[3] The myth of the bachelor machine informs cultural production through the late

nineteenth and twentieth centuries. It is a theatrical, imaginary machine, a "fantastic image that transforms love into a technique of death."[4]

As Constance Penley has pointed out, cinema is rooted in the discourse of the bachelor machine, and fits its fundamental requisites: "perpetual motion, the reversibility of time, mechanicalness, electrification, animation and voyeurism."[5] A mechanical scopophilic toy, the cinema is a dream factory, where animated psychic dreams, projected at a steady speed of twenty-four frames per second, exert the power of time travel. Revealing the cinematic apparatus as gendered, Penley reminds us of Michel de Certeau's assertions that the bachelor machine "does not agree to write the woman as well [as the man]"[6] and that the machine's chief distinction is its being male. "What becomes evident from the Bachelor Machines," as Harald Szeemann puts it, "is the denial of woman,"[7] a repression predetermined when the imaginary is presented as a machine.

Yet a space of, and for, desire is precisely the territory Horn claims as her own. The difficult space of sexual difference and attraction, repressed or produced as a male vision by bachelor machines, is appropriated, even revenged, by her "bride machines." These mechanisms question, challenge, and assert sexual visions, writing the woman as sexual and sensuous subject rather than object of desire. Horn's own practice of naming suggests this twist. In 1988, for example, she produced an installation titled *The Prussian Bride Machine*, a self-conscious play on Duchamp's *Large Glass* that enacts a reversal of meaning. And, in fact, Horn's machine literally subverts the signifiers of the masculine bachelor machine: "One-armed/ three-legged ejaculating Prussian blue all over the brides."[8] Producing a name and a practice of bride machines, Horn writes the woman with ink, writing her into the narrative, and fashioning her experience through a mechanism made of high-heeled shoes.

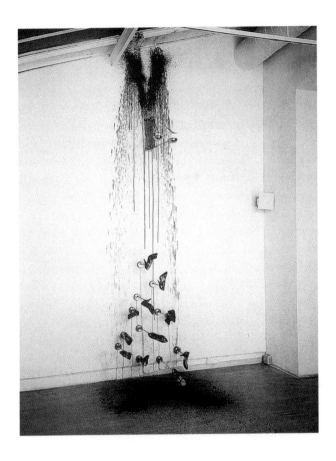

4.2

Rebecca Horn, *The Prussian
Bride Machine* (*Die preussische
Brautmaschine*), 1988. Installation
view. Courtesy of the artist.

This ink machine is symptomatic of Horn's overall practice. The bride machine is a writing/drawing tool, and it returns in different forms: the high-heeled shoes of *The Prussian Bride Machine* are replaced by books in *Salome* (1988) and by stretcher bars in *Printing Machine* (1988). Horn often plays with writing/drawing tools, metonymies, and prostheses. *Chorus of the Locust I* (1991) is a typing machine made of old-fashioned typewriters. *Brush Wings* (1988) is a brush bird, whose wings, composed of paintbrushes, are able to produce "dashes in the sentence of a painting."[9] Flying machines are a favorite theme of the artist-inventor, and, like Leonardo, Horn thinks of birds as powerful natural machines. She herself performed as a flying machine in the 1972 short *White Body Fan*, in which her body is filmed (s)trapped in two large enveloping wings that can move but do not allow her to take flight.

Wings, like bird's feathers, are a recurrent erotic object for Horn. With its sensuous texture, the feather mimics the surface of the skin; the *plume* stands for touch, for the caress. In the performance films *Cockfeathermask* (1973) and *Cockatoo Mask* (1973), the artist's feather-masked face seems to ask to be touched. A paradigmatic twist is always enacted, as wings become paintbrushes and feathers become writing tools. The feather mask metamorphoses into *Pencil Mask* (1972), in which Horn, her face covered with the pencil contraption, moves back and forth, writing on the wall, marking it. The touching object, the *plume*, was once literally, after all, the pen, a sensuous writing tool. Writing the woman, Horn makes herself a veritable *femme de plume*.

The *Caméra-Stylo*, a Sensory Machine

As *femme de plume*, Horn makes use of the filmic *plume* to inscribe sensuality. In 1972, she made *Feather Finger*, a performance film in which fingers made of feathers touch and explore bodily space. The first of the *Berlin Exercises*, called *Scratching Both Walls at Once*,

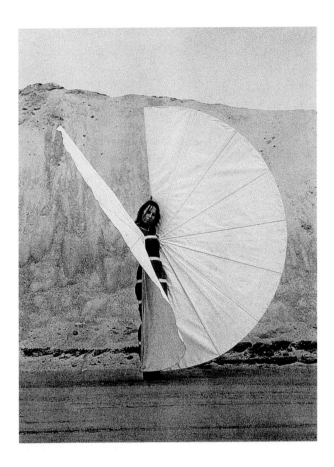

4.3

Rebecca Horn, *White Body Fan*
(*Weisser Körperfächer*), film still
from *Performances II,* 1973.
Courtesy of the artist.

uses the *caméra-stylo* to extend a woman's sensory extremities. Wearing mechanical gloves, Horn moves back and forth in space. With these long finger-gloves, she touches the walls of the room, exploring boundaries. It is as if she were coming to grips with the space. Her operation on the wall produces a scratch. The mark on the wall is a sign. Drawing perimeters, it becomes a signifier of desire and possession. Before, it was just an empty place. By scratching, it is as if she owned the room.

A Room of One's Own

The interrelation of space and desire, the desire of owning the room, and the desire for "a room of one's own," mark a female experience. In the words of Jessica Benjamin, psychoanalytically speaking, "what is experientially female is the association of desire with a space."[10] Woman's representation and self-representation often involve her body as an inner topos. Female sexuality itself is expressed as dermal topography. Moreover, it is the space between mother and baby, as it extends into the locus of creativity and fantasy that fosters intersubjectivity and, as Benjamin says, "the bonds of love"—a spatial mode of desire.

Horn makes space by mapping out the topos of femininity. In 1976, she wrote about the room as internal "architecture," a womb:

> These walls enclosing the room so lovingly, isolating it from the world, standing so close in front of you, intermingling with you . . . opening simultaneously into the furthest depths of the room, for not far from there is a small door—leading to three small chambers—chambers in which you can find everything. . . . And yet they are so tiny, these chambers, that you retain the feeling, continually, that you have never really left the other (main) room—the one from which you most want to separate yourself—and from which you will never completely

*escape. Nor do you get the feeling of ever having entered
a truly new space—no doors, no stairs; nothing lead-
ing anywhere. . . .*

*Once the door leading out of the main room has closed
behind you—the door which closes itself, leading you to
three small chambers— . . . then do you enter the third
and final chamber.*

This small (final) chamber is in itself like a cage. . . .

Rooms, kangaroos. [11]

An architectural site, the room is constructed and read as a
body. The walls have, or rather *are*, anatomical textures. They are
somatic divides, layers of skin. Space emerges as gendered: a fe-
male inner topos, somewhere between the womb and the mar-
supium, and a fluid geography of intersubjectivity. Not an idyllic
site but rather a Kleinian scenario, the female space of desire
skirts danger and pain. Accordingly Horn describes the room of
The Hydra Forest, Performing Oscar Wilde (1988)[12] as an installation
in which electric devices hang dangerously, "spewing out sizzlingly
destructive kisses."[13]

In its different forms, Horn's obsession with a spatial repre-
sentation of desire writes the woman, and the female experience
of space. It is precisely in this sense—mapping the association of
desire and space and the mechanics of desire—that Horn's works
are bride machines—they are female topographies.

Making Room: *Stanze*

A spatial drive pervades the whole of Horn's filmic drive. Like
the kinetic machines in her installations, the films are signifi-
cantly about site. Narrative space is their most important feature.

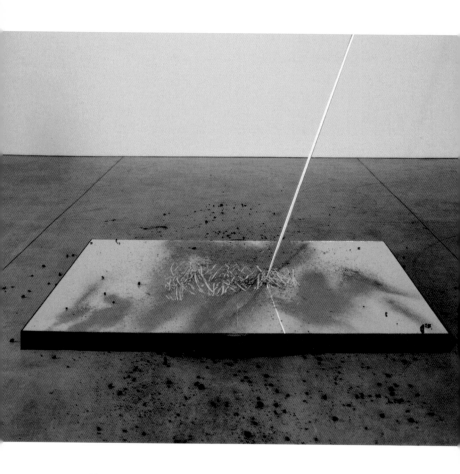

4.4

Rebecca Horn, *Book of Ashes,*
2002. Installation view. Courtesy
Sean Kelly Gallery, New York.
Photo: Sean Kelly.

Dwelling on space, the filmic narrative touches the geography of interiors. It becomes a filmic room—a *stanza*. Thirteenth-century Italian poets described their poetry as *stanza*, "room and receptacle," evoking, in this way, the belly and the womb.[14] *Stanze* express the joy of love; they are the spaces of eros. Horn's films and installations are *stanze*, for they house both the love joy and the amorous disease.

All three feature films made by Horn center on interpersonal relations. The fictional web of *Der Eintänzer* takes place in the New York loft in which the artist lived at the time she made it. In the fiction, it is the home and studio of a ballet teacher (Geta Konstantinescu), who gives lessons to young girls and to a blind man (David Warrilow) and who temporarily hosts two identical twins visiting the city. Another character, Max (Timothy Baum), the piano player, inhabits the space mostly via the telephone. The intersecting stories of *La Ferdinanda* are housed in a beautiful Medici villa, where Caterina de Dominicis (Valentina Cortese), an opera singer, and her friends come every summer. During their visit, the villa is also rented (as it is in reality) for a local wedding. *Buster's Bedroom* (1990), shot by the famed Sven Nykvist, revolves around the surreal sanatorium where the film student Micha (Amanda Ooms) goes in search of memories of Buster Keaton, once a guest of this so-called Nirvana House. Micha will find that the place, run by a doctor-patient (Donald Sutherland), houses complex relationships among its inhabitants, who include the prima donna (Cortese), a beekeeper (Warrilow), and a gardener (Taylor Mead). The interactions of these characters create a psycho-spatial topography, where the amorous meets the perverse.[15]

However different on the surface, the three films share this psycho-spatial topography. And, in all cases, the room is the real protagonist of the film. Everything happens there. Characters constantly traverse and pass through the space. Temporary and

permanent residents share the locale. People meet, eat, chat, seduce, touch, and tell stories there. The room becomes the locus of production of a fantasy. The film set enables the fantasmatic deployment of one's *vissuto*, the very space of one's lived experiences. As Horn says offscreen at the beginning of *Der Eintänzer*, "This is my studio in New York. While in Europe, I was able to imagine some possibilities of what could take place there when various people I had known before would suddenly be put all together in that same single space."

A kaleidoscope is produced. In the *Berlin Exercise* titled *Rooms Encountering Each Other*, for instance, fragments of identities and subjectivities are imaged and exchanged. As in the mirror stage—the very metaphor of the cinematic apparatus—the image is split. Multiple reflections of internal spaces are projected and reflected as exteriors. As rooms. As spatial fragments. One's being-in-space produces an inevitable diffraction. The room is a dissection, an anatomy of love—a *stanza*.

Claustrophilia

One location determines the narrative space in all three of Horn's cinematic fictions. This filmic set, a single static dwelling, is transformed into a place of *transito*, for the room houses passages, the crossing of transitory states and erotic circulation.[16] Horn constructs circular spaces, and the circularity of place. Not only is the set a unique web of actions, but these actions, repeated from one film to the next, are reassembled yet again. The erotic, gastronomic, and medical themes; actions like dance; characters such as the femme fatale, the musician, or the twins; animals such as birds and snakes return over and over again, together with performing objects, with the circularity of an obsession.

While the one locale enclosing each film is open to embody a nomadics of actions, these actions do not take us elsewhere. Or rather, they take us elsewhere practically without ever leaving the

site. We are confronted with an immobile voyage. A stationary leaving. Horn practices nomadism in one room.

Heterotopia, the attraction to and habitation of a multiple geography, is, overall, a main characteristic of cinema. While the film travels, the spectator stays in one place, enraptured in a special kind of journey. It is a voyage that takes us out of place, that deterritorializes us, without taking us out of the room. One goes and comes back, remaining in the same chair. The spectatorial seat is a kind of prosthesis of mobility—a wheelchair.

This wheelchair, the site of an (im)mobility, is an obsession of Horn's. In *Buster's Bedroom*, Mrs. Daniels (Geraldine Chaplin), an ex-diver and professional swimmer, gives up her bodily mobility to embrace the mechanical motion of the wheelchair. She has not actually lost the use of her legs, and could at all times leave her wheelchair and walk, but she does not out of an obsessive love for Dr. O'Connor. Likewise, all actors and actions in Horn's films appear to suffer from the dis/ease of mobility. However differently, all Horn's films are dictated by this very geography, the attraction to a journey in one place. They speak of a form of claustrophilia.

Housing the Unconscious

Horn's filmic claustrophilia organizes desire and difficulty around the figure of space. It is as if the boxed-in, eroticized space of *Paradise Widow* (1975) and *The Chinese Fiancée* (1976) were forever extended into a narrativized version. Conceived this way, her fictions touch on the very difficulty of spatial desire and mobility. This difficulty is central in, and for, films by women. However different in their deployment, many films made by women are implicated in this topos, and express this dis/ease. It constitutes a structural knot, the site of a possibly inescapable intertextuality. For if there is an intertextual thread binding together the history of women with a movie camera, it is the one that ties together sexuality, narrative, and space.

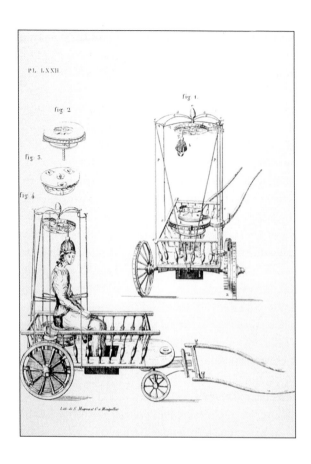

4.5

Orthopedic wheelchair, from Jacques
Delpech, *De l'orthomorphie, par rapport
à l'espèce humaine; ou recherches
anatomico-pathologiques sur les causes,
les moyens de prévenir, ceux de guérir
les principales difformités, et sur les
véritables fondemens de l'art appelé
orthopédique* (Paris: Gabon, 1828).

The *stanza* is a problematic space for this cinema. It is a tie that binds. As the epitome of enclosed space, the home is the setting of many women's stories. This is a set where the bonds of love meet the bonds of domination, and seduction meets submission. Narratives of pleasure and pain, fantasies obsessively located in one room—the bedroom—are repeatedly constructed. From the silent films of Germaine Dulac and Maya Deren to those of contemporary filmmakers like Chantal Akerman, this paradigm reoccurs, marking a feminine topos. The narrative of the room involves a loss or tends to end with a death, and this death often borders on suicide. Horn's own (bed)room fantasies are no exception. All the circular, claustrophilic stories of her fiction films end with a death, and the leap twice borders ambiguously on suicide. One is led to think that the enclosed narrative space requires, even demands, a death. In this respect, Horn's intervention in cinema continues a difficult tradition: the placing of woman, her taking place, the mobility of her erotic topography.

Filmic Topographies

While evoking the topography of the unconscious as realized in films by women, Horn's spatial constructions reference other filmic traditions where space dictates fiction. The first of the artist's fictions, *Der Eintänzer*, is a narrative produced in New York when the loft life of artists first found its way to the screen. Horn's film thus participates in the development of a filmic avant-garde, a movement for which the geography of the loft shapes the form of narrative space.[17]

Both the set and the filmic treatment of *La Ferdinanda*, the beautiful Tuscan villa, are reminiscent of Luchino Visconti's exquisite, elegant mises-en-scène and aesthetic passion. As in the long ballroom scene that ends Visconti's *The Leopard* (1963), in *La Ferdinanda* the single space houses class differences and benighted attempts to cross them. Cross-cutting between the wedding, the

guests at the villa, and the locals inhabiting the kitchen, a social geography is represented. Food is the pretext for its construction, as, counterpointed by different music, each group reveals its sociocultural position around the table. "Food for thought," suggests Horn's cinema, for food and *logos* go hand in hand.

Buster's Bedroom's absurdist sets evoke the surrealistic tradition of Luis Buñuel. The dinner party as social geography and site of claustrophilia were well known to the director who understood "the obscure object of desire" and made *The Exterminating Angel* (1962) and *The Discreet Charm of the Bourgeoisie* (1972). The blindfolding motif recurrent in Horn's films is evocative of the famous blinding scene in *Un chien andalou* (1929); the citation of, and dedication to, Buster Keaton is also a Buñuelian act. The citation is circular, for Buñuel very much admired Keaton, and even wrote in praise of his cinema. Keaton was, for Buñuel, one of the rare filmmakers "who are able to accomplish their destiny in the rhythmic and architectonic gearing of the film," and to make a film "as beautiful as a bathroom."[18]

This brings us back to the mechanics of the room. The room is a bedroom. This (Buster's) bedroom houses a particular type of journey: an Oedipal trajectory. Keaton is one of Horn's artistic fathers, an imaginary ancestry that aligns Buñuel, Visconti, and Duchamp with such intellectual figures of dandyism as Oscar Wilde. In the film, Keaton becomes the object of an Oedipal search. Early on, Micha, the film student in search of Keaton's memory, watches a clip from Keaton's *Steamboat Bill Jr.* (1928). On the TV set is a metronome, counting time through automatic movement in space. Looking for Keaton at Nirvana House, Micha finds herself in a perverse amorous relationship with the alleged doctor who rules the place, a man whose authority relies on teaching the inmates to enjoy immobility. Trapped by Dr. O'Connor in a straitjacket, she manages to free herself, as Keaton himself once did, but she cannot (or chooses not to) escape the affair. The se-

duction scene between Micha and the doctor is interwined with another story, as the young girl tells him about someone she once loved, a man, it turns out, who was her father. And the metronome returns, again marking time, except that this time Micha plays, and is, the metronome.

The Automaton, a Body-Machine

Automatism marks a cinema like Horn's, which is adorned with automatic objects—spatial apparatuses—performing in automated time and in automated motion. As Germano Celant has pointed out, the machines in her films "are automatons. . . . They obsessively scan the space. . . . With their steel apparatuses they create territories."[19] It is here that the kinetic aspect of Horn's diverse artistic practices is deployed. The link between films and installations is found in the spatio-erotic drive of the automaton.

The fascination with automatons is another way to read Horn's passion for film and filmmaking. The automaton is a mechanistic being, an aesthetic, ludic object that contains its own principle of motion.[20] A product of nineteenth-century technology, film is close to such an object. It is an aesthetic, scientific, and ludic toy, whose seductive imaging happens to be propelled by internal automated motion. Like the automaton, the film body scans imaginary space and psychic topographies. Cinema is, in its own right, an automaton, perhaps the archetypal automaton of the age of mechanical reproduction. It is the last incarnation of a mechanical myth, an imagistic android, dreamed and transformed by the machine age.

A charming filmic automaton appears at the end of *Der Eintänzer*. As the dance teacher and her blind partner tango away, another dancer enters the scene: a round black table with slender legs (*Dancing Table*, 1978). It also dances the tango, "performing the precision of his capricious, solitary life with the accuracy of a machine."[21] With this seductive object-body, halfway between

Duchamp and silent film comedy, Horn presents a particularly interesting fantasy, given the long line of female automatons and androids. From Baroque wax medical cadavers, the so-called waxen Venuses, to bachelor machines, such as Villiers de l'Isle-Adam's Hadaly, all the way to the Maria of Fritz Lang's *Metropolis* (1927), the object-body has usually been connoted as female. But Horn's automaton is definitively gendered male. It is a male body-machine. And he is not alone, dancing in the cultural field. As a fantasy, the male automaton crosses over from high to popular culture, in a time of the sheer crisis of masculinity. *Making Mr. Right* (1987), a popular film directed by a woman, Susan Seidelman, presents a similar fantasy, differing only in the anthropomorphic way of imaging the male android and love machine. Horn's male automaton is a stylized, elegant, mechanized male cavalier, a dancing table. And it is to him, to this gentleman-table, that the last words of the film, spoken offscreen by the artist, are dedicated: "The agility of his movements presents the actuality of his personality—that of an extraordinary gentleman . . . that, in fact, of *der Eintänzer.*"

Automated Body Motion

Horn's interest in automatic movement touches on dance. Like her artwork, her cinema shows an interest in rhythm, motion coordination, and the automatism of the body. One of the *Berlin Exercises, Feathers Dancing on Shoulders* (1974–1975), shows the dance of a body-machine: a feather apparatus, worn by a woman, dances as she pulls the strings in rhythmical synchronism with the music. Among other dances, *Der Eintänzer* presents a marionette dance in which two young ballerinas, bound together by white strings, respond to the teacher's order and dance symbiotically. The strings, stretched between them, dictate their movements. This is a kind of marionette theater. As Heinrich von Kleist described it, the marionette theater is a true dance spectacle, whereby not only the puppet but even the operator must

dance: investigating the path of a dancer's soul (that is, dancing), he or she creates the marionette.[22] The marionette is superior to a dancer. For one, it is not affected, for affectation appears when the soul (the motor force of the body) is found at any point other than the movement's center of gravity. As the operator precisely controls this point, all the other body parts are what they should be—dead, sheer pendulums. Antigravitational, the marionette does not know the inertia of matter; it can skim the ground like no human can and repeat the same movement over and over again with equal grace. It is precisely this form of grace, this type of motion, as described by Kleist, that Horn seeks in her work. The grace that appears in the body with infinite consciousness or none: the automaton, a dancer.

Mechanical Memories

In Horn's cinema, automatism is inscribed in the mechanics as well as on the margins of images. In *Buster's Bedroom*, it is an element of paratextuality. The film essentially pays homage to Keaton, for whom automatism and the mechanistic were synonymous with cinema. Horn's film is dedicated to such kinetics, to Keaton's architectonics of the environment and of the body in space, an offspring of the myth of the machine age and the mechanized body. Automatism dominates Keaton's work and his mastery of concrete intelligence and danger: as an actor, he performed a constant manipulation of objects, engaging with the physical world, often performing repetitive, automated tasks and absorbed in a kind of perpetual momentum.[23] Grappling with the mechanics of things, by extension Keaton treated the human body, his own as well as other people's, as an object. A programmed automaton, Keaton's screen persona paralleled that of his two favorite film characters, the train and the cinema—two mechanical objects, two apparatuses for viewing space, framed windows for traversing sites—the very epitome of modern vision.

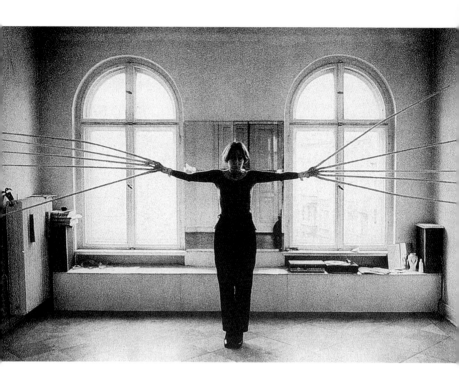

4.6

Rebecca Horn, *Scratching Both
Walls at Once* (*Gleichzeitig die
Wände berühren*), from the film
Berlin Exercises, 1974–1975.
Courtesy of the artist.

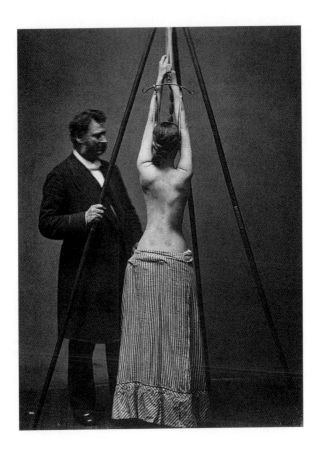

4.7

Treatment of a spinal curvature in a
young woman, from Lewis A. Sayre,
*Spinal Disease and Spinal Curvature:
Their Treatment by Suspension and
the Use of Plaster of Paris Bandage*
(London: Smith, Elder & Co., 1878).

Technological Prostheses

A moving window onto the world of bodies, the cinema provides Horn with a further tool to perceive and scan space. As a tool, the film lens is, for this artist, a true extension of her body-machines. Film, like the human body, is an organ of perception. As Vivian Sobchack has claimed, this instrument has a phenomenological power, since the world is felt at the junction between the eye and the camera-eye. A sensual and sensory way to sense-making, cinema is a sensuous machine.[24]

The sensory force driving Horn's own filmic machine is of a libidinal nature. Watching the filmic performances of the 1970s, one is reminded of Sigmund Freud's words describing technology as a bodily supplement: "With every tool man is perfecting his own organs, whether motor or sensory, or is removing the limits to their functioning. Motor power places gigantic forces at his disposal, which like the muscles, he can employ in any direction."[25] Horn's performance film *Finger Gloves* (1972) presents such a view—an empowered body-machine. A low-angle shot reveals a prosthetic mechanism attached to a woman's hands. The long finger-gloves begin to move, searching, sensing, touching the space around her. Such prostheses, like an animal's sensing antennas, speak of feeling as a way to spatial cognition. On this erotic route, the finger-gloves scan the body space of another woman, touching hair and sensuously moving down naked shoulders.

Beside their inherent mechanical power, Freud saw all major technological advances as a way to implement or supplement our physical capacities. Means of transportation extend our bodily motion; glasses, microscopes, and telescopes are bodily implements, for they extend the power of the lens of our own eye and its potential for sight. Technology is ultimately a prosthesis, or rather it is the ultimate prosthesis. "In the photographic camera," Freud writes,

[man] has created an instrument which retains the fleeting visual impressions; just as a gramophone disc retains the equally fleeting auditory ones; both are at bottom materializations of the power he possesses of recollection, his memory. With the help of the telephone he can hear at distances which would be respected as unattainable even in a fairy tale. Writing was in its origin the voice of an absent person; and the dwelling-house was a substitute for the mother's womb, the first lodging, for which in all likelihood man still longs, and in which he was safe and felt at ease.[26]

Most elements with which Horn dwells surface through this prosthetic view of the technological world.

Film technique itself is part of this prosthetic encyclopedia, one that, for Horn, is an "erotic library."[27] As a corporeal *techné*, film is an actual prosthesis. A way of experiencing through the camera, film technology intensifies the power of our sensorial apparatus. As a kind of binoculars, the film lens is a tool to see better, or rather to see what, and how, we do not see, and to grasp what, or whom, we cannot seize, clutch, grasp, or come to grips with. As an instrument, binoculars make a few metonymic appearances in Horn's films. In *Der Eintänzer*, one twin scans a "rear window" with binoculars, looking for clues to the whereabouts of the invisible man, the disembodied voice on the telephone. At the end of *Buster's Bedroom*, all the characters pass around the viewing instrument, and yet they do not see anything but an out-of-focus image. Thus the binoculars and the blindfold meet, as technology's impact on space becomes a way to both touch and obscure sight/site.

The Medical Body: Armatures

Horn makes sensory emotional maps much like anatomists, who penetrate bodies. Her work is anatomical in its shape and in its dwelling. Imaging the body and the machine, Horn constantly refers to a medical *imaginaire*, and this deeply shapes her body-sculptures. The medical body is fictionalized in *La Ferdinanda*, where one floor of the villa is an odd medical office in which an anorexic ballerina and a male patient in a wheelchair seek a cure. In the sanatorium of *Buster's Bedroom*, the amorous and the perverse meet in the reversals of the relation between doctor and patient.

The medical motif is deeply inscribed in Horn's aesthetic practice, for the medical terrain is, precisely, the domain of the body. Medicine has been central to the imaging of the body, in tandem with the visual arts. Body images feed both the fine and the popular arts and, most prominently, shape and are shaped by the language of cinema. Film's anatomical imaging goes hand in hand with its mapping of sexuality.[28] The history of sexuality, charted across a vast cross-cultural field, reveals how deeply the machine and the mechanism inflect the representation of sexuality and sexual obsessions.

Horn's *Overflowing Blood Machine* (1970) clearly exposes the interrelation of organism and machine. In this work, a person is encased in a mechanism made of plastic tubes: pumps enclose the body in an armature of veins and circulating blood. As Horn's body-sculpture suggests, the body is an extension of the mechanism of the machine, which is itself an extension of the body. Like the blood machine, many of Horn's body-machines enact an inscription of the medical body onto the sexual self. *Cornucopia* (1970), subtitled *Seance for Two Breasts*, extends a woman's breasts into her mouth with the application of two curved horns. An oral prosthesis, this mechanism allows a fluid circulation of oral functions: one can breathe and feed and talk to oneself, nourishing the body in a panoply of self-eroticism.

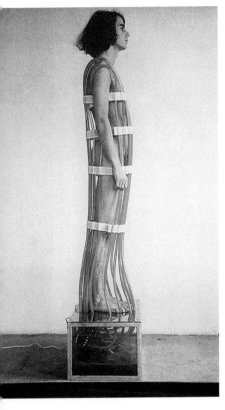

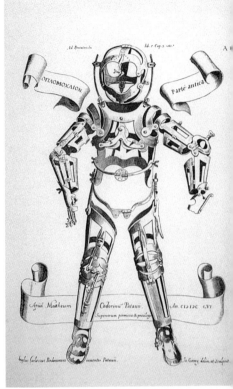

4.8

Rebecca Horn, *Overflowing Blood Machine* (*Überströmer*), 1970. Courtesy of the artist.

4.9

A body armature, from Hieronymus Fabricius, *Opera chirurgica* (1766).

Horn's writing of the medical is also a recollection of a medical past, and a reenactment of medical memories. Her work does not present the contemporary discourse of medical (in)visibility, which penetrates the body with image technology but, rather, re-presents an older discourse: the exposure of a medical apparatus. The artist's film performances record scenes of prosthesis. The filmed performance of *Head Extension* (1972) shows a long object extending the head, making it difficult for the person to move if not guided by those controlling the ropes of the mechanism. Prosthesis also informs *Arm Extensions* (1968), in which the arms of a bandaged yet naked woman are extended to the floor by tubular soft structures. Along the same lines, *Unicorn* (1971) shows a naked woman walking across a field. She is wearing a construction of white bandages that holds a horn precisely on her head, which becomes an armature, a form of armor.

With prosthesis, the bodily extension, we reach the very point where the body becomes an instrument. At close range, Horn's armatures call to mind the iconography of nineteenth-century orthopedics. This medical scene was inhabited by bandages, prostheses, and all kinds of elaborate apparatuses extending and supporting the injured body, immobilizing it in order to enable it, in time, to move. Prosthesis included the wheelchair, a machine for mobile immobile bodies, the very orthopedic instrument that Horn, in *Buster's Bedroom*, remade as an all-encompassing prosthetic device. This wheelchair is a dream chair that can satisfy all functions—mobile, oral, and emotional. It serves as a vehicle for the character played by Geraldine Chaplin, who is not only moved around by this machine, but made possible and actually constructed by it. Trained by Dr. O'Connor to master psycho-motorial energy—to stay perfectly still—Mrs. Daniels is immobilized by the contraption.

Nineteenth-century medical books insistently expose naked bodies tied up in bandages and (s)trapped into structures of re-

straint or mechanisms of (im)mobility. Bordering on the terrain of the erotic and the perverse, such a clinic exposes itself as a clinic of love. Medical treatises such as *Spinal Disease and Spinal Curvature: Their Treatment by Suspension and the Use of Plaster of Paris Bandage* (1878),[29] are filled with erotic representations and imagery not so far from Horn's own prosthetic imagination. Suspended or bandaged, the armatured naked body is scopophilically attractive; one is seduced by a kind of torture.

Touch of Evil

A topography of dark pleasures emerges from Horn's "desiring machines."[30] Sadism feeds them, inasmuch as sadism is itself a true psychological mechanism. The sadist persistently exposes the mechanistic aspect of the organism, and interchanges the image of the machinery for the human organism.[31] To achieve this sadism needs, or rather demands, a fantasy, a fiction, an elaborate story. A sexual one. A theatrical fantasy, masochism is also dramatic and formal. As Gilles Deleuze puts it, it is the "binding" action of eros, propelled by repetition, reiteration, the endless reenacting of the moment of excitation.[32] This is part of the seduction of Horn's work—a work of automatons, the organic-machinic of fantasy.

The erotic nature of such a fantasy always tells a story. And Horn's installations construct complex, elusive narratives. The motion of her installations recounts tales just as do her fictional motion pictures. Veritable tales of love, these fictions expose both the amorous desire—and its disease.

High Moon (1991) is one of Horn's lovely wounding machines, a loving-wounding fantasy. Two large glass funnels, hanging from the ceiling, are filled with a bloodlike liquid circulating into tubes. The liquid feeds two rifles that fire at each other at intervals. A tale of passion, this seductive machine enacts a love whose

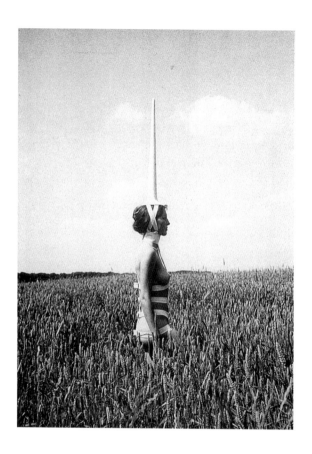

4.10

Rebecca Horn, *Unicorn* (*Einhorn*),
film still from *Performances,* 1972.
Courtesy of the artist.

4.11

Woman in prosthetic bandages, from
Joseph Marie Achille Goffres, *Manual
iconográfico de vendajes, apósitos y
aparatos* (Madrid: Librería de Miguel
Guijaro, 1864).

high voltage both feeds and wounds. A seductive torture, it is a blood (trans)fusion for lovers only.

Like many of Horn's installations, *High Moon* allows for the intersection of pleasure and pain, danger and the sensuous, and feeds a touch of evil into the automated mechanism. The mechanism inevitably attracts the spectator, though it feels dangerous to approach for fear of being wounded or sprayed. Love kills, and this murder involves all of us museum passersby, whose bodies Horn engages and constantly teases. The spectatorial body is part of the representational machine, a bride machine that, once again, writes the body, writing it into the mechanism. *High Moon* is a particular version of Horn's ink machines, one in which blood is a red ink, making its mark on the museum's wall. This is a love machine that writes with blood/ink, a bride machine that writes not only on, but with, the body.

Bandages: The Bonds of Love

The body is a terrain artists and anatomists have long shared, dwelling on its medical grounds. Traveling this route, Horn has constructed an anatomy of love. A corporeal affair, love can be measured. After all, it has a bodily temperature, is experienced as a rising fever. For such purposes, Horn offers her own *Thermomètre d'amour* (1985).

Horn's films are affected by the disease of love. Whether a bind or a bond, love is, inevitably, a sick tie. This illness is a captivating one, for one can ultimately be held captive in the room of passion, "in the realm of the senses." Love bonds are not easy to untie, for one puts oneself in the amorous straitjacket, participating in the submission, a slave to love. As we know, the bonds of love are of the same nature as the bonds of domination, and, like them, are bound by acts of complicity.[33] From the seduction between doctor and patient to the bandages of the armatured body, Horn's anatomy of love takes the shape of a bond that binds. As

one of the *Berlin Exercises*, titled *Keeping Those Legs from Touching Each Other* (1974–1975), testifies, tales of love inevitably question the bonds of love. Here, two people with their legs bandaged are filmed from the waist down. They are bound up, and bonded to each other, impeded from moving freely by the prosthetic device. Held together by magnets, they gingerly attempt to walk together in the forest of love.

The Mechanics of Fluids

While the body itself disappears from the scene in many of Horn's recent installations, the clinic of love does not. Electrified fields, Horn's interiors propagate the energy of electrifying experiences. Galvanic experiments on metonymic interiors, they always maintain a high voltage. Galvanizing in both form and matter, works like *The Hydra Forest, Performing Oscar Wilde* (1988) recall the experiments of Luigi Galvani (1737–1798), the inventor of the copper and zinc pile, and his assistant Giovanni Aldini (1762–1834). Using a Voltaic pile, they ran a current through the body, connecting the electrodes to corporeal fragments, in order to test sensibility.[34] Galvani believed that fluids accumulated in the body and that vital liquids were conducted throughout the biological machine via the nervous system, activating muscle response. By testing the automatic motion of the body, enjoyment or anguish could be physically measured. Like Horn's own, Galvani's is a sensory-activated machine, propelled by an electrical current. The artist's machine is a potentially dangerous one that can both electrify and galvanize back to life.

Different types of bodily fluids haunt Horn's scenes of dangerous liaisons. Blood, sperm, amniotic liquids—a mechanics of fluids—circulate throughout, conducted by currents. In *Missing Full Moon* (1989), Horn revived the waters of the eighteenth-century Cross Bath, in the city of Bath, pumping water through small, veinlike copper pipes. The amniotic feeling of this installation

4.12

Still from Rebecca Horn, *Keeping
Those Legs from Touching
Each Other* (*Die untreuen Beine
festhalten*), 1974–1975. Courtesy
of the artist.

4.13

Bandaged leg, from Joseph Marie
Achille Goffres, *Manual iconográfico
de vendajes, apósitos y aparatos*
(Madrid: Librería de Miguel Guijaro,
1864).

springs from the watery environment. The public bath was once a part of communal social life, the site where social habits coalesced.[35] The architecture of the bath soothed the corporeal being and was sympathetic to the leisure of bodily pleasure. Awakening the senses, the waters lulled the bather into temporary bliss. Dedicated and devoted to the body, the public bath became its architectural embodiment. A sensory experience, the bath was the locus of the body cult, its temple. Aware of this site-specific experience, Horn, in *Missing Full Moon*, transformed the bath into a body.

The Cross Bath was revitalized as if to affirm a feminine mechanics of fluids.[36] *Missing Full Moon* is a site of primordial waters and amniotic fluids. This inner sanctum, as Lynne Cooke has appropriately remarked, is an alchemic site: fusion and transmutation are dictated by the logic of alchemy, as if to emphasize the link of alchemy with obstetrics and gynecology.[37] Alchemy is present also in the film *La Ferdinanda*, in the form of the beautiful *Blue Bath* (1981), whose mysterious presence is accompanied by music and storytelling. As if affirming the hypothesis that the birthplace of the bachelor machine is the bachelor-alchemist's laboratory, Horn plays alchemic games, feminizing the bachelor science.[38] Her mechanics is a full alchemy of love: a bride alchemy, an alchemic writing of woman.

The Skin of Events

Horn's revenge of the bride assumes a female fetishistic form.[39] The most self-ironic expression of this oxymoron is contained in *The Berlin Exercises*, in the performance titled *Two Little Fish Remember a Dance* (1974–1975). To the sound of touristy exotic music, two fake goldfish, moved by rods, swim about a curious pond: a bodyscape composed of a man's bare, hairy chest. In its hilarious rendering of the (ob)scene, *Two Little Fish* performs numerous sexual twists and displacements. The male chest is so hairy

and is framed in such a way as to recall pubic hair, a joke on the pu-
bic shot of photographic and filmic pornography. The male chest
is a pub(l)ic site, in a film that is disturbingly funny, and plays as
many fetishistic games as Meret Oppenheim's fur teacup.

Hair, like feathers and fur, covers the surface of the body; it is an
extension of the skin, forming the tentacles of sensory percep-
tion. A bodily growth, it maps both erotic and aesthetic corporeal
zones. Hair is a sensitive body part, a protective and sensitive
protrusion of the skin, the very part of the body that feels pain.[40]
As hair is a corporeal form of touch, cutting it may be imagined to
elicit pain. Horn often shows touching and caressing of hair on
film, and, in *Cutting One's Hair with Two Scissors at Once* (1974–
1975), a performance in which she cut her own hair on film, she
renders a particular experience of pain. Her head is shown in
close-up—a Medusa's head—while the act of cutting the mass of
beautiful long red hair evokes the horrific experience of the
wound behind fetishism.

Fashion, a Corporeal Architecture

The diva, the fetish-object of cinema, also inhabits Horn's claus-
trophilic scene of filmic seduction. Valentina Cortese is the real
star of *La Ferdinanda*, dominating the film's erotics as both ac-
tress and character.[41] Cortese embodies the aging femme fatale,
and performs her various masquerades. A mask of femininity, the
femme fatale wears femininity itself as a mask.[42] Seductive and
dangerous, this female figure has the same destructive libidinal
force as Horn's machines. She is, in her own right, an android—a
"skin job."[43]

The seductiveness of the android, of the skin job, is tied to
fashion. Eroticism is expressed through the skin of images. It is
itself surface, cover, and clothing. Sets, like people, are equally
dressed (up). Fashion looks are the skin of imaging. The clothes of
Roberto Capucci, the most aristocratic fashion designer, as worn

4.14

Bandage intended for direct contact
with body parts in pain, from Joseph
Marie Achille Goffres, *Manual
iconográfico de vendajes, apósitos y
aparatos* (Madrid: Librería de Miguel
Guijaro, 1864).

by Cortese in Horn's films, fashion the imagistic object of desire, dressing the femme fatale. Erotic assemblages of the utmost elegance, Capucci's designs are themselves constructions. They are dwellings, and may be thought of as architecture. And as true architecture, clothes join in the design, building the erotic claustrophilia of the space, providing a corporeal mise-en-scène.

A Physiognomy of Love whereby "Entering the Rooms the Journey Deep within the Body Begins"

Touch, often represented in art as the embodiment of sight, transfers, in our mechanical age, onto the erotic surface of filmic images. A touching machine of vision, film explores the physiology of seeing with and against the body. As a sensory machine, cinema is a means to gain insight about the texture of the body. This very corporeal-architectural journey dictates the parameters of Horn's fourth feature film, an ongoing project based on her Barcelona installation *River of the Moon* (1992).

A drawing in the catalogue for the Barcelona installation maps the idea of the film. The body of a standing naked female is marked by writing: each area corresponds to a room. Here as elsewhere, Horn comments on both *soma* and *domus*, linking them in a two-way relation.[44] On the one hand, body parts are dwellings—body-rooms. On the other hand, the room becomes a body part—a prosthesis. The architecture of the room is corporeality itself. Rendering architecture as corporeal, the drawing allows the body to be read as architecture. Charted this way, the figure becomes a bodyscape. A topography. A map.

This drawing reveals a libidinal topography, a map of pleasures. The body-rooms are *stations amoureuses*, stops on a pilgrimage of passion, heart chambers. There are seven such *stanze*. And, as Horn writes, "In the seven pump stations of the heart chambers, the mercury pulses in different rhythms and flows in widely branching formations throughout the room. There is a key

4.15

Rebecca Horn, *The Raven's Twin*
(*Der Zwilling des Raben*), 1997.
Mixed media. Private collection.
Photo: Attilio Maranzano. Courtesy
of Hayward Gallery, London.

for each heart chamber, which leads to one of the seven rooms in the Hotel Peninsular. By entering the rooms, the journey deep within the body begins."[45]

In *River of the Moon*, the spectator is lured into entering the seven rooms of the Hotel Peninsular. Seduced by curiosity, one wishes to open the door of each one, as if it were a Pandora's box, to discover a secret, "to enter the sealed zone of . . . inner space."[46] By entering the rooms, the journey deep within the body begins, as one unlocks the secret of the interior.

The mystery unveiled is a narrative, for each hotel room contains a story—a posthumous story. The room houses memories of what just occurred and fantasies of what might have been. Opening the door, one detects tales of an amorous meeting or a fight. The tale takes shape, taking place for the spectator. Some incarnate evil: as one door opens, guns go off. There are abandoned objects, beds in disarray, the music of violins, cacophonous moods. Things touched, and touching. Moments lived and unlived . . . waiting. Metonymical traces of the narrative of inhabitation are suspended in space. The room is a living trace, a trace of living. A trace left behind. A relic.

A series of hotel rooms, the *stations amoureuses* are a site of passage, perhaps the very representation of passage. Housing transitory states and the site of erotic circulation, the hotel room constitutes a map of travel, a place of *transito*. It is a place where the mark of the occupant is continually erased by the next story. Yet again—and again—a tale of habitation will be inscribed on the same bed. The room, as layered as parchment, becomes a palimpsest. A superimposition of tales, the hotel room records each one of these transits as an elusive trace. A stop on a journey, the hotel room is the pause in a narrative voyage. A freeze frame.

Fantasies in a Suitcase

Stanze: fantasies of the room. Boxed in the room, in a (Pandora's) box, or in a boxed body, fantasies travel. They travel in the film machine, for cinema itself is a form of travel: a spectatorial tour through spatiotemporal densities, a journey with and through the body, a moving picture of bodies in space. No wonder Rebecca Horn makes films: spatio-corporeal surfaces, they are traveling fantasies.[47] Fantasies frozen on a strip of celluloid, permanently embalmed in time. Fantasies boxed in a can, locked in space. Fantasies one can take on a trip. Fantasies to travel with. Fantasies of travel.

Film can—the perfect suitcase.

VCU
1111 West Broad Street
Richmond, VA 23284
804-828-1678

Barnes & Noble @ VCU
804-828-1678

STORE:06200 REG:007 TRAN#:6259
CASHIER:AIJUNG K

Public Intimacy: A
TRADE
9780262524650 T
(1 @ 24.95)
20BARNES&NOBLE MEMBER 10% (2.50)
(1 @ 22.45) 22.45

Subtotal 22.45
 T1 Sales Tax (05.300%) 1.19
TOTAL 23.64
MASTERCARD 23.64
 Card# XXXXXXXXXXXXX2526
 Expdate: XX/XX
 Auth: 013100
 Entry Method: Swiped

I AGREE TO PAY ABOVE TOTAL AMOUNT
ACCORDING TO CARD ISSUER AGREEMENT

Amount Saved 2.50

V202.69 05/14/2014 12:30PM

CUSTOMER COPY

- With proof of a schedule change and original receipt, a full refund will be given in your original form of payment during the first 30 days of classes.
- No refunds on unwrapped loose leaf books or activated eBooks.
- Textbooks must be in original condition.
- No refunds or exchanges without original receipt.

GENERAL READING BOOKS, SOFTWARE, AUDIO, VIDEO & SMALL ELECTRONICS

- A full refund will be given in your original form of payment if merchandise is returned within 14 days of purchase with original receipt.
- Opened software, audio books, DVDs, CDs, music, and small electronics may not be returned. They can be exchanged for the same item if defective.
- Merchandise must be in original condition.
- No refunds or exchanges without original receipt.

ALL OTHER MERCHANDISE

- A full refund will be given in your original form of payment with original receipt.
- Without a receipt, a store credit will be issued at the current selling price.
- Cash back on merchandise credits or gift cards will not exceed $1.
- No refunds on gift cards, prepaid cards, phone cards, newspapers, or magazines.
- Merchandise must be in original condition.

Fair Pricing Policy

Barnes & Noble College Booksellers comply with local weights & measures requirements. If the price on your receipt is above the advertised or posted price, please alert a bookseller and we will gladly refund the difference.

REFUND POLICY

TEXTBOOKS:
- A full refund will be given in your original form of payment if textbooks are returned during the first week of classes with original receipt.
- With proof of a schedule change and original receipt, a full refund will be given in your original form of payment during the first 30 days of classes.
- No refunds on unwrapped loose leaf books or activated eBooks.
- Textbooks must be in original condition.
- No refunds or exchanges without original receipt.

GENERAL READING BOOKS, SOFTWARE, AUDIO, VIDEO & SMALL ELECTRONICS

- A full refund will be given in your original form of payment if merchandise is returned within 14 days of purchase with original receipt.
- Opened software, audio books, DVDs, CDs, music, and small electronics may not be returned. They can be exchanged for the same item if defective.
- Merchandise must be in original condition.

FABRICS OF TIME

5 FASHIONS OF LIVING
INTIMACY IN ART AND FILM

To live is to pass from one space to another.
—Georges Perec

A window on the architecture of living opens with a paradigmatic series of paintings and drawings made by Louise Bourgeois, beginning in the early 1940s. Called *Femme-Maison*, they represent a woman in the shape of a house. In this "architexture," the body and the house are joined in the itinerary of dwelling. In exposing this link, Bourgeois designs a haptic map of inhabitation, questioning what *domus* means for the female subject. Her work on architecture challenges the long-standing association of *domus* with gender fixity. Instead, the drawings suggest that a woman can conceive of home as something other than an enclosed, and enclosing, world. She can opt for a "traveling domestic," remapping herself in different notions of home. Here, this location is grounds of departure.

This is the retrospective voyage of a cultural hybrid. It is not by chance that Louise Bourgeois—a French artist transplanted in New York who, for fifty years, has mapped the architecture of the interior—included a map of her hometown in her autobiographical book of pictures, marking in red the itinerary of her travels

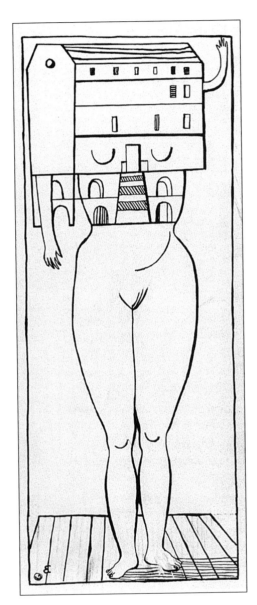

5.1

Louise Bourgeois, *Femme-Maison,*
1947. Ink on paper. Collection
of the Solomon R. Guggenheim
Museum, New York. Courtesy of the
artist and Robert Miller Gallery,
New York.

within.[1] She inscribed a journey on her map of home, using a form of cartographic representation that goes all the way back to Madeleine de Scudéry's *Carte du pays de Tendre* (1654), a map that visualized, in the form of landscape, a world of affects. An emotional journey is drawn in these maps of lived space. They show the motion of emotions that reside in-house. In this affective mapping drawn by women, home can indeed turn into a voyage.

Gender Travel

This vision of *emotion* inspires us to consider the relation of voyage and dwelling, in order to see how sexual difference can be housed differently. To look architecturally, and with geographical eyes, at the relation of private to public space can advance former notions of gender identity based on psychoanalytically oriented feminist theory. This outlook enables us to incorporate the diversity of cultural landscapes into our forms of urban dwelling. It can lead us to understand sexual difference in terms of space—as a geography of negotiated terrains. Thinking geographically, we can design different cultural maps as we venture into the terrain of an architectonics of gender—a lived space.[2]

Mobilizing gender positions requires a series of displacements. It requires undoing the fixity of binary systems that have immobilized the female subject in the domestic realm and erased her from the map of urban mobility. A problematic, recurrent critical position has made *domus* equal to domestication in the discourse on space and travel.[3] Such discourse traditionally maintains that a sense of destination is endemic to the activity of travel—a theoretical enactment of the *Odyssey*. Considering home as the origin and destination of a voyage implies, as the literary critic Georges Van Den Abbeele puts it in his book *Travel as Metaphor*, that "home [is] the very antithesis of travel."[4] Home is merely a concept, necessary to travel from or to be left behind. It exists only at the price of being lost and is perennially sought. In

this logic, voyage is circular: a false move in which the point of return circles back to the point of departure. The beginning and the end are asked to be the same destination, revealing the biological destiny behind the destination. The wish expressed is that the *oikos* be reinstated and reinforced. The anxiety of the (male) voyage is the fear that, upon return, one may not find the same home/woman/womb one has left behind. In this circular critical structure, *domus*, domesticity, and domestication are confused, and gendered feminine.

When seen as a return to the same, conceived as an enclosed departure-destination point, and gendered female, the *domus* is the womb from which one originates and to which one wishes to return. This is a psychoanalytically recurrent male fantasy, which historically returns in the travel writing and theory of (often) white males. But this circularity is a problematic notion for the (urban) *voyageuse*, who addresses origin, separation, and loss in different ways. Thinking as a *voyageuse*, then, can trigger a relation to dwelling that is much more *transito*rial than the fixity of *oikos*, and a cartography that is errant. Wandering defines this cartography, which is guided by a fundamental remapping of urban dwelling. A constant redrafting of sites, rather than the circularity of origin and return, ensures that spatial attachment does not become a desire to enclose and possess. For the *voyageuse* to exist as nomadic subject of inhabitation, a different idea of architectural voyage and different housing of gender become attractive: travel which is not separate from dwelling. As in the architectural artwork of Andrea Zittel, here too, housing turns into deterritorialization, and is replaced by *transito*—a mobile map of dwelling.

The House as Voyage

In the act of traversing visual space, a reflection on cultural journey leads us not only to a different notion of urban travel but also

to one of dwelling—one that does not exclude or marginalize the female subject. In fact, opening public space to women and re-thinking the space of the city through gender has been the focus of theoretical studies of architecture.[5] Interested in reclaiming female *flânerie*, I have myself argued for the mobilization of the female subject in the city.[6] As we traverse the urban space with re-newed eyes, and continue the itinerary of the *flâneuse*, it is now time for us to look *inside* the house of architecture as well, in order to mobilize it more intimately. This critical project involves relating space, mobility, and gender to the moving image, and mapping the *emotion* of lived space on this intersection.[7] To further displace the appropriations of voyage, the static nature of home, and its equation with the female subject's domesticity, let us move inward and explore the domestic as the place of what Elaine Scarry has called "the making and unmaking of the world."[8]

Traveling Domestic: The *House* Wife

Let us first consider the space of the house in *Craig's Wife*, a film made in 1936 by Dorothy Arzner.[9] Arzner is acknowledged as "virtually the only woman to build up a coherent body of work within the Hollywood system."[10] As a lesbian author, she has been reassessed by Judith Mayne in the context of queer theory and practice.[11]

Our first observation concerns the very title of the film. *Craig's Wife:* there is no name for the woman. Harriet Craig is defined in relation to her domestic role and by way of her husband's name. She is an upper-class housewife who, over the course of the film, will progressively come to embody a literalized definition of the term *housewife*. In a spatial way, the film offers a meditation on the relations between house and wife.

We quickly learn Harriet's ideas on wifehood and her passion-ate interest in the topos of the house when, at the beginning of the film, she reveals her unruly domestic philosophy to her newly en-gaged niece, a much more conventional woman devoted to the

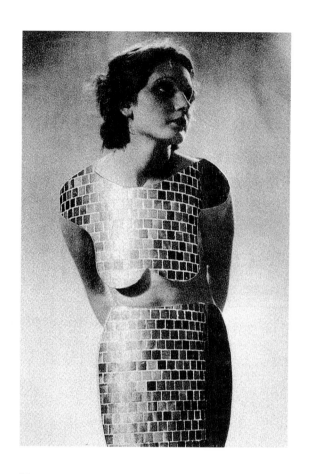

5.2

Karel Teige, *Untitled*, 1948. Collage.
Museum of Czech Literature, Prague.

ideals of marriage. The two women are seated next to each other on a train, yet are appropriately separated in the shot composition by a man in the background, whose anonymous figure acts as the shadow of male presence in their lives. Harriet explains what a house represents to her: she had no means to sustain herself; marriage had been a way to secure a house and, thus, her independence. She means independence from everybody, including her husband. She will achieve this by pursuing a further architectural plan, in which the house will provide the key to her continued independence. Harriet intends, by any means possible, to arrive at possessing—and controlling—a room of her own.

Harriet's views of home are far too scary for her niece, Ethel, who intends to conform to the script of the perfect wife. As her aunt's eyebrows rise ironically in disagreement and zipping noises from her purse voice her disapproval, Ethel's patriarchal beliefs, spoken too emphatically, become ridiculed. By way of shot composition and shot-countershot editing, Arzner offers two models to her female spectators: Ethel's passive acceptance versus Harriet's attempt to reverse the logic of patriarchy by working from within, against the grain of the system. This may have been what Arzner herself had to do, working in Hollywood as a lesbian director.

The choice between the two paradigms is actually a choice of models, cloaked in the haptic language of fashion. Arzner leads female spectators to identify with Harriet Craig by the way in which she has fashioned her transgressive subject. Her body language is irresistible. Not only is she physically more attractive than her plain niece; her demeanor and attire paint a far more seductive image. Arzner directs the course of events by accenting the sartorial difference between the two women. In this film, the position the viewer would like to occupy becomes a matter of the clothes she would like to wear. The minute you see Harriet's fabulous hat, you have no choice. Insofar as she has been made a

fashion model, Harriet, played by Rosalind Russell, is undoubtedly a role model. She transports other women into her world. For Arzner, fashion speaks, and speaks for the woman. Like the house, it is a road to the ownership of imaging.

As decor, fashion becomes embedded in architecture and in the very architectonics of the film. In *Craig's Wife*, these elements are essential. Architecture is conceived not merely as a set, nor is decor simply an object of set design. The house is the center of the film—indeed, it is the film's main protagonist. It is the core of (domestic) action and movement. In this respect, Arzner follows the path traced back in 1913 by Alice Guy in her film *A House Divided*, in which architecture is made to house, both literally and metaphorically, various forms of division, including gender division.

In *Craig's Wife*, architecture also houses the battle of the sexes: the house becomes the locus in which the relation between space and sexuality is negotiated. It is the site of an *error*, a mistake that is also a form of erring: a movement that sustains a departure from the norm. For Harriet the housewife, "house" and "wife" have been incorporated to such an extent that the wife has *become* the house. This shift is epitomized in a long shot in which Harriet Craig looks like a column as she stands in front of the staircase of her home. She has become the pillar of the house. By way of this error—a collapse of body with building—Harriet tries to twist the terms of housewife from within, bending the sense of the word to her own needs. She aims at exchanging one side, the wife, for the other, the house. Harriet proceeds to make herself suit the house. Working at gaining possession and establishing control over her house as if it were her own body, she tries to free herself from being a wife. Interestingly, the house represents her way out of domesticity and domestication. It is by way of this interior deviation that Harriet Craig embarks on the road to independence. She does not have to travel far. She travels domestic.

Harriet's fixation on the house, exhibited from the beginning, grows as the film develops, reaching paradoxical proportions. Her obsession with space is conveyed in her very first entrance into the house, after the train ride. One look suffices to establish that Harriet has fashioned her space with the same attention she has used in fashioning herself. Both body and house are styled with extreme care. For Harriet, dress and decor are germane.

Harriet has not overdone the decor of her home. By keeping it somewhat sparse she can better control her environment. As she enters the house she surveys the interior, carefully examining its configuration as if trying to chart each movement that has taken place during her absence. She is especially trying to track every possible false move that may have been made by the other inhabitants: the maids (have they broken anything?); her husband (would he have smoked indoors?); her aunt-in-law (who has the awful habit of letting those neighbors in—with offensive flowers that do not fit her aesthetic, not to mention a child!). Harriet scans the site, mapping the position of each object and piece of furniture in her space. She must spot every change that might have occurred, for nothing, and nobody, should upset the design of her interior. The mantel catches her eye. The vase. How strange it looks. It is not sitting right. An object out of place. Out of her place. This cannot be. Everything must be put back in place.

As Harriet Craig's obsession with the house intensifies, a narrative shift occurs: Craig's wife is becoming a *house*wife. Wrestling with the topos of the term, Harriet works from within its confines toward her goal of freedom. To be free, one must be free of others. She must thus free herself from the presence of others in the house. She must make room—room for herself. She needs space. A lot of it.

Little by little, by controlling all movements within the house, Harriet achieves her goal. Nobody can abide living by her spatial rules or fit into her domestic topography. Thus she manages to void it of all unwanted presence. One by one, they all leave: the

maids, her husband's aunt, and finally even her husband. Harriet can at last suit her house to herself. She has fashioned a place of her own. Having become a *house*wife, she can finally drop the wife for the house. By the end of the film, she has, *tout court*, become the house. And now the house is hers.

Unfortunately, this is not a happy ending. As Harriet Craig sits alone in her home, having conquered ownership of herself and her house (albeit at high cost), Dorothy Arzner conveys an uncanny sense of sadness. The walls appear to be closing in on Harriet, as if there were too much space and yet not enough. A house devoid of motion and with closed doors is as much a prison as the marriage it was built to contain. Harriet's plan to open up space for herself suffers from this intrinsic limitation: it stops short of circulation. Furthermore, while her transition from house*wife* to *house*wife is certainly a transgression, it is a trespass that has occurred within limits. Merely to twist the terms of a definition means still to remain within the same boundary. To wander freely while traveling domestic, the road that would explore the house as voyage must be well-traveled, and scouted with a less regimented map.

Fashioning a Mobile Home

A less regimented map may be found in the work of modern architecture. In the project of mobilizing *domus* in relation to the moving image, the writings of the architect Bruno Taut prove particularly illuminating. Taut's architecture, in fact, was important in the fashioning of gender on an interface which we can call the filmic-architectural screen. For example, in his 1924 book *Die neue Wohnung: Die Frau als Schöpferin* (The New Dwelling: Woman as Creator), Taut asserts that it is a woman's way of inhabiting space that creates and modifies architecture.[12] Her reception of space has an active role in its construction, as he shows, comparing architectural drawings to painterly renderings of interiors, thus intertwining the history of art with that of architecture.

To consider the input of the modern woman to the public making of private space is a crucial step in the mobilization of gender positions. Here, Taut makes an important contribution when he points out that architecture is made by way of using it. Speaking of women's use of architectural space as an active function, Taut touches on the birth of the female public. His architectural study programmatically addresses the new fashioning of female subjectivity as a public.

Acknowledging women's role as shapers of space, Taut speaks of mobilizing the environment. He designs a mobile home, one in which all trajectories are streamlined and rationalized to release women from domestic chores. Carefully outlining all movements that take place in the house, Taut works at making the new home an equivalent of fast, modern travel. This equation between house and travel is literally rendered in drawings that map in-house journeys. In these architectural designs, the architect charts a new home for the new woman as a transformative object. In Taut's view, modern architecture actually ends up becoming a means of transportation.

As a transitive prosthesis, this mobilized architecture is equated to another wearable art of the everyday: fashion. Speaking of the ideal form of habitation, Taut compares the house to a piece of clothing, and quite literally calls the house a woman's dress. Does this scenario expose a conflation, the suiting of house and woman? In a design that is close to the dwelling voyage of Bourgeois's *Femme-Maison*, the architect's "house dress" turns out to be a means of travel:

> [Designing] the ideal house . . . we must reach an organism that is the perfect dress, one that is to correspond to the human being in her most fertile qualities. In this respect, the house is similar to clothing and, at a certain level, is its very extension. Fertility and human creativity

5.3

An apartment plan by Bruno Taut
for *The New Dwelling: Woman as
Creator*, 1924.

reside, now as ever, in transforming things. Today, we find visible signs of these changes in all those phenomena that until recently did not even exist, that is, the industrial creations. They have already transformed our everyday life, and they will transform the house. This is evident if we observe the means of transportation, that is, cars, airplanes, motorboats, ocean liners, trains, and if we fully comprehend the extent of revolutionary inventions whose possession has become indispensable to us: things like the telegraph, the telephone, the radio message, electricity, all the applications of the motor, to which we must recently add the increased manipulation of water and wind, and the stove.[13]

In this modern physiognomy of architecture, the house travels. The modern home is fashioned as a haptic dwelling place. Considered from our angle, this mobile home resembles a movie house. It is a home of mechanical organisms and a means of transportation. This traveling home is not only a moving entity but a removable one. It is equipped with epidermic qualities. It shows its wear. It wears its history. As such an extension of skin, this (movie) house is a special dress: its fabric is a filmic fabric-ation.

Although Taut himself does not make the connection between the house and the movie house, and does not even mention the cinema among the means of transport and communication that he equates with new forms of urban domesticity, his very cinematic language triggers our comparison. The moving image suits his model. Taut's argument easily extends from the house dress to the movie house, for it touches new ways of fashioning space and new sites of mobility. A haptic component binds architecture to fashion and film. A new territorial fashion was taking place in these spaces of modernity, one that was changing socio-sexual roles. The female public of the house of moving images was indeed addressing new forms of mobile intersubjectivity.

Fragments of an Architectural Discourse

The modern shift to site-seeing includes the feminine gender: *"Now, Voyager,"* she travels in-house in forms of living that are mobile. Mobilization has to be extended from the public to the domestic realm, redrafting its private borders. In the act of exploring in this way the architectonics of home, a different, mobile mapping of urban space can be designed. A form of this architectural thinking is visualized in an *Untitled* series of paintings by Toba Khedoori, an Australian-born artist living in Los Angeles. Khedoori's large elegant paintings on waxed paper tour dwelling insistently. They depict facades of houses, cross-sections of interiors, windows, hallways, stairs, walls, doors, railings, and fences. Their subtle intervention on housing travels the architectural path of Gordon Matta-Clark and takes it into new realms, contributing moving views to the analysis of dwelling. The architectural fragments—remnants of an architectural dissection—are metonymically related to the moving image. These fragments of an architectural montage picture a sequence of film frames. Khedoori's floating world seems to suggest that a filmic, mobile map of traveling-dwelling is to be architecturally drafted.

Setting in motion a gender displacement necessitates this repositioning of "dwelling." Rather than merely addressing urban exterior, we should pay more attention to the interior. No longer the spatial antithesis of urban travel, the house, as the dwelling place of home, is to be theoretically constructed in a different way. If we roam about the house architectonically, and look at the notion of home with traveling eyes, through the lens of various filmic and visual work, we will discover its liminality. The video artist Gary Hill has conceived the house as one in a series of *Liminal Objects* (1995 onward), traversed by such lived matters as brains, which constantly change its perspective. The views of these subjects are, in turn, modified in the act of domestic traversal. Mapped as such a liminal object, the house becomes the center of our tour.

5.4

Toba Khedoori, *Untitled* (*House*),
1995. Oil and wax on paper. Detail.
Collection of Sammlung Hauser
and Wirth, Zurich. Courtesy of the
artist; Regen Projects, Los Angeles;
and David Zwirner Gallery, New York.

As we stroll around the house and refocus it, we may follow the architectural/photographic path traced by Seton Smith, a New York artist living in Paris, and question, as she does, the idea that *Five Interiors Equal Home* (1993). As Smith does in her series of photographs of *Interiors* (1993), we may wish to approach our interiors as out-of-focus spaces. In such a way, we may position ourselves on staircases, reviewing architectural fragments such as beds, cradles, and gowns, or see ourselves through a "distracted mirror" that reflects doorways. We may find ourselves on thresholds in front of oblique compositions and address mirrored mantelpieces looking up at a ceiling. We may choose to sit in skewed-cornered chairs, face reframed windows, or travel in soft focus along any of the home passages. As we shift our focus in this way onto the various forms of traveling domestically, let us direct our lens at some stories of interior design, in the vital hyphen between the architectural wall and the filmic screen.

Maps of E*motion:* A Bedroom Story

The type of dis-placement that we have theoretically evoked constitutes a terrain of artistic mapping for Guillermo Kuitca, an Argentinian artist of Russian Jewish descent, whose bedroom stories make up a fascinating, errant cartography. Kuitca travels the domain of the *Carte de Tendre*, working, delicately and sensuously, with architectural methods and geographic imagery. These include the floor plan of an apartment and maps. Kuitca's road maps, regional charts, architectural designs, urban plans, blueprints, tables, and genealogical charts radiate from Buenos Aires but speak beyond its borders. The artist has inventively charted space and reworked maps of existing cities or countries, imaginatively exploring their topography. He has also made maps of people in the form of genealogies and family trees, and charted relations and connections between human beings.

In Kuitca's work, the veinal cartographic grid is subject constantly to retraversal and internal movement. A path may be stained with paint, red as blood, as if to mark a painful passing. Names of cities from different countries may be interpolated on a single road map, creating an imaginary topography. In the fashion of a film spectator, the viewer of Kuitca's maps is asked to remake a trajectory and retrace a spatiotemporal journey. Along this route, uncanny things may happen. The name of a city may be inscribed, over and over again, on the same map. Showing how an entire world may be reduced to a single place—the site of unavoidable destiny and inevitable destination—Kuitca reveals the obsessional nature of our emotional geography.

In his mapping of history and loss, the artist travels domestically. This journey becomes a map in *Coming Home* (1989), a painting in which an apartment plan is designed to look like an airport landing strip. The domestic ground turns into a plane field. In Kuitca's work, we always land in this place of coming and going as the floor plan of what is essentially the same empty apartment is endlessly refigured. As in *House Plan with Broken Heart* (1990), *House Plan with Teardrops* (1989), or *Disposal House Plan* (1990), for Kuitca, home is an architectural landscape: a physiology mapped, traversed, and redesigned by the trajectory of emotions. Architecture incorporates and expels. It is a melancholic fragment. Kuitca's homes cry, bleed, secrete, defecate. In *Union Avenue* (1991) this inner working of urban planning is charted as an interior design. Here the lines that mark city blocks are made of forks, knives, and spoons. In such a way, the map recreates the geometry of the domestic. This is a plan of familial topographies. In his mappings, Kuitca has also used thorns and bones as the delineation of architectural edges to reveal the true perimeter of his mapping and to suggest what the border actually contains and releases.

Kuitca's architectural views map a world of daily objects. Like the passengers in the films of Michelangelo Antonioni or Chantal Akerman, in Kuitca's paintings we move between a bed and a chair. But, most of all, we travel on a mattress. Kuitca's most evocative landscapes are bedroom worldviews. These are imprinted in a number of works entitled *Untitled*, produced mostly in the early 1990s: matresses upon which road maps of Europe have been designed. In the installation *Untitled* (1993), for example, the mattress-map, repositioned sequentially in an architectural space, entices us to share a private bedroom fantasy. Lonely mattresses are scattered on the floor. The space is suspended and frozen. It is as if something has just taken place or is about to happen. No one is lying on the beds. But the maps are there to speak of a fiction—an arresting architectural tale. This is a story written on a bed, inscribed in the fabric of a room, layered on the geological strata of a used mattress, entagled in the buttons punctuating its surface. The map haunts the mattress like a stained memory. It is a residue, a trace, a living document. The mattress was a witness. It absorbed a story, some event—perhaps too many events or not quite enough of them. Now, inevitably, it recounts the tale of what was lived—or unlived—on it. Like a film, the bedroom map retains and explores folds of experience. It charts the private inner fabric of our mental landscape. The mattress-map is a complex narrative: a nocturnal chronicle, an erotic fantasy, an account of the flesh. The road map of cities designed on a bed is a chart of our phantasmatic life. It belongs to the realm of dreams and their interpretations. Reproducing the immobility that allows us to travel in the unconscious, it traces the very itinerary of our unconscious journeys. The mattress-map portrays the motion of the emotions. It is our life map. An anatomy of life, this is a relational chart. It is an inhabited vessel, with roads that are veins and places that are belly buttons. Such a map, in which land is skin, retraces the layers of people populating our

5.5

Guillermo Kuitca, *Untitled* (*Roads*),
1990. Mixed media on mattresses.
Courtesy of Sperone Westwater
Gallery, New York.

space and draws the places populating our peopled landscapes. It tells us that, in a kind of "mimicry,"[14] people themselves become places, marks and markers of our living map, just as our faces, decorated with the lines of memory, become the map of our passing—that very landscape recorded by film.

Positioned in this private architecture, Kuitca's residual cartography touches the living house of memory and dreams—the very cartographic debris that is the fabric of motion pictures. It charts the same haptic space that fashions the *emotion*al space of the moving image: a mnemonic cultural journey of genealogic measure. The filmic connection of Kuitca's cultural mapping, in fact, is made textually explicit in his work. Eisenstein's Odessa steps become the painterly scene of *El mar dulce* (1984 and 1985) and *Odessa* (1987). In *Coming* (1989), a story is mapped filmically in twelve frames, each containing a different angle of view. Somewhere in a city, there is a dining room, a bathroom, and an empty bed. While apartment views appear in axonometric projection and ground plan, a diagram of street plans and regional maps resides in other frames of the painting, (dis)locating us. The whole scene is stained by bodily fluids. Corporeal marks leave their impression in an empty, deserted bed, intractably painting a vacant apartment with the liquidity of love.

The cinematic range that exists in Kuitca's maps extends from a filmic form of storytelling to the architecture of filmic space itself. In the series of gigantic miniatures called *Tablada Suite* (1991–1993), his art of memory becomes an architecture, which takes a spectacular form: the shape of *puro teatro*. It becomes spectatorial space, a site where, quite suitably, the archive and the cemetery are placed next to other theatrical sites of recollection. As they chart in this way the geography of imaging—the site of public intimacy and collective dreaming—Kuitca's maps touch the very texture that has produced the space of the unconscious optics of film. Narrating the architecture of socio-sexual space,

the maps inhabit the same room of filmic matter. The house of moving pictures. The home of emotion pictures. Gigantic miniatures, indeed, in the collective cartography of recollection.

The Wall and the Screen

Like a film, the house tells stories of comings and goings, designing narratives that rise, build, unravel, and dissipate. In this respect, there is a tactile continuum—a haptic hyphen—between the house and the house of pictures. The white film screen is like a blank wall on which the moving pictures of a life come to be inscribed. Etched on the surface, these experiential pictures change the very texture of the wall. The white film screen can become a site of joy or a wall of tears. It can act like the wall envisaged by Ann Hamilton in her moving installation *Crying Wall* (1997). On its white surface, drops of feelings drip, seeping through, as if all bodily liquids were conjoined on the architextural surface. One can feel the pain that the surface bears. The film screen sweats it, like this artist's wall. It holds it like the house's own wall. The screen is itself a wall of emotion pictures, an assemblage of affects.

Remembered and forgotten, the stories of the house constantly unfold on the wall/screen. They are sculpted in the corporeality of architexture, exposed in the marks of duration impressed on materials, inscribed on fragments of used brick, scratched metal, or consumed wood, and, especially, in the non-spaces. They are written in the negative space of architecture, in that lacuna where the British artist Rachel Whiteread works, casting the architectural void of everyday objects, and the vacuum of the domestic space. The volumes of stories of her *House* (1993–1994) become material once exposed in a solid cast of its hollow volumetric space. They continue in the discarded *Furniture* (1992–1997) laid on the street, in the filled holes of a *Table and Chair* (1994), or the *Amber Bed* (1991). They show in the peeling wallpaper or the paint stain of the *Rooms* (1996–1998), in the unfinished or about to be

5.6

Rachel Whiteread, *House,* 1993.
London, Grove Road, back view.

demolished *Constructions* (1993–1998), in the space of the *Closet* (1988), and in another (in)visible *Untitled (Room)* (1993).

Transformed in this way, stories unfold on the surface of the wall/screen. As in Mona Hatoum's work, the surface absorbs a moving design. In the hands of this Lebanese Palestinian artist exiled in London, all marks that are made are constantly erased as if redrawn on the sand. Sometimes all that is left of the movement is a remnant—what she calls a *Short Space* (1992): hanging bed-springs, relics that speak of dislodging, the remains of diaspora.

In the hands of the Colombian artist Doris Salcedo, *La casa viuda* (I–VI, 1992–1994) becomes, through the specific and traumatic historicity of her country, an "Unland" (the title of another of her pieces, from 1997). Her series of untitled furniture pieces (1989 to 1995) testifies to a history that came to perturb an intimate geography. An armoire (*Untitled*, 1995), laden with cement, makes this visible through its glass doors. The folds of the garments that were stored there now seep through the porous texture of the cement. Held in this melancholic way, they have become further worn. By the force of this exhibition, which includes us as mourners, the work returns to us the very architexture of an intimate space, its fabric. A bed and an armoire can, indeed, be a ruin in the ruined map of one's history—that map held by the house and traversed by the cinema.

As it narrates in its own negative space diverse stories of intimacy, recording the movement of lived space, architecture adjoins film, acting as domestic witness. Both function as moving documents of our dwelling. A site of traveling-dwelling, they design our lodging in space and trace our passages in the interior. A map of cultural motion, this place of moving images is a shifting dwelling, the virtual trace of our haptic (e)motion. As in Kuitca's house plan shaped as an airport, what becomes palpable in this design is our passing—the screen of our changing spatial historicity. There is a moving house in the movie house. It shows a moving lived space.

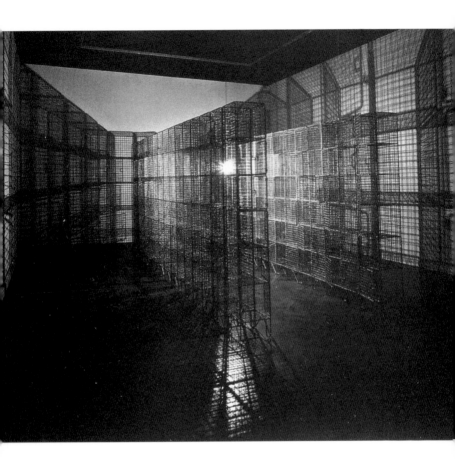

5.7

Mona Hatoum, *Light Sentence,*
1992. Photo: Edward Woodman.
Courtesy of Alexander and Bonin
Gallery, New York.

5.8

Doris Salcedo, *Untitled,* 1995.
Wood, cement, cloth, glass, and
steel. Detail. Private collection,
Rotterdam. Courtesy of
Alexander and Bonin Gallery,
New York. Photo: David Heald.

6 ARCHITECTS OF TIME
REEL DURATION FROM WARHOL TO TSAI MING-LIANG

No more actors, no more story, no more sets, which is to say that in the perfect aesthetic illusion of reality there is no more cinema.
—André Bazin

A building, seen from a window. No actors, no story, no sets. A simple location, a map of place. Still, yet moving in time. From night to daylight, architecture moves at the speed of the (every)day here. For eight hours, we watch this architectural *Empire* (1964) exist.

In Andy Warhol's famous but little-seen film, the skyscraper comes into being over the course of time, becoming an architecture of light. The effect is uncanny when the film is screened today, given the posthumous reflections cast by the World Trade Center and considering the shadows that such reflections have projected, sometimes literally, onto the architectural reconfiguration of Ground Zero. It seems even more uncanny now that a skyscraper has acquired the status of a lamp of memory by incarnating lights that are the ghosts of a building.

In Warhol's version of a building's form, made before this time, the life of the skyscraper becomes, in time, the very spirit of light. As we watch, the tectonics of building transforms into the architecture of light. The facade of the skyscraper molds into pure reflective matter. In this way, architecture and film are tangibly

connected. The two mediums meet on the grounds of their shared light texture, morphing into each other. Both are rendered as surfaces, screens—materials prone to absorb and cast back light. In this *Empire* of architecture, the skin of the building actually turns into celluloid.

A tangible film of a building emerges from the compression of urban movement into the steady rhythm of geographical tempo. In this cinematic architectonics, sensing place is achieved through the observation of time passing and the feeling of light changing. Through this phenomenological construction of a filmic architecture, a meteorology is built: architecture becomes weather report. By following so closely the passage of light between night and day, the film records the building's atmospheric life—subtle changes in the air, light particles, shifts in visibility, clouded visions, hazy contours, blur. What finally unfolds in this moving portrait of the Empire State Building is the actual rhythm of a site. The film reveals the extent to which architecture is sensible to atmosphere. In fact, it makes architecture into pure atmosphere. Such is the real spirit of Warhol's "reel time." His cultural climate is the very *Empire* of atmosphere.

Now turn from a building to a face. It is time to watch another microphysiognomy. Here is the head of a man. There is no story here either. The man is acting out an ordinary event. He is getting his *Haircut* (1963). A decent haircut cannot be cut short. No way to perform it in less than a half hour. From different angles we watch, along with other bystanders, this real cut with no reel cuts.

A man with a hat. This man acts out nothing more than a domestic routine. The set is a simple daily action, which includes a cat—no particular story. The man is just eating. To *Eat* (1963) a mushroom can take a while. We watch and ingest, consuming the film. An absorption of images, a visual feast, cinema is an oral affair.

═══

I *Kiss* (1963), you kiss, he kisses, she kisses, we kiss, you kiss, they kiss. A serial of touching images. The oral action of couples kissing is a sample of the many film portraits Warhol made: recordings of people exhibiting daily behavior, enjoying leisure inactivity or pleasure time, from smoking a cigar to having sex. They would hang out on camera until the rolls of film ran out. Shot in the manner of screen tests (a form the artist used literally, to record individual subjects' faces in close-up), Warhol's early films dwell in the atmosphere of life cycles as set in reel time.

═══

No story, no sets. Just a body and a piece of furniture couching reel/real time. To *Sleep* (1963) well, one must be engaged in the act for at least six hours. To film a man sleeping, Warhol follows this everyday rule of atmospheric time. The sleeper is relentlessly explored across the course of time—repetitive, private time. Body parts take film parts. A breathing abdomen in close-up, a body lying, the cave of an armpit, the curve of a leg, a neck's suture, a dormant face—these take up the time of sleep.

Warhol's Reel Time

"To show a man sleeping, is this a movie?" asked Jonas Mekas in 1972.[1] When even the avant-garde is puzzled enough to raise a question like this, the very nature of cinema is at stake. To ask if

6.1

Still from *Empire* (1964) by
Andy Warhol. 16 mm film, b/w, silent,
8 hours, 5 minutes. Reel 1: July 25,
1965, at approximately 8:13 pm.
© 2004 The Andy Warhol Museum,
Pittsburgh, a museum of the
Carnegie Institute.

6.2

Still from *Empire* (1964) by
Andy Warhol. 16 mm film, b/w, silent,
8 hours, 5 minutes. Reel 1: July 25,
1965, at approximately 8:24 pm.
© 2004 The Andy Warhol Museum,
Pittsburgh, a museum of the
Carnegie Institute.

Warhol's *Sleep* is a movie is implicitly to pose André Bazin's question, "What Is Cinema?" It means calling into question what the medium of film does, especially in relation to time, subjectivity, and space. Indeed, Warhol's films question the workings of cinema in these arenas. They are films that reidentify cinema in a manner that approaches the space of today's moving-image installations. They reconfigure a spectatorial protocol: the films yield to viewers' walking around and talking in the theater; they encourage spacing out. Hyperrealist wanderings themselves, they tell us about the "zero degree" of film.

To approach the zero degree of cinema according to Warhol, a useful beginning is with Bazin. Bazin claimed that the invention of cinema arose from the techniques of observation of the nineteenth century, a time obsessed with the mechanical reproduction of the real. This obsession turned into early film's reel time and returned, transformed, at different moments of film history, eventually shaping the postwar aesthetic of neorealism.

Without the teleological bent, the outlines of Warhol's cinematic opus can be read as a movement from "primitive cinema" to Hollywood's modes of representation, for his film work retraces the very course of cinema's history.[2] Reproductive, as was his art work, it is an actual remake of film history. Warhol began by shooting silent black-and-white films that remake silent cinema, and then moved toward stargazing.[3] The reinvention of the language of motion pictures in his early films reproduces early cinema's interest in daily life. Even literally: *Kiss*, Warhol's first released film, treats the subject and even bears the same title of an 1896 Edison short.

Although often engaging sexuality, even when the object is simply a skyscraper occupying erect space, Warhol's peeking at the real is not really a form of voyeurism. His films do take a look, and certainly corporeally expose.[4] The pleasure they offer, however, does not involve peeking at unaware subjects, but rather watching and experiencing diffraction. Warhol's early films provide the

pleasure of peeking into the gap—and exhibiting the suture—between the real and the reel, between real time and reel time. Shot at twenty-four frames per second and projected at sixteen (the speed of silent film), these films are not a matter-of-fact reproduction of the real. They are cinematic meditations on real matters. Real performances, they look at how reality itself matters.

It is for this reason that Bazin's writings on neorealism, an extract from which is offered at the opening of this inquiry, become particularly pertinent in examining Warhol's reel/real time and space. Although Bazin was not writing about *Empire*—a vertical story of nothing but "light" urban architectures—he defined the zero degree of cinema by thinking architecturally. Writing about *Bicycle Thieves* (1949), a film shot on location in an urban setting, he recognized it as nothing but "the story of a walk through Rome."[5] In this way, Bazin arrived at defining an architectonics of location as the reel time of space.

Following this logic of urban reelism, the experimental film *Empire* paradoxically turns out to be one of the most realistic films ever made. Its realism abides in the space of its duration, in the sustained exploration of an architectural atmosphere. It resides in the exhibition of nothing but the span of architectural time and the time of architectural space. In this rhythmic observational sense, this is, indeed, an atmosphere film.

As Warhol once said: "When you just sit and look out the window, that's enjoyable. It takes up time. . . . If you're not looking out of a window, you're sitting in a shop looking at the street. My films are just a way of taking up time."[6] This statement, among others, gives us room to read Warhol's early cinema as exhibiting an aesthetic of boredom. Indeed, Warhol can be seen as practicing a type of boredom theory and, in such a way, translating into cinema an aspect of the discourse of modernity—a discourse in which boredom abides alongside distraction and shock. But if Warhol's work, broadly understood, engages boredom, it does so

6.3

Still from *Empire* (1964) by
Andy Warhol. 16 mm film, b/w, silent,
8 hours, 5 minutes. Reel 1: July 25,
1965, at approximately 8:30 pm.
© 2004 The Andy Warhol Museum,
Pittsburgh, a museum of the
Carnegie Institute.

6.4

Still from *Empire* (1964) by
Andy Warhol. 16 mm film, b/w, silent,
8 hours, 5 minutes. Reel 1: July 25,
1965, at approximately 8:35 pm.
© 2004 The Andy Warhol Museum,
Pittsburgh, a museum of the
Carnegie Institute.

in a complex way—as a tempo in the larger context of an exploration of modern forms of subjectivity. Modernity's exploration involved a spatialization—the journey through time. Picturing the body's temporality and architectural duration, Warhol's film work expanded a modern(ist) filmic zone. His films signaled the rise of a late modernist aesthetics, characterized in the cinema by a preoccupation with duration.

Duration, a Modern Geology

Pausing to grasp this movement of atmospheric duration, let us reread Warhol's statement—"My films are just a way of *taking up time*"—and think again of *Empire*. You sit and look out the window. That's enjoyable. If you are not looking out the window, you are sitting at street level, looking at the street. Warhol's urban take recalls an urban tale, a passage in Henri Lefebvre's *Writings on Cities*, in which, to introduce the notion of "rhythmanalysis," the author tells himself: "I must write: 'Seen from my windows overlooking a big intersection in Paris, therefore onto the street.'"[7]

As in Lefebvre's own rhythmanalysis, a film like *Empire* engages the production of daily urban rhythms. It opens a filmic window onto architectural space and its existence in time. Filmically exploring architectural duration alongside the time of sleeping, eating, kissing, or getting a haircut, Warhol's early cinema touches on the very mechanism of the time and space of the everyday. It furthermore engages the practice of everyday life and its production of space. Taking on the time of sex, food, or architecture, Warhol's films take up a haptic landscape. Here, the atmosphere of dailiness is a space of incorporation.

This absorption of images involves a time that is spatialized. The eight hours of *Empire* render the time of architecture as the space of history. A building is planted in a city. It is immobile, yet in the course of a day it becomes a vehicle for many motions. It holds the motion of time and the passing of people. Day after day,

a building lives this way, atmospherically. As darkness turns to light, the building, withstanding time, stands there. As times go by, it is inhabited, eroded, traversed, negotiated, navigated.

Like the sea, architecture transports. And like an ocean, it inhabits duration. It abides the time of history that modern historians interested in space, such as Fernand Braudel, call the *longue durée*. Duration—the time span that was once proper to geology and a property of landscape—now transfers to architecture. The architectural landscape is the geology of modern life. The depth of the terrain reveals strata of urban planning and artifacts of their ruin. The cityscape is our horizon line. Skyscrapers are the mountains of cities. Watching them *be*, simply exist, in space and time, as in Warhol's *Empire*, is to experience the expanse of geological time—an earthly lingering.

As we look at *Empire* and think of architecture as the place where bodies *Sleep*, we approach the ticking of biological clocks. This cinema lets us meditate on the time of the body. It gets us close to interior time. Slow motion finally reveals an interior landscape. This landscape emerges, right in the midst of New York City, if one just sits (in a movie theater) and watches (a building), letting one's self be transported by the atmosphere of either.

The Atmosphere of *Temps Mort*

Unlike early modernism, which was more interested in speed, velocity, and acceleration, the late modernism that emerged in the postwar period conceived of modernity as inhabiting different, extended temporal zones, and it set out to explore this new shape of modern times. Broadening, expanding, fragmenting, layering, exploring, rethinking time marked a new international filmic movement. As an architectonics of duration, Warhol's early cinema was in tune with its time and joined with filmmaking practices involved, in different ways, in developing the rhythm of late modern(ist) cinematics.

Among the most prominent artists to experiment with these practices—at the time when Warhol was creating *Empire* and *Sleep*—was the architectural filmmaker Michelangelo Antonioni, who was articulating modernist filmic space by dwelling on the architectonics of time. In his modernist view, reel time became something other than the abridged, compressed, sped-up time of conventional cinema. His cinema privileged description over plot, fashioning a filmic *nouveau roman.* It was an aesthetic of *temps mort,* absorbed in framing and mapping (interior) landscapes, and drawn to the time of non-action, a time when actors stop acting and space tells its story. Journeying in postdiegetic space—that is, dwelling on the time after characters have left the scene, lingering on that space, navigating the leftovers of time, exploring the slow motion of an architectural everyday—Antonioni, in a way, joined in Warhol's interest in the profilmic, reaching for a zero degree of cinema.

The redesign of reel/real time in the modernist cinema that emerged around Warhol opened the road to a new geography, one which included new maps of gender space. As modernist aesthetics peered at new temporalities and the time of everyday life, there arose a questioning of the gendered realm of lived space and lived time. Chantal Akerman's exquisitely minimalist long take, in particular, began calling modernist duration to real task. Repetition, private time, the unfolding of ordinary temporalities, the rhythm of the everyday, the time when seemingly nothing goes on—all this has been radically called into question as a corporeal texture of woman's time in Akerman's work.

Today, such modern architectural ruminations are reemerging in a series of urban images from the East. Perhaps the most direct heir of the architectonics of duration is the Malaysian-born, Taiwan-based filmmaker Tsai Ming-liang. He, too, works in reel time as he reengages Chantal Akerman's early filmic strategies and picks up exactly where Michelangelo Antonioni's left off.

There is a relevant formal relation between Akerman's "domestic" films and Tsai's interiors, and both are rigorous filmmakers whose style is relentlessly challenging. They use contemplative compositions characterized by long takes, which are fixed.

Like Akerman and Antonioni, Tsai dwells in the space of observation with a resolute fixation on staying and lingering within the frame. Working slowly, from inside out, Tsai's films take time to make incisive portraits of the urban condition and its affective discontents, with a minimalist architectural framing exposing the very architecture of time. As in Antonioni's own rendering of urban disquiet and amorous malaise, the camera stays with a space for a long period, as if to draw us in and absorb us, enveloping us within a frame that is a frame of mind. This type of cinema resides inside a mental space, which is an architecture of interiors. In fact, it shows that the rhythm of the city coincides with that of a person's own internal clock. Ultimately, the setting here is the internal rhythm of urban life, for the city is seen through an inner eye. This cinema represents place, minimally, as a subjective space, a mental state—an atmosphere.

An empty apartment. A bed. A bathtub. There is little else here, but a story develops out of this void. The apartment is for sale. This lifeless space becomes casually inhabited by three lonely people: a real-estate agent, her accidental lover, and someone who steals the key to the place to kill himself there quietly. No one moves into the empty apartment, but all use it as a way to be with themselves or attempt an encounter. In shot after shot, we watch this empty place simply *be*, observe it being transformed, and see it failing to become the catalyst for a relational connection. There is irony in the film and its title, *Vive l'Amour* (1994), for love cannot be found anywhere near the place. Finally exiting the apartment, without resolution, we walk with the real-estate agent to a city park. There she sits, for a long time, crying. After a while she stops weeping. But then she cries some more. In this memorable

6.5

Tsai Ming-liang,
What Time Is It There? (2001).
Courtesy of the artist.

sequence of internal rain, which turns sadness into smile, the camera, as always, simply watches, at once impassive and compassionate, until the end.

In this architectonics of time we are neither voyeurs nor detectives who spy on characters. By virtue of the camera position, which refuses to move with the characters and rolls independently, remaining steady in time, we cannot pry. We are simply there. Witnesses, we are made to exist in the space. We are asked to stay overtime. This "being there" enables us to make a psychic leap and go beyond mere attendance toward a more intimate involvement. Reaching for a closer spectatorial position, we can stay there to take part in a scene, becoming participants. As an affective atmosphere unfolds in slow time-space, we can let ourselves slide in. We can take in what is in the air and partake in a mood. In this moody way, affects turn around. We become mourners, lovers, eaters, sleepers.

Another person is sitting at a table, eating. A daily routine. No particular story. It takes him a while to eat. As we watch, we ingest as well. When the man dies, we continue to sit at the table with his wife and son, who try to digest this death. Time is the only way to deal with passing. Time passing, in fact, becomes the very question in Tsai's *What Time Is It There?* (2001). While the mother awaits the reincarnation of her husband's soul, the son finds a different temporal strategy to deal with matters of life and death.

A seller of cheap watches on a skyway in Taipei, he becomes obsessed with time. A casual meeting with a young woman who buys his watch en route to Paris sets off in him the wish to live differently—in her time. Perhaps in an attempt to get closer to her, he proceeds to change the time of every clock he sells and encounters in the city of Taipei, adjusting them to Paris time. As he travels the city to change the time, moving from the clock atop a skyscraper down into the computerized time that runs the city's

6.6

Tsai Ming-liang, *What Time Is It There?*
(2001). Courtesy of the Taipei Cultural
Center, New York.

subway, Taipei turns into Paris. Meanwhile, she melancholically travels *la ville lumière*. The film proceeds in parallel montage. The two never meet or cross paths again. They simply become connected in this virtual time zone.

In the end, everyone in this film is bound to inhabit his or her own time, while dreaming of sharing it. Such is the time of urban loneliness, which is given room here: the time one spends with oneself; the time of retreat, withdrawal, seclusion, or hibernation; the time of nonaction. A *temps mort*. It is the leftovers of time, recaptured to feed the self. Morsels of time extended, even wasted, squandered, dissipated, used up. The time of luxuriating in time. The time of reflection, stolen away from pressure. That private time, reclaimed from functionality. The place where so often fears, anxiety, melancholia, and desire settle in. In other words, inner time.

In Tsai's interior films we watch characters carry out elaborate private rituals. Everything one does with oneself in one's own time is the real focus of Tsai's cinema. This includes the display of bodily functions, sleeping or being unable to sleep, finding a way to take a leak without having to walk to the bathroom. All matters of eating, sleeping, kissing unravel in reel time here, and often in the same place.

In fact, in an architectural ritual, Tsai often uses the same apartment as his location for different films, and thus these daily actions are positioned for us in a home that becomes familiar. In most of his films he also uses the same nonprofessional actor, Lee Kang-sheng, whom he discovered in a video arcade and who inhabits, not acts, his characters. Hence mother, father, son, and the apartment (fish tank included) travel from film to film, enabling us to follow a private routine and take part in a private life that is always architecturally bound. Emotions are given a real place here. The stories are written on the walls of the apartment.

6.7

Tsai Ming-liang, *The Skywalk Is Gone*
(2002). Courtesy of the Taipei Cultural
Center, New York.

The films build on the feeling of the place. We get to know and recognize the atmosphere. We sense the mood changing. It breathes out from the walls and leaks down through the pipes.

In fact, it all starts with a leak. There is a gaping *Hole* (1998), and for Tsai this is a sensational subject for a movie. As the title suggests, here we have a film about a void: nothing but a hole; the hole is it. The film dwells in hollow space, and in this way it tackles a very architectural issue. It explores architecture's generative void. This is a cinema that dares to look at architecture at its zero degree and builds stories out of its bare bone.

The leak sets the film in motion. It always rains in Tsai's films, whether from the inside or the outside. A corporeal rain is present in the seepage of our plumbing or in our tears. As the filmmaker said, "Water is like love, we all need it but do not know what to do with it."[8] As in real life, in this reel life things always leak. Holes are always there. One can never really fill them in and perhaps should not even try, for one never knows what's actually hidden in a hole.

Here, the hole works its magic. Left by a plumber who has tried to fix a leak in the apartment after an interminable rain, the hole becomes the character of the film. This hole, an empty space, becomes filled with wonderful stories. It also becomes pregnant with gags. Tsai uses reel time the way Jacques Tati did in his urban critiques and architectural mediations. As in Tativille, the slow, silent observation of architectural space enables us to see the ironies of life. Here, the hole enables characters to overcome the emptiness of loneliness. It creates a connection between the inhabitants of two apartments, above and below. The leak-turned-hole takes up room and makes room. The hollow becomes an actual space. There is even holiness to this hole. A hole is, after all, literally and metaphorically many things: crater, cavity, pit, shaft, pocket, interval, intermission, indentation. In the end, it can even turn into a real opening.

Architecture and Film at Ground Zero

What emerges from this attachment to the space of nothingness and void is a cinema that is pure spatial meditation—a cinema of atmospheric moods. We can see how this relates to *Empire*, with its own architectural unfolding in time. In a way, speaking of *Empire* is a way to engage the wide-ranging development of a filmic-architectural minimalism of atmosphere: no acting, but space acting out; no sets, but locations unraveling in reel time. Real stories of place. This is the ground zero of filmic architectures. In this aesthetic zone, as we have traversed it in time, the zero degree of cinema is the zero degree of architecture.

To dwell in this zero degree exposes a transition revealing the moment of film's own emergence and extinction. In this respect, watching *Empire* is a spectatorial experience that engages film space in the transient manner of Hiroshi Sugimoto's film *Theaters*—pictures that render film as light architecture.[9] These pictures are conceived at the crossroads between modernity's extended temporality and a Buddhist sense of time.[10] In his photographic journey, Sugimoto also travels in a phenomenological, atmospheric terrain.

Sugimoto achieves duration by adjusting the exposure time of his photographs to the length of a feature film that is projected in the theater he is depicting. The effect is that the film itself disappears from view, leaving only the image of a white film screen. But something else becomes visible: the architecture of cinema is exposed. Neither shown nor show, the filmic text ends up shaping a picturing of cinema. A blaze of light emerges from the screen, casting an eye on the interior space of the theater. As pure screen, cinema shows its atmospheric texture and durational substance. This reel time constructs film's real visual space—a spatialized time. No more actors, no more stories, no more sets, no more cinema. The zero degree of cinema is the temporal space of moviegoing—a geography that takes place in the architecture of the

6.8

Tsai Ming-liang, *The Skywalk Is Gone*
(2002). Courtesy of the Taipei Cultural
Center, New York.

movie house. Cinema is a house: a home of voyages, an architecture of the interior, it is a map of shifting atmospheres.

Representing cinema at the moment of generative extinction, Sugimoto casts it as a morbid space and links it to other modern heterotopias of this kind. On the map of modernity's time zone, Sugimoto's sea of film images adjoins his images of wax museums and the natural history view of his dioramas. Looking at his photographic series as interconnected, the geological time of history is exposed. Moving with times of *longue durée*, Sugimoto's series render the geography through which corporeal stories are told—a transient, floating world of ruination. This is a meditation on modernity and its ruins, a place of "accelerated decrepitude," as *Blade Runner* describes it. In such a way, Sugimoto's morbid physicality and duration engage modernity's speed. Incorporating the very speed of cinema in a rendering of ruination—indeed, making it the very exposure of such a state—Sugimoto's architectonics join Warhol's atmospheric reel film of *Empire* on the very space of modern representation and its ruins.

East Meets West

What is at stake in charting these meditative relations is the construction of a genealogy, built around the *Empire* of atmosphere. Speaking of Warhol's reel time, and then considering a series of still lives touching on Akerman, Antonioni, Tati, Tsai Ming-liang, and Sugimoto, means drafting a set of spatiotemporal connections on the late modern(ist) map rather than proposing a series of influences. Warhol is the preface, for he was a symptom—the expression of a cultural movement, a figure able to cathect the cultural energy, or atmosphere, of a time.

Just as Warhol was a master of appropriation, so in turn he has been appropriated, even indirectly. His strategies of taking up time are transposed into other film work and even transferred into other visual forms. Warhol's *Sleep* is a case in point, for it has

been reawakened in different fashions. The time of *Sleep* has reappeared in an aesthetic of duration in different forms. If the extended duration of Warhol's early cinema is read as an aesthetic weightlessness, and his minimized sensory output is perceived as the creation of a spectatorial bliss or trance, then Buddhist-informed returns can be expected.[11] "Sleepers," however transformed, have imaginatively returned in this way, from the East, in the work of video artist Bill Viola. The form of video installation—a spatio-visual technology of present duration—has given Viola the opportunity to restage the present tense of *Sleep*. Warhol's "time exposed" becomes Viola's *The Sleep of Reason* (1988). *The Sleepers* (1992) now lie in barrels of steel filled with water; they repose in monitors, casting a bluish light that illuminates space. While electronic signboards broadcast news reports outside, we step into an entryway, thirty years later, and again face a Warholian sleeper, featured in large projection, resting in a dark room permeated only by the silence of sleeping noises. In this video passage to inner life, *Sleep* becomes a *Threshold* (1992).

Time to Let It Be

In many ways, the sixties and seventies have returned—have come back into fashion. Warhol, master of all trends, guides the reconsideration of an era. Retrospectives continually resurface on the cultural horizon. On such occasions, one hopes that remembering a trend of the sixties may become a real reawakening. Indeed, the sixties' modernist aesthetic was, among other things, a political trend. It was a radical refashioning of a politics of time. In an era of reality bytes, a time of pressure and managerial efficiency where speed and simultaneity do not even allow for accelerated decrepitude, a time when the Taylorization of creativity is biting us up and beating us down, Warhol's early films yet again have something creative to say. They are there to remind us of an

important aspect of modernity and modernist aesthetics: a radical temporal refashioning of subjectivity. A politics of time means giving space to time. Make room. Look out the window. Look onto the street. Space out. Watch a building be. Take the time to eat your lunch. Take up time. Get a haircut. Take your time. Massage your soul. Sleep. Dream something up. Revel in this mood. Get lost in the empire of atmosphere. As in the unconscious, something always happens when nothing does.

NOTES

FOREWORD

1. Jacques Lacan, *The Ethics of Psychoanalysis, 1959–1960*, translated and with notes by Dennis Porter (New York: Norton, 1992), 135–136.

CHAPTER ONE

This text was published in *Camera Obscura, Camera Lucida*, ed. Richard Allen and Malcolm Turvey (Amsterdam: Amsterdam University Press, 2003).

1. Hugo Münsterberg, *The Film: A Psychological Study: The Silent Photoplay in 1916* (New York: Dover, 1970).

2. Ibid., 41.

3. See, for example, Kyanston McShine, ed., *The Museum as Muse: Artists Reflect* (New York: Museum of Modern Art, 1999), and Ingrid Schaffner and Matthias Winzen, eds., *Deep Storage: Collecting, Storing, and Archiving in Art* (New York: Prestel, 1998).

4. See, among others, Reesa Greenberg, Bruce W. Ferguson, and Sandy Nairne, eds., *Thinking about Exhibitions* (New York: Routledge, 1996); *The End(s) of the Museum* (Barcelona: Fundació Antoni Tàpies, 1996); Lynne Cooke and Peter Wollen, eds., *Visual Display: Culture Beyond Appearances* (Seattle: Bay Press, 1995); Tony Bennett, *The Birth of the Museum* (London: Routledge, 1995); Daniel J. Scherman and Irit Rogoff, eds., *Museum Culture: Histories, Discourses, Spectacles* (Minneapolis: University of Minnesota Press, 1994); Susan M. Pearce, *Museums, Objects and Collections: A Cultural Study* (Leicester, England: Leicester University, 1992); Eilean Hooper-Greenhill, *Museums and the Shaping of Knowledge* (New York: Routledge, 1992); and Ivan Karp and Steven D. Lavine, eds., *Exhibiting Cultures: The Poetics and Politics of Museum Display* (Washington, D.C.: Smithsonian Institution Press, 1991).

5. This work seeks to pursue the interdisciplinary study of art and film, both of which are lifelong passions of Annette Michelson, to whom this essay is dedicated. On art and film, and their function as cognitive instruments, see her *On the Eve of the*

Future (Cambridge: MIT Press, forthcoming). For the study of art and film, see also Peter Wollen, *Raiding the Icebox: Reflections on Twentieth-Century Culture* (Bloomington: Indiana University Press, 1993), and Anne Hollander, *Moving Pictures* (Cambridge: Harvard University Press, 1991).

6. Lewis Mumford, "The Death of the Monument," in *Circle: International Survey of Constructivist Art*, ed. J. L. Martin, Ben Nicholson, and N. Gabo (New York: E. Weyhe, 1937), 267.

7. André Bazin, *What Is Cinema*, ed. and trans. Hugh Gray (Berkeley: University of California Press, 1967), 9–10.

8. There are obvious and established institutional differences between the gallery and the museum that are not discussed here. It is important to note, however, that in terms of modes of display, curatorial strategies, and the amount of space offered to contemporary art, the distance between the two has diminished in the United States. Here, young artists move easily and quickly between gallery and museum exhibitions, many intersecting and hybrid exhibition spaces have been created, and alliances between all of these have taken place. These reasons partially excuse an excursus that combines the two discourses without delving into their differences.

9. On this work, see the exhibition catalogue *Bordering on Fiction: Chantal Akerman's "D'Est"* (Minneapolis: Walker Art Center, 1995). The exhibition originated at the Walker Art Center in Minneapolis and was on view at the Jewish Museum in New York, 23 February–27 May 1997.

10. Peter Greenaway, *The Stairs 2: Munich, Projection* (London: Merrell Holberton, 1995), 24.

11. Julien's *Vagabondia* explores re-collection in London's Sir John Soane Museum, home of the architect Sir John Soane (1753–1837), and was first shown there in the exhibition "Retrace Your Steps: Remember Tomorrow." It was shown at the MIT List Visual Arts Center in Cambridge, Massachusetts, 22 April–1 July 2001.

12. On this film, see Robert Beck, "Paranoia by the Dashboard Light: Sophie Calle's and Gregory Shephard's *Double Blind*," *Parkett*, no. 36 (1993): esp. 109.

13. Larry Clark directed *Kids* (1995); Robert Longo directed *Johnny Mnemonic* (1995); David Salle directed *Search and Destroy* (1995); Julian Schnabel directed *Basquiat* (1996) and *Before Night Falls* (2001); and Cindy Sherman directed *Office Killer* (1997). On artists making films, see Thyrza Nichols Goodeve, "Fade to Blue," *Guggenheim Magazine*, no. 10 (Spring 1997): 40–47.

14. On Horn's film and installation work see Giuliana Bruno, "Interiors: Anatomies of the Bride Machine," in *Rebecca Horn* (New York: Guggenheim Museum, 1993), with complete filmography and bibliography.

15. On one of the films of the *Cremaster* cycle, see Matthew Barney, *Cremaster 5* (New York: Barbara Gladstone Gallery, 1997 [exhibition catalogue]). Other work in the series includes *Cremaster 1* (1995), *Cremaster 4* (1994), *Cremaster 2* (1999), and *Cremaster 3* (2002). For a critical reading of the series, see Norman Bryson, "Matthew Barney's Gonadotrophic Cavalcade," *Parkett*, no. 45 (1995): 28–41.

16. On Jacob's work see Bart Testa, *Back and Forth: Early Cinema and the Avant-Garde* (Toronto: Art Gallery of Ontario, 1993 [exhibition catalogue]) and William C. Wees, *Recycled Images: The Art and Politics of Found Footage Films* (New York: Anthology Film Archives, 1993). On Conner, see *Bruce Conner: Sculpture/Assemblages/Drawings/Films* (Waltham, Mass.: Rose Art Museum, Brandeis University, 1965 [exhibition catalogue]); Anthony Reveaux, *Bruce Conner* (Minneapolis: Walker Art Center, and St. Paul: Film in the Cities, 1981); and Leger Grindon, "Significance Reexamined: A Report on Bruce Conner," *Post Script: Essays in Film and the Humanities* 4, no. 2 (Winter 1985): 32–44.

17. On Douglas's work see, among others, Daniel Birnbaum, "Daily Double: The Art of Stan Douglas," *Artforum International* 38, no. 5 (January 2000): 90–95; Daina Aligaitis, ed., *Stan Douglas* (Vancouver: Vancouver Art Gallery, 1999 [exhibition catalogue]); Scott Watson, Diana Thater, and Carol J. Clover, *Stan Douglas* (London: Phaidon, 1998); Bill Horrigan, "Taxing Memories," *Art & Text* 60 (February–April 1998): 72–77; *Stan Douglas* (Paris: Centre Georges Pompidou, 1993 [exhibition catalogue]); and *Stan Douglas: Monodramas and Loops* (Vancouver: UBC Fine Arts Gallery, 1992 [exhibition catalogue]).

18. Kerry Brougher, "Hall of Mirrors," in *Art and Film since 1945: Hall of Mirrors*, ed. Russell Ferguson (New York: Monacelli Press, and Los Angeles: Museum of Contemporary Art, 1996), 137. On this subject, see also *A. D. Art and Design*, special issue "Art and Film," no. 49 (1996).

19. "Spellbound: Art and Film" was held in London at the Hayward Gallery, February 1996. See Philip Dodd and Ian Christie, eds., *Spellbound: Art and Film* (London: British Film Institute and Hayward Gallery, 1996 [exhibition catalogue]).

20. *Silent Movie* was commissioned for cinema's centennial celebration by the Wexner Center for the Arts in Columbus, Ohio. It was subsequently shown at

the Museum of Modern Art, in New York, as part of the show "Video Spaces: Eight Installations," 22 June–12 September 1995. See *Chris Marker: Silent Movie* (Columbus, Ohio: Wexner Center for the Arts, 1995 [exhibition catalogue]) and Molly Nesbit, "Chris Marker (*Silent Movie*)," *Artforum International* 34 (April 1996): 96–97.

21. On Gordon's work see, among others, Douglas Gordon, *Douglas Gordon: Blackspot* (Liverpool: Tate Publishing, 2000); Stan Douglas, *Double Vision: Stan Douglas and Douglas Gordon* (New York: Dia Center for the Arts, 2000 [exhibition catalogue]); Amy Taubin, "Douglas Gordon," in Dodd and Christie, eds., *Spellbound*; Michael Newman, "Beyond the Lost Object: From Sculpture to Film and Video," *Art Press*, no. 202 (May 1995): 45–50; and Andrew Renton, "24 Hour Psycho," *Flash Art* 26, no. 172 (November–December 1993).

22. For an analysis of this film in the context of a theorization of filmic *flânerie*, see Giuliana Bruno, *Streetwalking on a Ruined Map* (Princeton: Princeton University Press, 1993), especially chapters 4 and 15. Since the print of *La neuropatologia* preserved at the film archive of the Museo del Cinema in Turin is too damaged to circulate, I was glad to see a museum space provide a public "archival" offering when *Hysterical* was presented as part of an exhibition associated with the Hugo Boss Prize 1998, at the Guggenheim Museum Soho, 24 June–20 September 1998, and was the prize winner.

23. Mario Dall'Olio, "La neuropatologia al cinematografo," *La Gazzetta di Torino*, Turin, 18 February 1908.

24. On the moving images placed on revolving wheels by the Catalan poet and mystic Ramon Lull, see Frances A. Yates, *The Art of Memory* (Chicago: University of Chicago Press, 1966), especially chapter 8; and Paolo Rossi, *Clavis Universalis: Arti mnemoniche e logica combinatoria da Lullo a Leibniz* (Milan: Riccardi, 1960).

25. See Rosanna Albertini's interview with the artist in "Bill Viola: the Dividing Line," *Art Press*, no. 233 (March 1998): 20–25; and *Bill Viola* (Paris: Flammarion, and New York: Whitney Museum of American Art, 1998 [exhibition catalogue]).

26. On Neshat's installations see, among others, Bill Horrigan, "A Double Tour," in *Shirin Neshat: Two Installations* (Columbus: Wexner Center for the Arts and Ohio State University, 2000 [exhibition catalogue]); Arthur Danto, "Pas de Deux, en Masse, Shirin Neshat's *Rapture*," *Nation*, 28 June 1999, 33–36; and Leslie Cahmi, "Lifting the Veil," *Art News* 99, no. 2 (February 2000): 148–151.

27. On filmic site-seeing, see Giuliana Bruno, "Site-Seeing: Architecture and the Moving Image," *Wide Angle* 19, no. 4 (October 1997): 8–24.

28. The museographic archaelogy of cinema and cinematic affective transport are treated further in my *Atlas of Emotion: Journeys in Art, Architecture, and Film* (New York: Verso, 2002).

29. On this exhibitionary culture, see Patricia Mainardi, *The End of the Salon: Art and the State in the Early Third Republic* (New York: Cambridge University Press, 1993).

30. Sergei M. Eisenstein, "Montage and Architecture" (c. 1937), with an introduction by Yve-Alain Bois, *Assemblage*, no. 10 (1989): 111–131.

31. Ibid., 116.

32. Eisenstein, "El Greco y el cine" (1937–1941), in *Cinématisme: Peinture et cinéma*, ed. François Albera, trans. Anne Zouboff (Brussels: Editions complexe, 1980), 16–17.

33. Marcus Tullius Cicero's version of the art of memory is outlined in his *De oratore*, trans. E. W. Sutton and Harris Rackman (London: Loeb Classical Library, 1942). Marcus Fabius Quintilianus's rendition of the subject is laid out in his *Institutio oratoria*, vol. 4, trans. H. E. Butler (New York: G. P. Putnam's Sons, 1922).

34. Quintilian, *Institutio oratoria*, vol. 4: 221–223.

35. See Yates, *The Art of Memory*; and Yates, "Architecture and the Art of Memory," *Architectural Design* 38, no. 12 (December 1968): 573–578.

36. See Plato, *Theaetetus*, trans. Harold N. Fowler (London: Loeb Classical Library, 1921), and Sigmund Freud, "A Note on the Mystic Writing Pad," in *Complete Psychological Works*, vol. 9 (London: Hogarth Press, 1956).

37. Raúl Ruiz, "Miroirs du cinéma," *Parachute*, no. 67 (Summer 1992): 18.

38. Mary Carruthers, *The Book of Memory: A Study of Memory in Medieval Culture* (New York: Cambridge University Press, 1992), 59–60.

39. See Giulio Camillo, *L'idea del teatro*, ed. Lina Bolzoni (Palermo: Sellerio, 1991).

40. Desiderius Erasmus, *Epistolae*, ed. P. S. Allen et al., vol. 9: 479. Cited in Yates, *The Art of Memory*, 132.

41. See, in particular, Giordano Bruno, *L'arte della memoria: le ombre delle idee* (Milan: Mimesis, 1996). On Bruno's work, see Frances A. Yates, *Giordano Bruno and the Hermetic Tradition* (Chicago: University of Chicago Press, 1964).

42. See Barbara Maria Stafford, *Voyage into Substance* (Cambridge: MIT Press, 1984), 4. See also John Dixon Hunt, *Gardens and the Picturesque* (Cambridge: MIT Press, 1992).

43. Christopher Hussey, *The Picturesque: Studies in a Point of View* (London and New York, 1927), 4.

44. On Choisy and Le Corbusier see Richard A. Etlin, "Le Corbusier, Choisy, and French Hellenism: The Search for a New Architecture," *Art Bulletin*, no. 2 (June 1987): 264–278. On Eisenstein and architectural history, see Yve-Alain Bois's introduction to Eisenstein's "Montage and Architecture," and Anthony Vidler, "The Explosion of Space: Architecture and the Filmic Imaginary," in *Film Architecture: Set Designs from Metropolis to Blade Runner*, ed. Dietrich Neumann (New York: Prestel, 1996).

45. This interview, the only one that Le Corbusier gave during his stay in Moscow in 1928, is cited in Jean-Louis Cohen, *Le Corbusier and the Mystique of the USSR*, trans. Kenneth Hylton (Princeton: Princeton University Press, 1992), 49.

46. Eisenstein, "Montage and Architecture," 120.

47. Le Corbusier and Pierre Jeanneret, *Oeuvre complète*, vol. 1, ed. Willi Boesiger (Zurich: Editions Girsberger, 1964), 60.

48. See Beatriz Colomina, *Privacy and Publicity: Modern Architecture as Mass Media* (Cambridge: MIT Press, 1994).

49. Le Corbusier, *Oeuvre complète*, vol. 2: 24.

50. On new museum architecture, see Victoria Newhouse, *Towards a New Museum* (New York: Monacelli Press, 1998).

51. See Walter Benjamin, *One Way Street and Other Writings*, trans. Edmund Jephcott and Kingsley Shorter (London: Verso, 1985), 295.

52. Libeskind's statement is cited in Michael W. Blumenthal, ed., *Jewish Museum Berlin* (G + B Arts International, 1999), 41. See also Daniel Libeskind, "Between the Lines," *A.D., Architectural Design* 67, nos. 9–10 (September–October 1997): 58–63.

53. This building was designed over the period 1981–1987.

54. On the notion of the fold, see Gilles Deleuze, *The Fold: Leibniz and the Baroque*, trans. Tom Conley (Minneapolis: University of Minnesota Press, 1993).

55. Frank Gehry, interviewed by Michael Sorkin, in "Beyond Bilbao," *Harper's Bazaar* (December 1998), 261.

56. *200 Minute Museum* is a project developed as Hani Rashid's "Paperless Studio" at Columbia University's School of Architecture. It was exhibited at the Storefront

for Art and Architecture, New York, 12 December 1998, a gallery featuring a cutout facade designed by Vito Acconci and Steven Holl.

57. See Judith Barry, *Projections: Mise en abyme* (Vancouver: Presentation House Gallery, 1997 [exhibition catalogue]); Barry, "The Work of the Forest," *Art and Text*, no. 42 (May 1992): 69–75; Barry, *Public Fantasy* (London: ICA, 1991); Barry, *Ars Memoriae Carnegiensis: A Memory Theatre* (Pittsburgh: Carnegie Museum of Art, 1991 [exhibition catalogue]); Barry, "Casual Imagination," in *Blasted Allegories*, ed. Brian Wallis (Cambridge: MIT Press, 1987); and Barry, "Dissenting Spaces," in Greenberg et al., *Thinking about Exhibitions*, which discusses El Lissitzky's 1920s wish for spectatorial, even tactile, agency in the design of the museum gallery.

58. On the museum and the shop, see in particular Chantal Georgel, "The Museum as Metaphor in Nineteenth-Century France," in Scherman and Rogoff, eds., *Museum Culture*; Erin Mackie, "Fashion in the Museum: An Eighteenth-Century Project," in Deborah Fausch, Paulette Singley, Rodolphe el-Khoury, and Zvi Efrat, eds., *Architecture: In Fashion* (Princeton: Princeton Architectural Press, 1994). On the department store and cinema's virtual gaze, see Anne Friedberg, *Window Shopping: Cinema and the Postmodern* (Berkeley: University of California Press, 1993). On mass culture and the museum see also Vanessa R. Schwartz, *Spectacular Realities: Early Mass Culture in Fin-de-Siècle Paris* (Berkeley: University of California Press, 1998). For the way in which the theatrics of display is bound up with ethnographic practice, see Alison Griffiths, "'Journeys for Those Who Can Not Travel': Promenade Cinema and the Museum Life Group," *Wide Angle* 18, no. 3, special issue "Movies before Cinema: Part II," ed. Scott MacDonald (July 1996): 53–84.

59. On this subject, see Gottfried Semper, "Style in the Technical and Tectonic Arts or Practical Aesthetics" (1860), in *The Four Elements of Architecture and Other Writings*, trans. Harry Francis Mallgrave and Wolfgang Herrmann (Cambridge: Cambridge University Press, 1989).

60. See Pierre Bourdieu, *Distinction: A Social Critique of the Judgment of Taste*, trans. Richard Nice (Cambridge: MIT Press, 1984).

61. Benjamin, *One Way Street*, 314.

62. André Malraux, *Museum without Walls*, trans. Stuart Gilbert and Francis Price (New York: Doubleday, 1967).

63. Denis Hollier, "Premises, Premises: Sketches in Remembrance of a Recent Graphic Turn in French Thought," in *Premises: Invested Spaces in Visual Arts, Architecture and Design from France: 1958–1998* (New York: Guggenheim Museum, 1998 [exhibition catalogue]), 64.

64. See Rosalind E. Krauss, "Postmodernism's Museum without Walls," in Greenberg et al., *Thinking about Exhibitions*, especially 345–346. On the subject of Malraux's *musée imaginaire*, see also Douglas Crimp, "On the Museum's Ruins," in *The Anti-Aesthetic: Essays on Postmodern Culture*, ed. Hal Foster (Port Townsend, N.Y.: Bay Press, 1983).

65. Stephen Greenblatt, "Resonance and Wonder," in *Exhibiting Cultures*, ed. Karp and Lavine.

66. Andreas Huyssen, "Escape from Amnesia: The Museum as Mass Medium," in *Twighlight Memories: Marking Time in a Culture of Amnesia* (New York: Routledge, 1995), 15.

67. On the force of rituals and psychic dramas enacted in the museum setting, see Carol Duncan, "Art Museum and the Ritual of Citizenship," in *Exhibiting Cultures*, ed. Karp and Lavine; and Duncan, *The Aesthetics of Power: Essays in Critical Art History* (Cambridge: Cambridge University Press, 1993).

68. Pierre Nora, "Between Memory and History: *Les Lieux de Mémoire*," *Representations*, no. 26 (Spring 1989): 12–13.

69. Aby Warburg, "Introduzione all'Atlante *Mnemosyne*" (1929), in *Mnemosyne. L'Atlante della memoria di Aby Warburg*, ed. Italo Spinelli and Roberto Venuti (Rome: Artemide Edizioni, 1998), 38 (my translation).

70. Ibid., 38, 40, 42.

71. Ibid., 43.

72. Alfonso Frisiani so describes the daguerreotype's potential future in the *Gazzetta privilegiata di Milano*, 3 December 1838. As cited in Giuliana Scimé, *On Paper* (January–February 1997), 28.

73. For an introduction to this term, see Yi-Fu Tuan, *Topophilia: A Study of Environmental Perception, Attitudes, and Values* (New York: Columbia University Press, 1990). Although I have found inspiration in this work, I have developed the notion of topophilia along a different path.

74. See Simon Schama, *Landscape and Memory* (New York: Vintage Books, 1995).

75. On Cardiff's work see, in particular, Sylvie Fortin, "Journeys through Memory Gardens and Other Impossible Homecomings," in *La ville, le jardin, la mémoire* (Rome: Académie de France, 1998 [exhibition catalogue]); and Rochelle Steiner, ed., *Wonderland* (St. Louis: Saint Louis Art Museum, 2000 [exhibition catalogue]), which contains further bibliographical references.

76. For example, in the history of landscape, the sea and the seashore have functioned as lures. See Alain Corbin, *The Lure of the Sea: The Discovery of the Seaside 1750–1840*, trans. Jocelyn Phelps (London: Penguin Books, 1994).

77. See *Doris Salcedo* (New York: New Museum of Contemporary Art, 1998 [exhibition catalogue]).

78. Gaston Bachelard, *The Poetics of Space*, trans. Maria Jolas (Boston: Beacon Press, 1969), 10, 62.

79. Xavier de Maistre, *Voyage around My Room*, trans. Stephen Sartarelli (New York: New Direction Books, 1994).

CHAPTER TWO

This text, originally titled "Modernist Ruins, Filmic Archaeologies," was written for the monograph *Jane and Louise Wilson: A Free and Anonymous Monument* (London: Film and Video Umbrella and the BALTIC Centre for Contemporary Art, 2004).

1. Victor Pasmore, as cited in Alan Bowness, "Introduction," *Victor Pasmore: With a Catalogue Raisonné of Paintings, Constructions and Graphics, 1926–1979*, ed. Alan Bowness and Luigi Lambertini (London: Thames and Hudson, 1980), 14.

2. Ibid., 15.

3. Le Corbusier, *Oeuvre complète*, vol. 2, ed. Willi Boesiger (Zurich: Editions Girsberger, 1964), 24. Here, Le Corbusier develops the idea of the architectural promenade by reading the itinerary of Villa Savoye (1929–1931) in relation to the movement of Arabic architecture.

4. On postwar British art, see *The Independent Group: Postwar Britain and the Aesthetics of Plenty*, ed. David Robbins (Cambridge: MIT Press, 1990).

5. Pasmore, in "A Symposium with Sir J. M. Richards, A. V. Williams, A. T. W. Marsden, and Victor Pasmore," in *Victor Pasmore*, ed. Bowness and Lambertini, 261.

6. See Alois Riegl, *Problems of Style: Foundations for a History of Ornament* (1893), trans. Evelyn Kain (Princeton: Princeton University Press, 1993); and Riegl, *Late*

Roman Art Industry (1901), trans. Rolf Winkes (Rome: Giorgio Bretschneider Editore, 1985).

7. For a general introduction to the culture of modernity, see Stephen Kern, *The Culture of Time and Space, 1880–1918* (Cambridge: Harvard University Press, 1983); Sigfried Giedion, *Space, Time and Architecture* (Cambridge: Harvard University Press, 1962); and Giedion, *Mechanization Takes Command* (New York: Norton, 1969).

8. Charles Baudelaire, "The Painter of Modern Life," in *The Painter of Modern Life and Other Essays* (New York: Garland, 1978), 9–10.

9. I gathered this and other information on the Wilsons' working methods in interviews with the artists on Governors Island on June 23, 2004, and in New York City on July 1, 2004. Thanks to Jane and Louise Wilson for their generous contribution.

10. Sergei M. Eisenstein, "Montage and Architecture," *Assemblage*, no. 10 (1989): 111–131. The text was written circa 1937, to be inserted in a book-length work.

11. On Gordon Matta-Clark, see Pamela M. Lee, *Objects to Be Destroyed: The Work of Gordon Matta-Clark* (Cambridge: MIT Press, 1999).

12. See Giuliana Bruno, *Atlas of Emotion: Journeys in Art, Architecture, and Film* (London: Verso, 2002).

13. Pasmore, in "A Symposium," *Victor Pasmore*, 261.

14. See, for example, *Jane and Louise Wilson*, with essays by Jeremy Millar and Claire Doherty (London: Film and Video Umbrella, 2000); and *Jane and Louise Wilson*, with essay by Peter Schjeldahl, dialogue with Jane and Louise Wilson and Lisa Corrin (London: Serpentine Gallery, exhibition catalogue, 1999).

15. Robert Polidori, *Zones of Exclusion: Pripyat and Chernobyl* (Göttingen: Steidl, 2003).

16. Nigel Burnham, *The Sunday Telegraph*, July 16, 2000.

17. This is a project of the Public Art Fund, New York.

CHAPTER THREE

This text was originally titled "Spectatorial Embodiments: Anatomies of the Visible and the Female Bodyscape," and published in *Camera Obscura*, special issue, "Imaging Technologies, Inscribing Science," ed. Paula A. Treichler and Lisa Cartwright, no. 28 (January 1992).

1. See, for example, Siegfried Kracauer, "Cult of Distraction: On Berlin's Picture Palaces," *New German Critique*, no. 40 (1987): 91–96. This essay is part of a collec-

tion of Kracauer's writings in English in *The Mass Ornament*, trans. and ed. Thomas Y. Levin (Cambridge: Harvard University Press, 1995).

Miriam Hansen has pointed out that Kracauer's work anticipates some of the aspects of Benjamin's writings on the arcade as well as on cinema. See Hansen, *Babel and Babylon: Spectatorship in American Silent Film* (Cambridge: Harvard University Press, 1992), 29 esp.

2. For a discussion of arcades and cinema as architectures of *transito*, see my "Street-walking around Plato's Cave," *October*, no. 60 (Spring 1992): 110–129, and *Streetwalking on a Ruined Map: Cultural Theory and the City Films of Elvira Notari* (Princeton: Princeton University Press, 1992).

On the notion of *transito*, see Mario Perniola, *Transiti. Come si va dallo stesso allo stesso* (Bologna: Cappelli, 1985). *Transito* (untranslatable in English as one word) is a wide-ranging and multifaceted notion of circulation, which refers to the spatial component of desire as inscribed in both physical and mental motion. It includes passages, traversing, transitions, transitory states, and erotic circulation, and it incorporates a linguistic reference to transit. It is such a traversing of desire that I call upon in my work to account for spectatorial fascination in cinema.

3. Kracauer, "Abschied von der Lindenpassage," quoted in Johann Friedrich Geist, *Arcades: The History of a Building Type* (Cambridge: MIT Press, 1983), 158–159.

4. St. Augustine included *curiositas* as one of "the lusts of the eyes," and related it to the attractions of seeing, among them, unbeautiful sights such as mangled corpses. See Augustine, *The Confessions* (New York: New American Library, 1963).

5. Tom Gunning has called attention to the relation between *curiositas* and silent cinema in "An Aesthetic of Astonishment: Early Film and the (In)credulous Spectator," *Art & Text*, no. 34 (Spring 1989): 31–45. Gunning claims that early cinema's "aesthetic of attraction" developed precisely out of the paradigm of vision of *curiositas*; that is, distraction and the ambivalence of shock. On the aesthetic of attraction, see also Gunning's earlier essays, "The Cinema of Attraction," *Wide Angle* 8, nos. 3–4 (1986): 63–70; and "An Unseen Energy Swallows Space: The Space in Early Film and Its Relation to American Avant-Garde Film," in *Film before Griffith*, ed. John Fell (Berkeley: University of California Press, 1983).

Adopting a different view of curiosity stemming from psychoanalytic reading of Pandora's box, Laura Mulvey speaks of a relation between curiosity and the feminine, as grounded in the terrain of fetishism. See her "Pandora: Topographies of

the Mask and Curiosity," in *Sexuality and Space*, ed. Beatriz Colomina (New York: Princeton Architectural Press, 1992).

I am intrigued by Gunning's and Mulvey's excellent readings, and our work shares fundamentals, but my aim is to explore the dark side of *curiositas*'s shocking effects, especially in regard to imaging mangled female bodies and exploring anatomies of the visible, retracing a genealogy of visuality beyond the workings of fetishism.

6. Vittorio Paliotti and Enzo Grano, *Napoli nel cinema* (Naples: Azienda Autonoma Cura Soggiorno e Turismo, 1969), 34; Aldo Bernardini, *Cinema muto italiano*, vol. 1 (Rome and Bari: Laterza, 1980), 153–154; and *La Lanterna*, Naples, September 22, 1907.

7. Paliotti and Grano, *Napoli nel cinema*, 32.

8. On this subject see Michel Foucault, *The Birth of the Clinic: An Archeology of Medical Perception* (New York: Pantheon Books, 1973).

9. See Walter Benjamin, "The Work of Art in the Age of Mechanical Reproduction," in *Illuminations*, ed. and with an intro. by Hannah Arendt (New York: Schocken Books, 1969), 233 and 243.

10. Ibid., 233–234.

11. Ibid., 248.

12. I am not claiming the anatomical descent to the exclusion of, but rather alongside other models or cultural configurations that play a part in filmic genealogy. However, my microhistorical object leads me to highlight its function within this context.

13. Jonathan Brown, *Jusepe de Ribera: Prints and Drawings* (Princeton: Princeton University Press, 1973), 136–137. Brown affirms the opinion of Walter Vitzthum, who first revealed the achievement of the master draftsman of Naples. On Ribera, see also *Jusepe de Ribera, Lo Spagnoletto 1591–1652*, ed. Craig Felton and William B. Jordan (Seattle: Washington University Press, 1983); and Elizabeth du Gué Trapeir, *Ribera* (New York: Hispanic Society of America, 1952). *The Bearded Woman* was commissioned by Fernando Afán de Ribera y Enríquez (1570–1673), viceroy of Naples and a renowned intellectual, and collector of art books.

14. This interpretation is offered by Lucy Fischer in "The Lady Vanishes: Woman, Magic and the Movies," *Film Quarterly* (Fall 1979): 31–40.

15. Linda Williams, "Film Body: An Implantation of Perversions," *Ciné-Tracts*, no. 12 (Winter 1981): 19–35.

16. Annette Michelson, "On the Eve of the Future: The Reasonable Facsimile and the Philosophical Toy," *October*, no. 29 (Summer 1984): 1–22. On Villiers's text, see also Raymond Bellour, "Ideal Hadaly," *Camera Obscura*, no. 15 (1986): 111–135; and Lucilla Albano, "Beauty Masque," *Nuovi Argomenti*, no. 9 (January–March 1984): 112–117.

17. For further elaboration of this idea see Michelson, "'Where Is Your Rupture?': Mass Culture and the Gesamtkunstwerk," *October*, no. 56 (Spring 1991): 43–63.

18. Michelson, "On the Eve of the Future," 20.

19. See Michel Foucault, *The History of Sexuality*, vol. 1 (New York: Pantheon Books, 1978). See also the special three-volume issue of *Zone*, titled "Fragments for a History of the Human Body," published in 1989; Sander L. Gilman, *Sexuality: An Illustrated History: Representing the Sexual in Medicine and Culture from the Middle Ages to the Age of AIDS* (New York: John Wiley & Sons, 1989); Thomas Laqueur, *Making Sex: Body and Gender from the Greeks to Freud* (Cambridge: Harvard University Press, 1990); and Barbara Maria Stafford, *Body Criticism: Imaging the Unseen in Enlightenment Art and Medicine* (Cambridge: MIT Press, 1991). The very publishing of these texts is a case in point.

20. On this subject, see Hollis Frampton, *Circles of Confusion* (Rochester, N.Y.: Visual Studies Workshop Press, 1983), esp. the essay "Eadweard Muybridge: Fragments of a Tesseract."

21. In research on film and physiology, Lisa Cartwright claims that the physiological laboratory filmwork developed internationally produced a substantial number of films whose language predates experimental filmic practices. See Lisa Cartwright, "The Place of Physiology in Early Cinema," unpublished paper, presented at the Society for Cinema Studies Conference, University of Iowa, Iowa City, April 1989; and idem, *Physiological Modernism: Cinematography as a Medical Research Technology* (Ph.D. diss., Yale University, 1991), where the historico-theoretical analysis of medicine's use of film is further pursued.

22. See Jonathan Crary, *Techniques of the Observer* (Cambridge: MIT Press, 1990). See also Crary, "Modernizing Vision," in *Vision and Visuality*, ed. Hal Foster, Dia Art Foundation Discussions in Contemporary Culture, no. 2 (Seattle: Bay Press, 1988), 36–46; and Crary, "Spectacle, Attention, Counter-Memory," *October*, no. 50 (Fall 1989): 97–107.

23. Allan Sekula analyzes this epistemology in an essay on photography's impact on the formation of a criminal archive. See "The Body and the Archive," *October*, no. 29 (Winter 1986): 3–64. Discussing, in particular, the work of Alphonse Bertillon and Francis Galton, Sekula articulates the epistemological relation among photography, criminology, phrenology, and anatomy.

24. See, for example, Giovanni Morelli, *Italian Painters: Critical Studies of Their Works* (London: Murray, 1892–1893).

Carlo Ginzburg has noted that Morelli's art-historical model, attentive to the morphology of the ear, recalls Bertillon's criminal archive. See Ginzburg, "Clues: Morelli, Freud, and Sherlock Holmes," in *The Sign of the Three: Dupin, Holmes, Pierce*, ed. Umberto Eco and Thomas A. Sebeok (Bloomington: Indiana University Press, 1983). This essay tackles Freud's involvement with Morelli in Freud's pre-analytic phase and points to a shared territory of signs in Freud, Morelli, and Sherlock Holmes. I discuss this "detective paradigm" in its potential relation to film history in my "Towards a Theorization of Film History," *Iris* 2, no. 2 (September 1984): 41–55.

25. Sigmund Freud, *Moses and Monotheism* (New York: Vintage Books, 1939).

26. Ludmilla Jordanova, *Sexual Visions: Images of Gender in Science and Medicine Between the Eighteenth and the Twentieth Centuries* (London: Harvester Wheatsheaf, 1989), 51–52.

27. Dr. Negro made *La neuropatologia* in collaboration with Roberto Omegna, cameraman of Turin's production house Ambrosio Film, who became Italy's most important medical filmmaker.

28. D. M. Bourneville and P. Regnard, *Iconographie photographique de la Salpêtrière* (Paris, vol. 1, 1877; vol. 2, 1878; vol. 3, 1879–1880).

29. Alberto Farassino, "Il gabinetto del Dottor Negro: analisi di un film psichiatrico del 1908," *Aut Aut*, nos. 197–198 (Fall 1983): 151–170.

30. Reviews of the event mention the attendance of Lombroso, confirmed by Farassino, "Il gabinetto del Dottor Negro," 161.

31. Cesare Lombroso and William Ferrero, *The Female Offender* (London: T. F. Unwin, 1895).

For a treatment of Lombroso's work in the context of physiognomy, phrenology, and physiology, see Patrizia Magli, "The Face and the Soul," *Zone*, no. 4 (1989), special issue, "Fragments for a History of the Human Body," part 2.

32. Béla Balázs, *Theory of the Film* (New York: Dover, 1970), 61–62.

33. According to Farassino, in Naples Rummo had been showing the films made since 1898 by the French doctor Eugène Doyen, a pioneer of medical-scientific cinema, who had been accused by the official union of French doctors of having degraded the medical profession to the level of the circus. Farassino, "Il gabinetto del Dottor Negro," 159.

34. Mario Dall'Olio, "La neuropatologia al cinematografo," in *La Gazzetta di Torino*, February 18, 1908, quoted in Maria Adriana Prolo, *Storia del cinema muto italiano*, vol. 1 (Milan: Poligono, 1951), 32–33.

 La Gazzetta di Torino, Turin's daily newspaper, had just established a regular film column, the first to appear in Italy. For information on Turin's film industry and journals, see Gianni Rondolino, *Torino come Hollywood* (Bologna: Cappelli, 1980).

35. This expression is borrowed from Teresa de Lauretis, *Technologies of Gender* (Bloomington: Indiana University Press, 1987).

36. Alessandro Benedetti's statement is quoted in Hyatt Mayor, *Artists and Anatomists* (New York: Metropolitan Museum of Art and Artist's Limited Edition, 1984), 41.

37. It was Benjamin's belief that every epoch dreams the following, an opinion expressed, for example, in his "Fourier or the Arcades," published in *Charles Baudelaire: A Lyric Poet in the Era of High Capitalism* (London: Verso, 1973). In recent years, among others, Fredric Jameson, Andrew Ross, and Constance Penley, in different ways, have pointed to the utopian dimension and potential of popular culture. See Jameson's 1979 essay "Reification and Utopia in Mass Culture," in his *Signatures of the Visible* (New York: Routledge, 1990); and *Technoculture*, ed. Constance Penley and Andrew Ross (Minneapolis: University of Minnesota Press, 1991).

CHAPTER FOUR

This text was originally titled "Interiors: Anatomies of the Bride Machine," and published in the exhibition catalogue *Rebecca Horn* (New York: Guggenheim Museum, 1993).

1. Alexandre Astruc, "The Birth of a New Avant-Garde: *La Caméra-Stylo*" (1948), in *The New Wave*, ed. Peter Graham (Garden City, N.Y.: Doubleday, 1968), 17–23.

2. Bruce Ferguson, "Rebecca Horn: Really Dangerous Liaisons," in *Rebecca Horn: Diving through Buster's Bedroom* (Los Angeles: Museum of Contemporary Art, and Milan: Fabbri Editori, 1990), 19–27.

3. See Michel Carrouges, *Les Machines célibataires* (Paris: Editions Arcanes, 1954). Duchamp's bachelor machine and Jean Tinguely's modernism are genealogically tied to work such as Villiers de l'Isle Adam's 1886 novel *L'Ève future*.

4. Carrouges, "Directions for Use," in *Le macchine celibi/The Bachelor Machines*, ed. Jean Clair and Harald Szeemann (New York: Rizzoli, 1975), 21–22.

5. Constance Penley, *The Future of an Illusion: Film, Feminism and Psychoanalysis* (Minneapolis: University of Minnesota Press, 1989), 58.

6. Michel de Certeau, "Arts of Dying/Anti-mystical Writing," in *Le macchine celibi/The Bachelor Machines*, 95.

7. Harald Szeemann, "The Bachelor Machines," in ibid., 7.

8. Rebecca Horn, "Die preussische Brautmaschine/The Prussian Bride Machine," in *Rebecca Horn: Diving through Buster's Bedroom*, 86.

9. "An Art Circus," in ibid., 90.

10. Jessica Benjamin, "A Desire of One's Own: Psychoanalytic Feminism and Inter-subjective Space," in *Feminist Studies/Critical Studies*, ed. Teresa de Lauretis (Bloomington: Indiana University Press, 1986), 97.

11. Rebecca Horn, "Rooms, Kangaroos," in *Rebecca Horn: Zeichnungen, Objekte, Video, Filme, 17 März–24 April 1977* (Cologne: Kölnischer Kunstverein, 1977), 11.

12. On the topic of sensitivity, see Toni Stoos, "Short Pictorial Anthology of 'Touching,'" and Bice Curiger, "The Anatomy of Sensitivity," in *Rebecca Horn* (Chicago: Museum of Contemporary Art, 1984), 10–20 and 23–63.

13. Horn, "The Hydra Forest, Pittsburgh, 1988," in *Rebecca Horn: Diving through Buster's Bedroom*, 88.

14. See Giorgio Agamben, *Stanzas: Word and Phantasm in Western Culture*, trans. Ronald L. Martinez (Minneapolis: University of Minnesota Press, 1992).

15. See Germano Celant, "Alter Ego: Buster Horn," in *Rebecca Horn: Diving through Buster's Bedroom*, 11–17.

16. For the notion of *transito*, a wide-ranging and multifaceted view of circulation, see Mario Perniola, *Transiti. Come si va dallo stesso allo stesso* (Bologna: Cappelli, 1985).

17. Around the time Horn made this film, Yvonne Rainer, a dancer and filmmaker, was also engaged in constructing the narrative space of her films around the architec-

ture of her own loft, and Michael Snow had linked the epistemological space of narrative discovery to the geography of the loft.

18. Luis Buñuel, "Buster Keaton's College," in *The Shadow and Its Shadow*, ed. Paul Hammond (London: BFI, 1978), 34.

19. Celant, "Rebecca Horn, Dancing on the Egg," *Artforum* 23, no. 2 (October 1984): 55.

20. See, among others, Jean-Claude Beaune, "The Classical Age of Automata: An Impressionistic Survey from the Sixteenth to the Nineteenth Century," *Zone*, special issue "Fragments for a History of the Human Body," ed. Michel Feher with Ramona Nadaff and Nadia Tazi, part I (1989): 431–437.

21. From the voiceover, spoken by Horn, accompanying the entrance of *Der Eintänzer*.

22. Heinrich von Kleist, "On the Marionette Theatre," *Zone*, special issue "Fragments for a History of the Human Body," part I: 415–420. Images from *Der Eintänzer* are accompanied by Kleist's text in the newsletter of Samangallery, ed. Ida Giannelli, Genoa, December 15, 1978.

23. In his work on Keaton, Noël Carroll has raised the issue of automatism, most effectively revealing the automaton-like aspect of the Keaton character. See, in particular, Carroll, "Keaton: Film Acting as Action," in *Making Visible the Invisible: An Anthology of Original Essays on Film Acting*, ed. Carole Zucker (Metuchen, N.J.: Scarecrow Press, 1990), 198–223.

24. Vivian Sobchack, *The Address of the Eye: A Phenomenology of Film Experience* (Princeton: Princeton University Press, 1992).

25. Sigmund Freud, *Civilization and Its Discontents*, trans. and ed. James Strachey (New York: Norton, 1961), 37.

26. Ibid., 38. For an interesting recent discussion of visual technology and prosthesis, see Paul Virilio, *The Aesthetics of Disappearance*, trans. Philip Beitchman (New York: Semiotext(e), 1991).

27. Horn, *Rebecca Horn: El riu de la lluna* (exhibition catalogue), trans. Melissa Drier, (Barcelona: Fundació Espai Poblenou, 1992), 7.

28. The anatomical seduction of and in cinema, and its interrelation with (erotic) topographies, are pursued further in my book *Streetwalking on a Ruined Map: Cultural Theory and the City Films of Elvira Notari* (Princeton: Princeton University Press, 1993).

29. Lewis A. Sayre, *Spinal Disease and Spinal Curvature: Their Treatment by Suspension and the Use of Plaster of Paris Bandage* (London: Smith, Elder & Co., 1878).

30. I am borrowing and freely adapting the term "desiring machines" from Gilles Deleuze and Félix Guattari's work. See, in particular, Gilles Deleuze and Félix Guattari, *Kafka: Toward a Minor Literature*, trans. Dana Polan (Minneapolis: University of Minnesota Press, 1986), and Deleuze and Guattari, *A Thousand Plateaus: Capitalism and Schizophrenia*, trans. Brian Massumi (Minneapolis: University of Minnesota Press, 1987).

31. Walter Benjamin, *Passagen-Werk* (Frankfurt: Suhrkamp Verlag, 1982), vol. 5, esp. 466. Hal Foster recalls Benjamin's view, speaking of the body as armor in "Armor Fou," *October*, no. 56 (Spring 1991): 65–97.

32. Deleuze, *Masochism: Coldness and Cruelty*, trans. Jean McNeil (New York: Zone Books, 1989).

33. Jessica Benjamin, *The Bonds of Love: Psychoanalysis, Feminism and the Problem of Domination* (New York: Pantheon, 1988).

34. See Barbara Maria Stafford, *Body Criticism: Imaging the Unseen in Enlightenment Art and Medicine* (Cambridge: MIT Press, 1991), esp. 410–411 and 459–461. While Galvani experimented on animals, Aldini conducted ghoulish experiments on human cadavers, and performed galvanizations that sought to jolt dead creatures back to life.

35. See Fikret Yegül, *Baths and Bathing in Classical Antiquity* (Cambridge: MIT Press, 1992).

36. The term is borrowed from Luce Irigaray's "The Mechanics of Fluids," in *This Sex Which Is Not One*, trans. Catherine Porter (Ithaca: Cornell University Press, 1985), where Irigaray claims the feminine as fluid.

37. Lynne Cooke, *Rebecca Horn: Missing Full Moon* (Bath: Artsite Gallery, 1989), 7–16.

38. Gaston Bachelard affirmed that alchemy is a science of bachelors, intended to service masculine society, in his book *Psychoanalysis of Fire*, trans. Alan C. M. Ross (Boston: Beacon Press, 1964). See also Arturo Schwarz, "The Alchemical Bachelor Machine," in *Le macchine celibi/The Bachelor Machines*, 156–171.

39. Fetishism and dandyism, as practiced by Horn, have a female history. See Naomi Schor, "Female Fetishism: The Case of George Sand," in *The Female Body in Western Culture*, ed. Susan Suleiman (Cambridge: Harvard University Press, 1985).

40. Diane Ackerman, *A Natural History of the Senses* (New York: Vintage Books, 1991).

41. Valentina Cortese, born in Italy in 1924, is an icon of both Italian and international productions. Her performances run from Hollywood roles to the cinema of

Michelangelo Antonioni and Frederico Fellini. She gave a memorable portrayal of a grotesque fading film star in François Truffaut's *Day for Night* (1973).

42. See Mary Ann Doane, *Femmes Fatales: Feminism, Film Theory, Psychoanalysis* (New York: Routledge, 1991).

43. The term "skin job" was used to refer to androids in Ridley Scott's 1982 film *Blade Runner*.

44. In this respect, Horn participates in the current cross-cultural remaking of this link. On the body, architecture, and the investigation of the interior, see *Sexuality and Space*, ed. Beatriz Colomina (New York: Princeton Architectural Press, 1992), and Giuliana Bruno, "Bodily Architectures," *Assemblage*, no. 19 (1992): 106–111.

45. Horn, *Rebecca Horn: El riu de la lluna*, 16.

46. Ibid., 14.

47. In an interview with the artist in New York on October 12, 1992, Horn's manner of speaking suggested this train of thought to me.

CHAPTER FIVE

This text was originally titled "Fashions of Living," and published in *Quarterly Review of Film and Video* 20, no. 3 (July–September 2003).

1. Louise Bourgeois, *Album* (New York: Peter Blum, 1994). See also Bourgeois, *Destruction of the Father/Reconstruction of the Father: Writings and Interviews 1923–1997* (Cambridge: MIT Press, and London: Violette Editions, 1998).

2. For an introduction to social space as lived space, see Henri Lefebvre, *The Production of Space*, trans. Donald Nicholson-Smith (Oxford: Blackwell, 1991).

3. See Meaghan Morris, "At Henry Parkes Motel," *Cultural Studies* 2, no. 1 (1988): 1–47.

4. Georges Van Den Abbeele, *Travel as Metaphor* (Minneapolis: University of Minnesota Press, 1992), xviii.

5. See, among others, Beatriz Colomina, ed., *Sexuality and Space* (Princeton: Princeton Architectural Press, 1992); Diana Agrest, Patricia Conway, and Leslie Kanes Weisman, eds., *The Sex of Architecture* (New York: Abrams, 1996); and Jane Rendell, Barbara Penner, and Iain Borden, eds., *Gender, Space, and Architecture: An Interdisciplinary Introduction* (New York: Routledge, 2000).

6. See Giuliana Bruno, *Streetwalking on a Ruined Map* (Princeton: Princeton University Press, 1993).

7. This is further pursued in my book *Atlas of Emotion: Journeys in Art, Architecture and Film* (London and New York: Verso, 2002).

8. Elaine Scarry, *The Body in Pain: The Making and Unmaking of the World* (New York: Oxford University Press, 1985).

9. The film was based on a Pulitzer Prize-winning play by George Kelly. It was remade in 1950 in a less interesting film version called *Harriet Craig*, directed by Vincent Sherman and starring Joan Crawford. An art exhibition inspired by this latter film and entitled "Harriet Craig" was presented at Apex Art in New York, 19 November–19 December 1998. It included the work of Alex Bag, Martha Rosler, and John Boskovich.

10. Claire Johnston, "Dorothy Arzner: Critical Strategies," in *Feminism and Film Theory*, ed. Constance Penley (New York: Routledge, 1988), 36. In this same volume, see also Pam Cook, "Approaching the Work of Dorothy Arzner," and Jacquelyn Suter, "Feminine Discourse in *Christopher Strong*."

11. Judith Mayne, *Directed by Dorothy Arzner* (Bloomington: Indiana University Press, 1994).

12. Bruno Taut, *Die neue Wohnung: Die Frau als Schöpferin* (Leipzig: Klinkhardt und Biermann, 1924).

 On Taut's role in the fashioning of modern architecture, see Mark Wigley, *White Walls, Designer Dresses: The Fashioning of Modern Architecture* (Cambridge: MIT Press, 1995).

13. This citation is taken from the Italian edition of Bruno Taut's book, entitled *La nuova abitazione: la donna come creatrice* (Rome: Gangemi editore, 1986), 84–85 (my translation).

14. On this notion, see Roger Caillois, "Mimicry and Legendary Psychasthenia," *October*, no. 31 (Winter 1984): 17–32.

CHAPTER SIX

This text was originally titled "Architects of Time: Reel Images from Warhol to Tsai Ming-liang," and published in *Log*, no. 2 (Spring 2004).

1. Jonas Mekas, *Movie Journal: The Rise of a New American Cinema, 1959–1971* (New York: Collier, 1972), 109. On the relation of Warhol to the avant-garde, see also P. Adams Sitney, *Visionary Film: The American Avant-Garde 1943–1978* (Oxford: Oxford University Press, 1974); Annette Michelson, "'Where is Your Rupture?': Mass

Culture and the Gesamtkunstwerk," *October*, no. 56 (Spring 1991): 42–63; and Colin MacCabe, Mark Francis, and Peter Wollen, eds., *Who is Andy Warhol?* (London: British Film Institute, 1997).

2. See Gregory Battcock, "Four Films by Andy Warhol," in *Andy Warhol Film Factory*, ed. Michael O'Pray (London: British Film Institute, 1989), a useful collection of essays on Warhol's cinema.

3. On this topic, see Stephen Koch, *Stargazer: Andy Warhol's World and His Films* (New York: Praeger, 1973).

4. For a postmodern reading emphasizing "corporeal stupidity," see Steven Shaviro, "Warhol's Bodies," in his *The Cinematic Body* (Minneapolis: University of Minnesota Press, 1993).

5. André Bazin, *What Is Cinema?*, vol. 2, ed. and trans. Hugh Gray (Los Angeles: University of California Press, 1971), 55.

6. Andy Warhol's statement is cited in Peter Gidal, "Warhol—Part One of an Analysis of the Films of Andy Warhol," *Films and Filming*, no. 7 (April 1971): 27. For a more recent treatment of Warhol in the context of the aesthetic of boredom, see Patrice Petro, "After Shock/Between Boredom and History," in *Fugitive Images*, ed. Patrice Petro (Bloomington: Indiana University Press, 1995).

7. Henri Lefebvre, *Writings on Cities*, ed. and trans. Eleonore Kofman and Elizabeth Lebas (Cambridge: Blackwell, 1996), 219.

8. From a roundtable discussion with the author, at the Harvard Film Archive, Harvard University, 7 October 2003.

9. For a more extended treatment of filmic architecture and Sugimoto's own architectures, see Giuliana Bruno, *Atlas of Emotion: Journeys in Art, Architecture, and Film* (London: Verso, 2002).

10. See Norman Bryson, "Hiroshi Sugimoto's Metabolic Photography," *Parkett*, no. 46 (1996): 120–123.

11. An interpretation offered by David James in his *Allegories of Cinema: American Film in the Sixties* (Princeton: Princeton University Press, 1989), 65.

INDEX

Akerman, Chantal, 8, 9, 133, 180, 200–201, 211
Aldini, Giovanni, 149
Antonioni, Michelangelo, 180, 200–201, 211
Arzner, Dorothy, 167–172
Astruc, Alexandre, 119

Bachelard, Gaston, 40
Balázs, Béla, 112
Banham, Reyner, xi
Barney, Matthew, 11
Barry, Judith, 30, 31
Baudelaire, Charles, 60
Bazin, André, 6–7, 189, 194–195
Benedetti, Alessandro, 116
Benjamin, Jessica, 126
Benjamin, Walter, ix, 29, 33, 93–94, 229
Boltanski, Christian, 3
Bourdieu, Pierre, 32
Bourgeois, Louise, 163–165, 173
Brakhage, Stan, 93
Braudel, Fernand, 199
Brougher, Kerry, 12
Bruno, Giordano, 23
Buñuel, Luis, 134

Caillois, Roger, 234
Calle, Sophie, 11
Camillo, Giulio, 22
Capucci, Roberto, 153, 155

Cardiff, Janet, 39
Carruthers, Mary, 22
Cartwright, Lisa, 102
Cattaneo, Menotti, 90–91, 95, 99, 116
Celant, Germano, 135
Certeau, Michel de, 122
Charcot, Jean-Martin, 107
Choisy, Auguste, 26
Cicero, Marcus Tullius, 20, 21
Clark, Larry, 11
Condillac, Étienne Bonnot de, 100
Conner, Bruce, 12
Cooke, Lynne, 152
Cortese, Valentina, 129, 153, 155
Crary, Jonathan, 104

Debord, Guy, xii
Deleuze, Gilles, 145, 232
Delpech, Jacques, 132
Deren, Maya, 133
Douglas, Stan, 12
Drozdik, Orshi, 111
Duchamp, Marcel, 121, 122, 134, 136
Dulac, Germaine, 133
Duncan, Carol, 35

Edison, Thomas, 100, 194
Egoyan, Atom, 9
Eisenstein, Sergei, ix, 18–20, 25–26, 62, 182
Erasmus, Desiderius, 22

Fabricius, Hieronymus, of Acquapendente, 143
Farassino, Alberto, 107
Ferguson, Bruce, 121
Fludd, Robert, 24
Foucault, Michel, 102
Freud, Sigmund, 21, 105, 140–141
Frölich, Jacob, 89

Galvani, Luigi, 149
Gehry, Frank, 29
Giedion, Sigfried, ix
Ginzburg, Carlo, 228
Goffres, Joseph Marie Achille, 147, 151, 154
Gordon, Douglas, 13, 15
Greenaway, Peter, 9
Greenblatt, Stephen, 34
Gunning, Tom, 90, 225–226
Guy, Alice, 170

Hamilton, Ann, 183
Hamilton, Richard, 45
Hartley, Hal, 9
Hatoum, Mona, 185, 186
Hill, Gary, 176
Hitchcock, Alfred, 13
Hodges, Mike, 65
Hollier, Denis, 34
Horn, Rebecca, xi, 11, 119–158
Huyssen, Andreas, 35

Jacobs, Ken, 12
Jordanova, Ludmilla, 105(n26)
Julien, Isaac, 9, 10

Keaton, Buster, 129, 134, 137
Khedoori, Toba, 176, 177
Kiarostami, Abbas, 9
Kierkegaard, Søren, 3

Klein, Melanie, 127
Kleist, Heinrich von, 136, 137
Kracauer, Siegfried, 87, 90
Krauss, Rosalind E., 34
Kruger, Barbara, 106
Kuitca, Guillermo, 178–183, 185
Kuleshov, Lev, 62
Kulmus, Johann Adam, 88

Lacan, Jacques, ix–x, xi, xii
Lang, Fritz, 136
Le Corbusier, ix, 26–27, 47
Lee Kang-sheng, 206
Lefebvre, Henri, 199
Leonardo da Vinci, 124
Lessing, Gottfried, x
Libeskind, Daniel, 29
Lombroso, Cesare, 107, 109
Longo, Robert, 11
Lull, Ramon, 15

Maistre, Xavier de, 41
Malraux, André, 33–34
Marey, Étienne-Jules, 104
Marker, Chris, 9, 13, 14
Matta-Clark, Gordon, 66, 176
Max, Gabriel von, 101
Mayne, Judith, 167
Mekas, Jonas, 191
Méliès, Georges, 95, 97
Michelson, Annette, 100
Minh-ha, Trinh T., 9
Morelli, Giovanni, 105
Mulvey, Laura, 225–226
Mumford, Lewis, 6, 7, 9
Münsterberg, Hugo, 4
Muybridge, Eadweard, 95, 97, 102

Negro, Camillo, 13, 107–109, 112–116

Neshat, Shirin, 16
Nissl, Franz Xaver, 103
Nora, Pierre, 35
Notari, Elvira, 98–99, 116
Nouvel, Jean, 29
Nykvist, Sven, 129

Omegna, Roberto, 13
Oppenheim, Meret, 153
Orozco, Gabriel, 81

Pasmore, Victor, 43, 44–48, 53–55,
 58, 62, 66–67, 68, 78–79, 81
Penley, Constance, 122
Perec, Georges, 163
Perniola, Mario, 225
Plato, 21
Polidori, Robert, 75
Poulleau, Claude-René-Gabriel, 113

Quintilianus, Marcus Fabius, 20–21,
 22, 39

Rainer, Yvonne, 9
Rashid, Hani, 30
Recanati, Mario, 91
Ribera, Jusepe de, 95–97
Riegl, Alois, 54
Ruiz, Raúl, 9, 21
Rummo, Gaetano, 112
Russell, Rosalind, 170

Salcedo, Doris, 40, 185, 187
Salle, David, 11
Sánchez Cotán, Juan, 97
Sayre, Lewis A., 139
Scarpa, Carlo, 81
Scarry, Elaine, 167
Schama, Simon, 39
Schnabel, Julian, 11

Scudéry, Madeleine de, xii, 165
Seidelman, Susan, 136
Sekula, Allan, 228
Shephard, Gregory, 11
Sherman, Cindy, 11
Smith, Seton, 178
Sobchack, Vivian, 140
Sugimoto, Hiroshi, 209–211
Szeemann, Harald, 122

Tati, Jacques, 208, 211
Taut, Bruno, 172–175
Teige, Karel, 168
Tsai Ming-liang, 200–208, 210,
 211
Turner, J. M. W., 72

Van Den Abbeele, Georges, 165
Varda, Agnès, 9
Vertov, Dziga, 72
Vesalius, Andreas, 92
Villiers de l'Isle Adam, Auguste,
 comte de, 100, 136
Viola, Bill, 15–16, 212
Visconti, Luchino, 133, 134

Warburg, Aby, 36, 37
Warhol, Andy, 189–200, 208–209,
 211–213
Whiteread, Rachel, 183–185
Wilde, Oscar, 127, 134
Williams, Linda, 97
Wilson, Jane and Louise, xi–xii,
 43–82
Wright, Frank Lloyd, 34

Yates, Frances, 21

Zick, Stephan, 110
Zittel, Andrea, 166